VINEYARDS

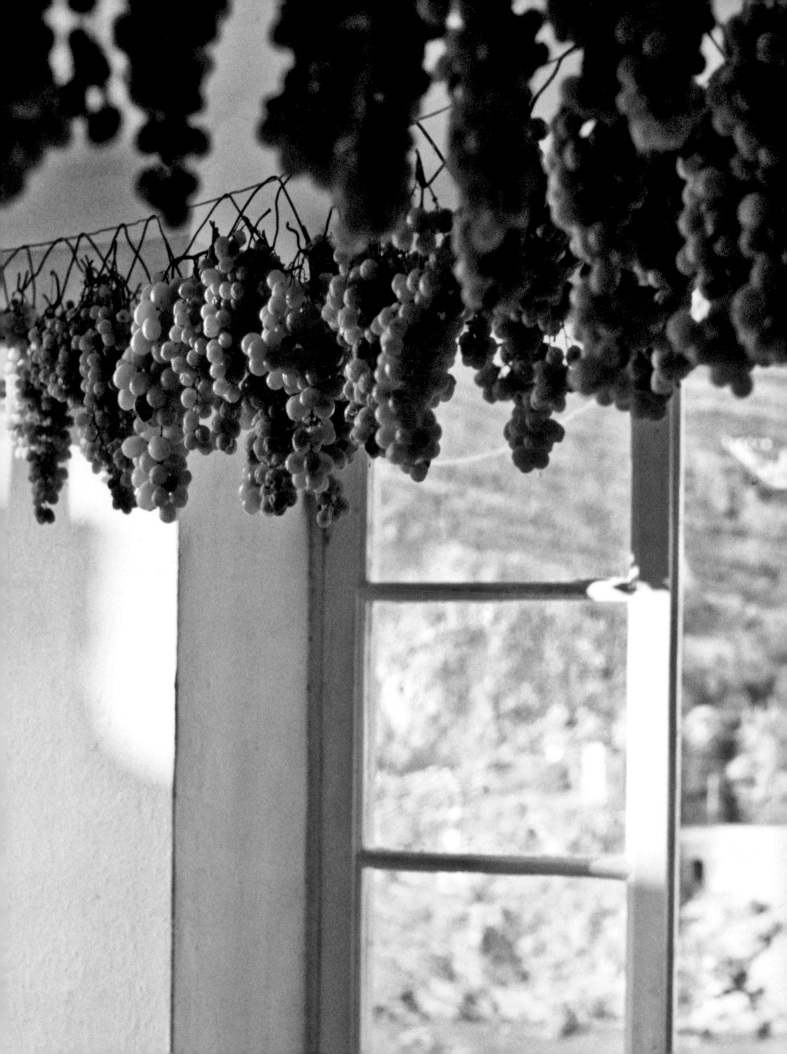

VINEYARDS

PHOTOGRAPHS BY

FRED LYON

PRINCETON ARCHITECTURAL PRESS

NEW YORK

Published by Princeton Architectural Press
202 Warren Street, Hudson, NY 12534
www.papress.com

Editor: Sara Stemen
Designer: Benjamin English

Special thanks to: Paula Baver, Janet Behning, Abby Bussel,
Jan Cigliano Hartman, Susan Hershberg, Kristen Hewitt,
Stephanie Holstein, Lia Hunt, Valerie Kamen, Jennifer Lippert,
Sara McKay, Parker Menzimer, Eliana Miller, Wes Seeley, Rob Shaeffer,
Jessica Tackett, Marisa Tesoro, Paul Wagner, and Joseph Weston
of Princeton Architectural Press —Kevin C. Lippert, publisher

Library of Congress Cataloging-in-Publication Data
NAMES: Lyon, Fred, author. Title: Vineyards / Fred Lyon.
DESCRIPTION: First edition. | Hudson, New York: Princeton
Architectural Press, [2019]
IDENTIFIERS: LCCN 2019006451 | ISBN 9781616898489
(hardcover : alk. paper)
SUBJECTS: LCSH: Landscape photography. | Vineyards—Pictorial
works. | Wine and wine making.
CLASSIFICATION: LCC TR660.5 .L97 2019 | DDC 779/.96348—dc23
LC record available at https://lccn.loc.gov/2019006451

*Exuberant San Francisco photographer Fred Lyon is approaching the century
mark with his nose in a wineglass. Gleefully, he says, "My camera
got me into this and refuses to lead me out. I'm here until the music ends."*

WINE SIDLED INTO MY LIFE in the days of my youth, when I was first
developing a taste for whiskey. In those lean times, a friendly gallon jug
was often the practical alternative. Then, curiosity turned to obsession,
as nosiness and the innocence of youth led me to examine the wine
photography of the time and say, "Hell, I can do better than that!"

My luck has been exceptional. Opportunities have always presented
themselves, and being a world-class snoop, I have pounced on them.
I've chased them all over the world to France, Hungary, Italy, Greece,
and Chile, among other fertile areas. My camera and an interest in
winemaking proved a great entrée, and I found myself dining with counts
and countesses, often staying at grand châteaux in Bordeaux, Burgundy,
and Champagne. What an education: quizzing the most experienced
and innovative winemakers and vineyardists while sampling their
solutions. Heaven!

My hometown, San Francisco, has long been the gateway to the Napa-
Sonoma wine region to its north. The Bay Area was originally settled by
immigrant families who brought their winegrowing traditions to this
hospitable land. As wine demand exploded in the mid-twentieth century,
investment in vineyards and wineries sparked a boom that continues
today. The heroic efforts of the local characters, so intense in their search
for the ultimate wine, have produced landmark varietals.

The region's endless eye candy offered me a sharp contrast to the shapes,
textures, and purpose of the city. Eventually, San Francisco's summer fog
gave me an excuse to acquire a small Napa Valley vineyard in Rutherford.
This wasn't just the view from my ancient Ford pickup truck—my young

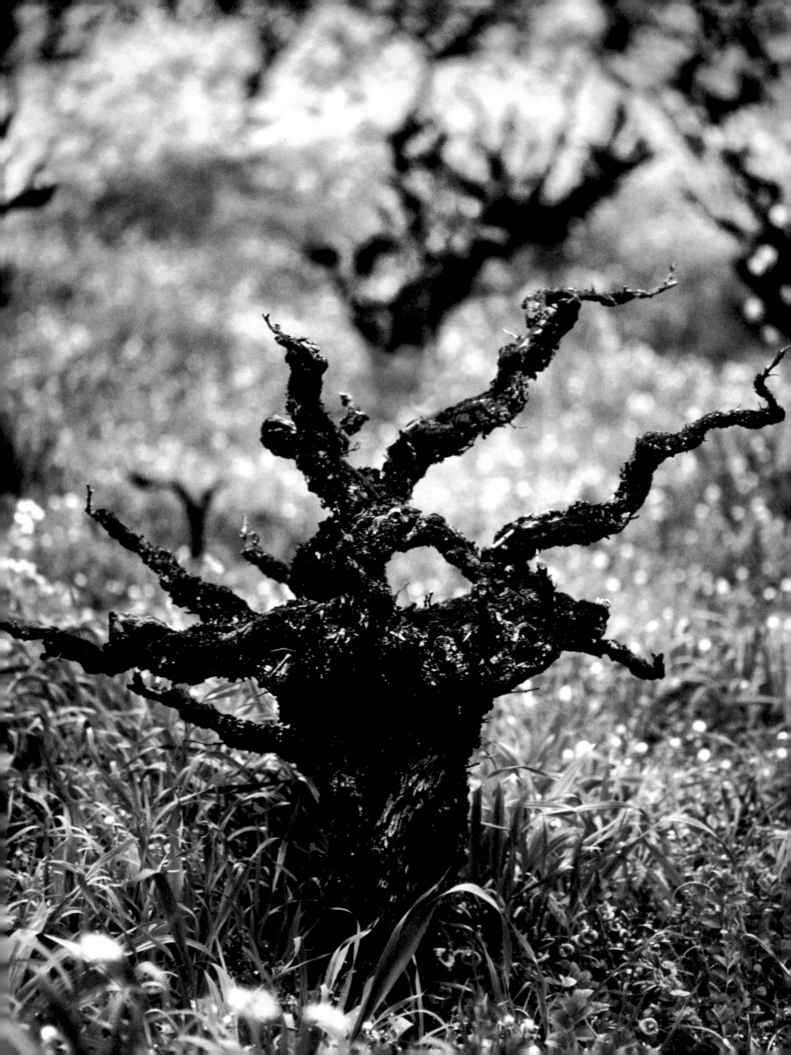

family joined in the fun, and we all became hands-on grape growers. Our seasons ranged from mud to dust, and we learned to tolerate clouds of fruit flies and leafhoppers flying into our eyes and ears. We lived in fear of a spring freeze. My new skills included stringing barbed wire to ward off marauding deer and anticipating the habits of occasional visiting rattlesnakes. Still, I fell in love with grapevines. These gnarled, black sculptures struggle to emerge from their winter dormancy, then produce quantities of lush foliage and even fruit. This dramatic act, so seductive, seems to relate to something deep in my character.

A friend who had a new vineyard nearby suggested that we make wine together, and for several years we did. In his day job as a well-known financier, he was suave and faultlessly groomed. I just loved it when we were sweaty and covered in purple muck. It was like "The Marx Brothers Make Wine." One of our early experiments involved a scavenged washing machine that I modified to use as a centrifuge on its spin cycle. It worked, but the word got out, and we took such a ribbing that we acquired a real basket press for the next harvest.

For thirty years, raising wine grapes competed with photography for my energy, as my image making focused increasingly on wine, food, and travel. Vineyard work was a form of meditation and often furnished a leafy studio. The dusty act of climbing down from my tractor shaped my camera's vision.

This book was a scary project, requiring me to sift through files spanning more than seventy years and containing thousands of images. Photography has grown and changed in recent years, and the challenge of finding fresh, relevant material consumed me. Though I grumbled at the effort, now I congratulate myself for turning up finds previously overlooked. And designer Ben English has worked his unique design wizardry, making unexpected selections and weaving inspired sequences. Oh boy, does he ever make me look good!

This book is for everyone who shares the conviction that the long history of wine proves that life's best moments are enhanced, relationships deepened, and cares banished by the enchantment of the grape.

—Fred Lyon

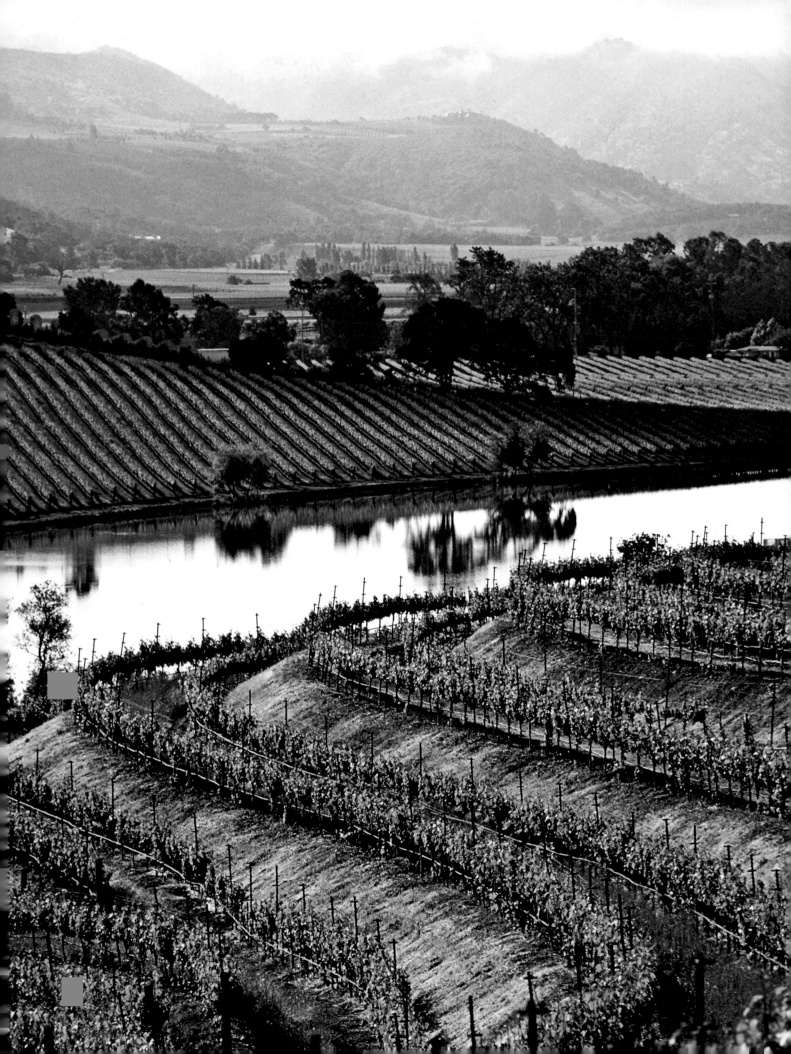

FRED LYON IS THE preeminent photographer of the city of San Francisco, but here he takes his lens outside to wine country, to the vineyards of both the old world and the new. What we see is how much they have in common: the ravishing vistas, the careful layouts of the vineyards, and the serious and dedicated workers.

But each world also sets itself apart. In Europe, baskets of purple-blue grapes are juxtaposed with baskets of shiny steel balls ready for a game of *pétanque.* An old woman carries her provisions up a steep cobblestone street, another picks her own grapes, and a beautiful woman who could be from a classic Italian film sits near a flower seller, passing the time.

Vistas of Alps and meadows and castles abound. Church spires reach heavenward from their small villages. A simple French table shows a ravaged plate of snails, a baguette, and a bottle of Muscadet. In a vineyard, a small group of young men and women sit in conversation under a pergola. A row of cafe tables awaits customers, while fishermen show off the prizes they net and then go out on their small boats at night to seek more.

As we enter the new world, we feel right at home. Black-and-white photos of vineyards and workers establish the unbroken link between the old world and the new, while the rolling hills, the low morning fog, the synchronized sprinklers, a barely hidden yurt, and the native live oak trees make for a distinctly Californian landscape.

Anyone who loves the highly refined yet deeply rustic world of wine and winemaking will find those passions celebrated in this book. Fred Lyon, acclaimed poet of the city, here shows us some of the equally deep and timeless pleasures to be found outside it.

—Nion McEvoy

THE
OLD WORLD

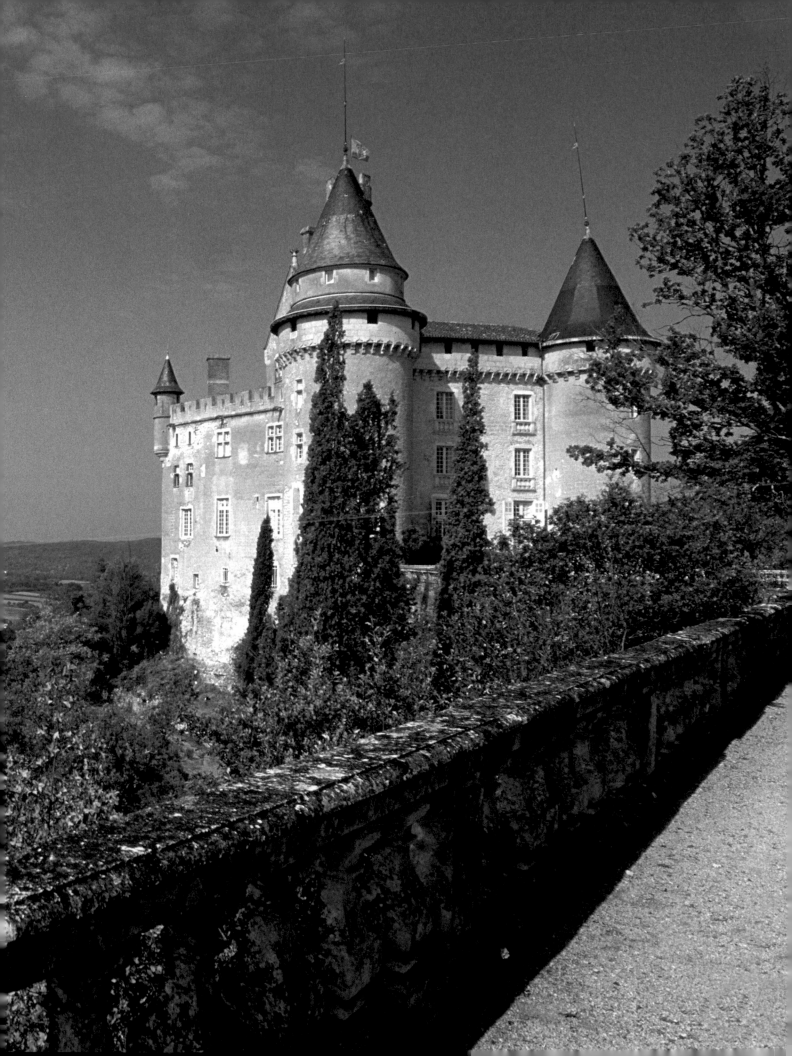

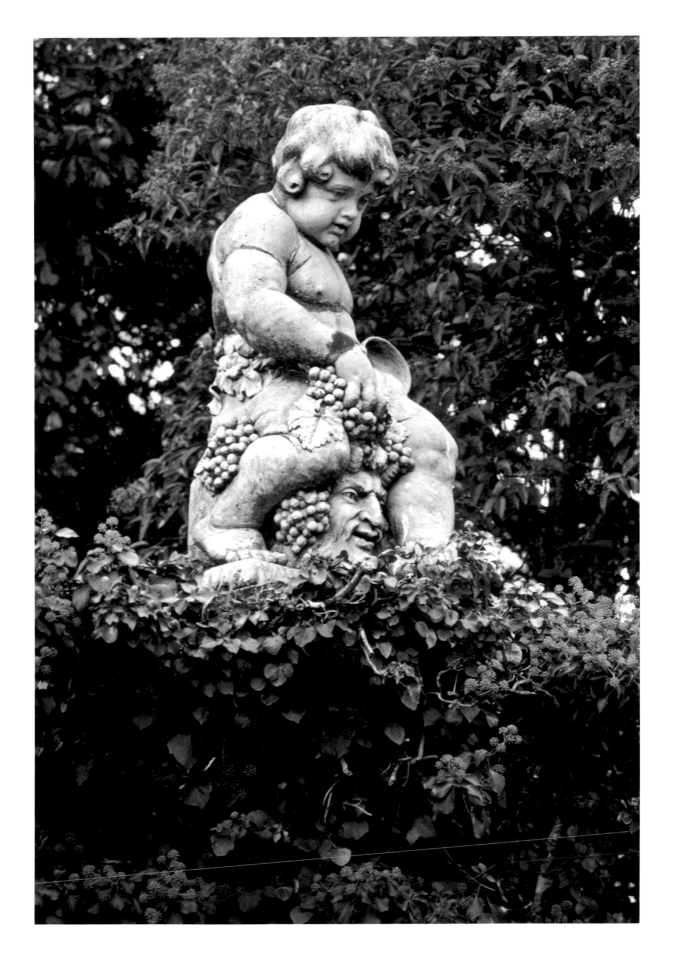

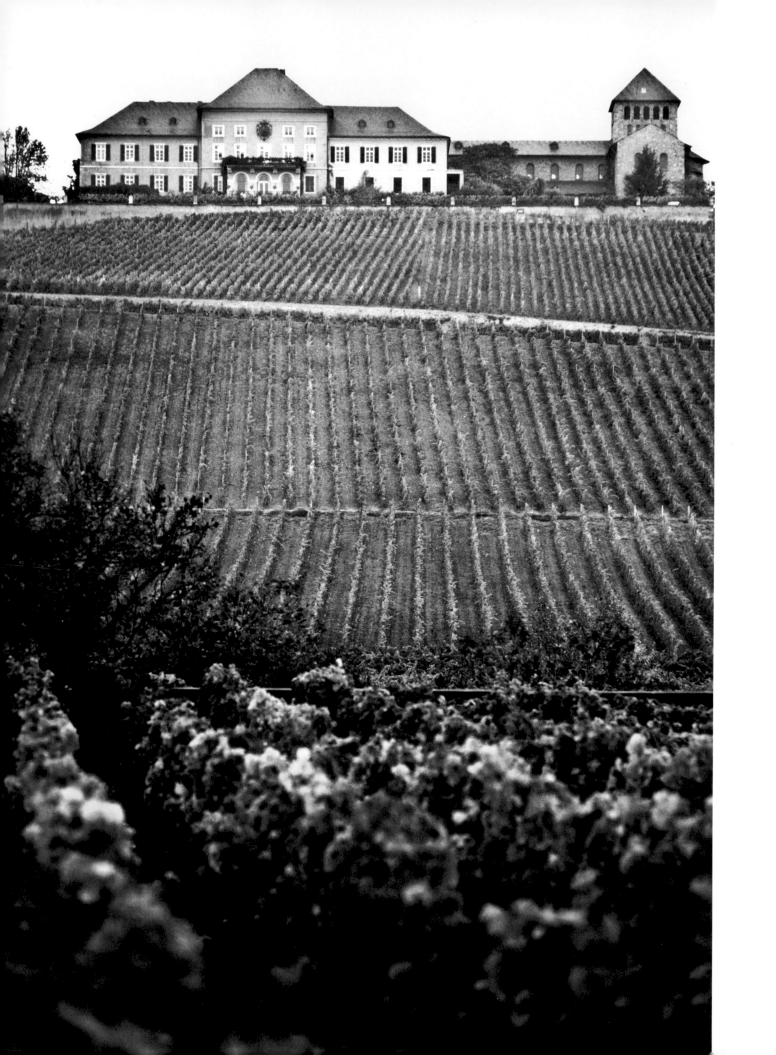

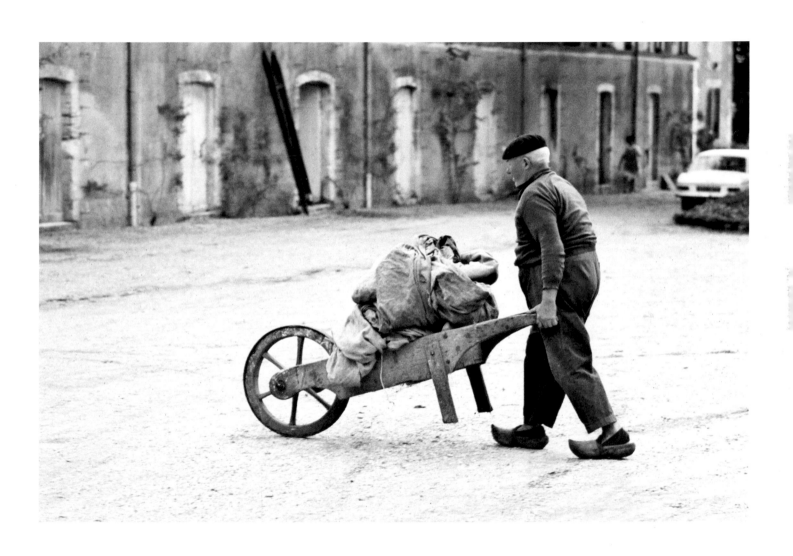

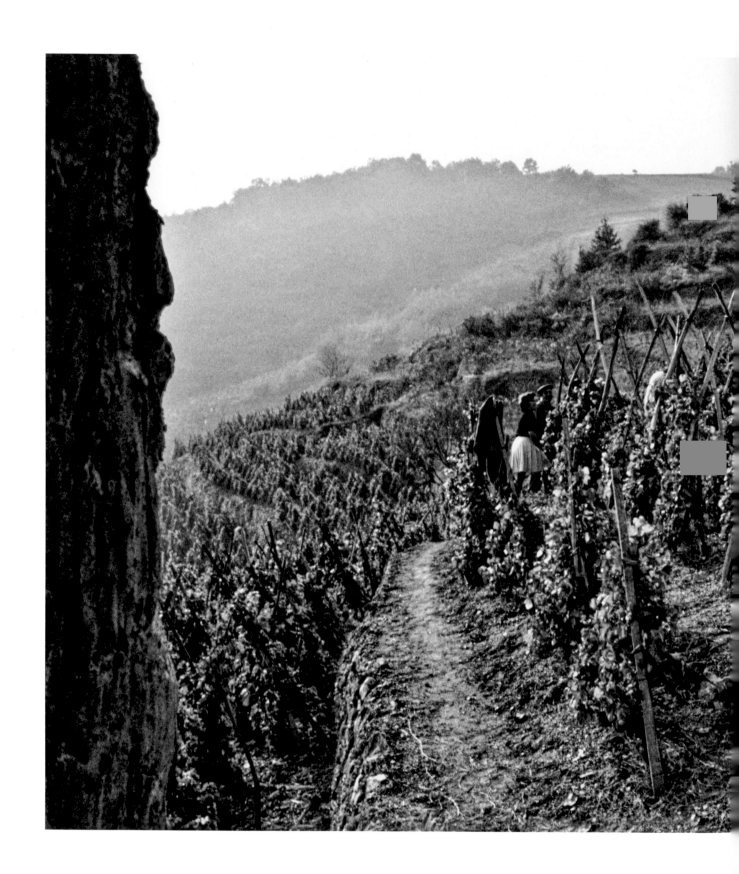

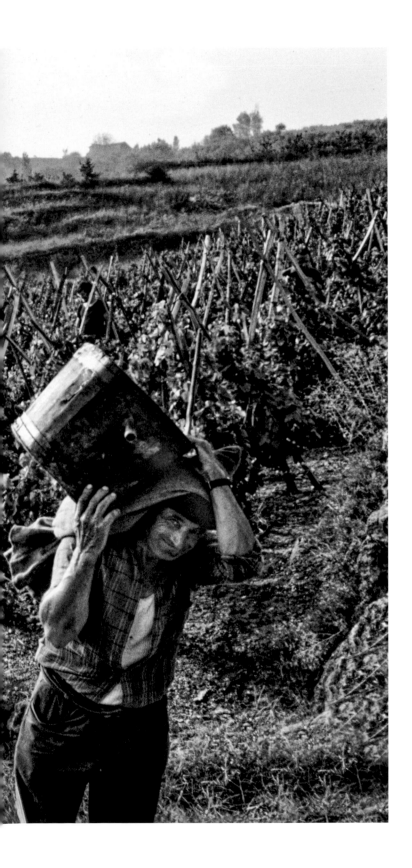

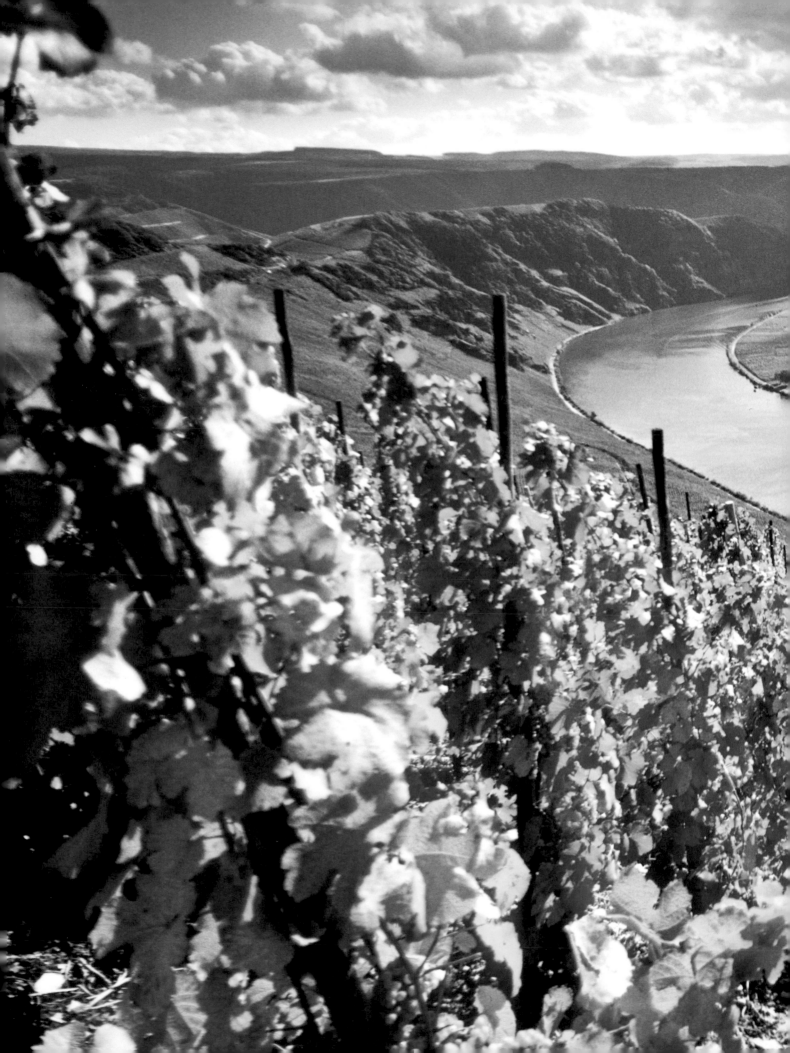

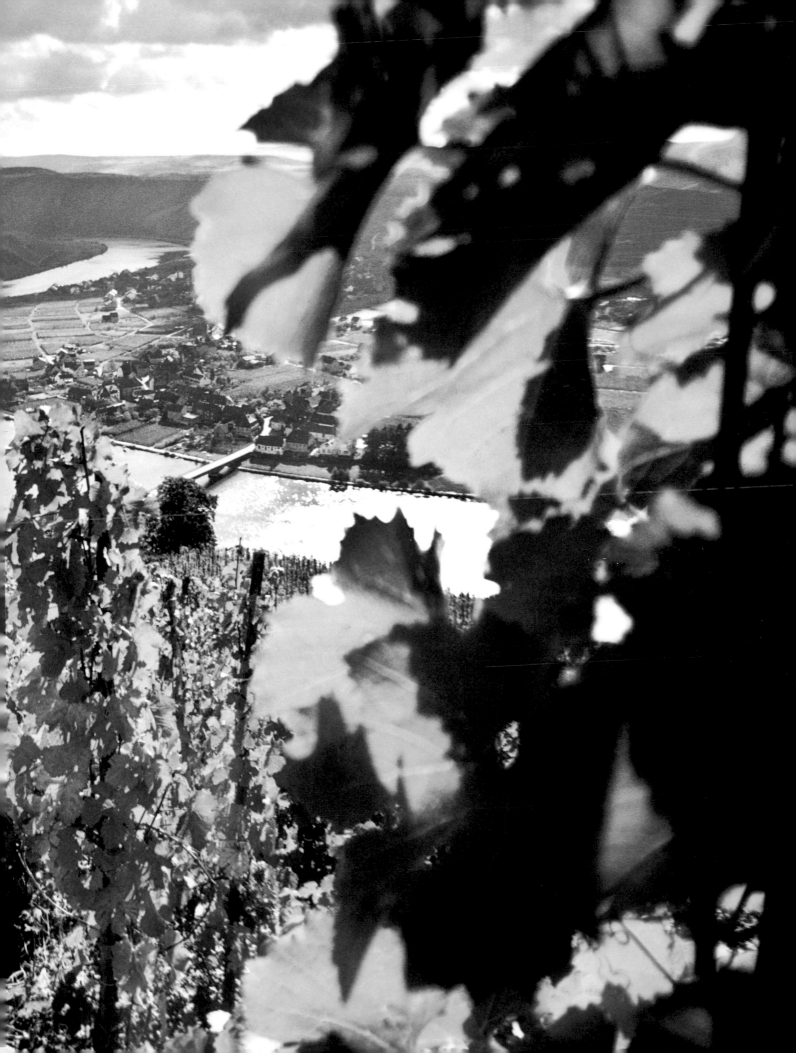

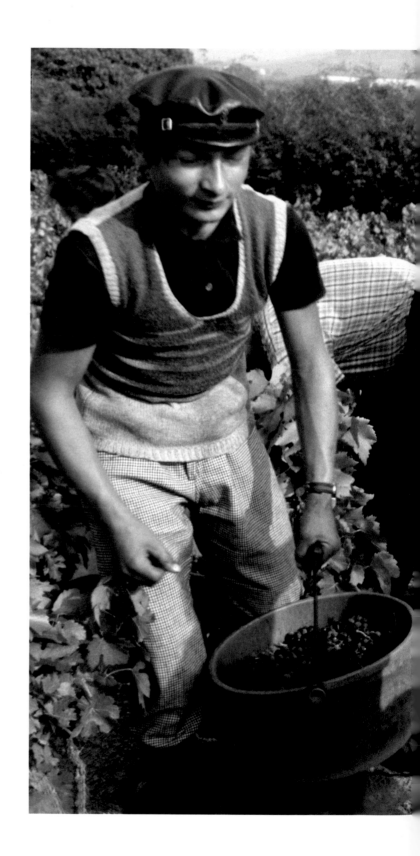

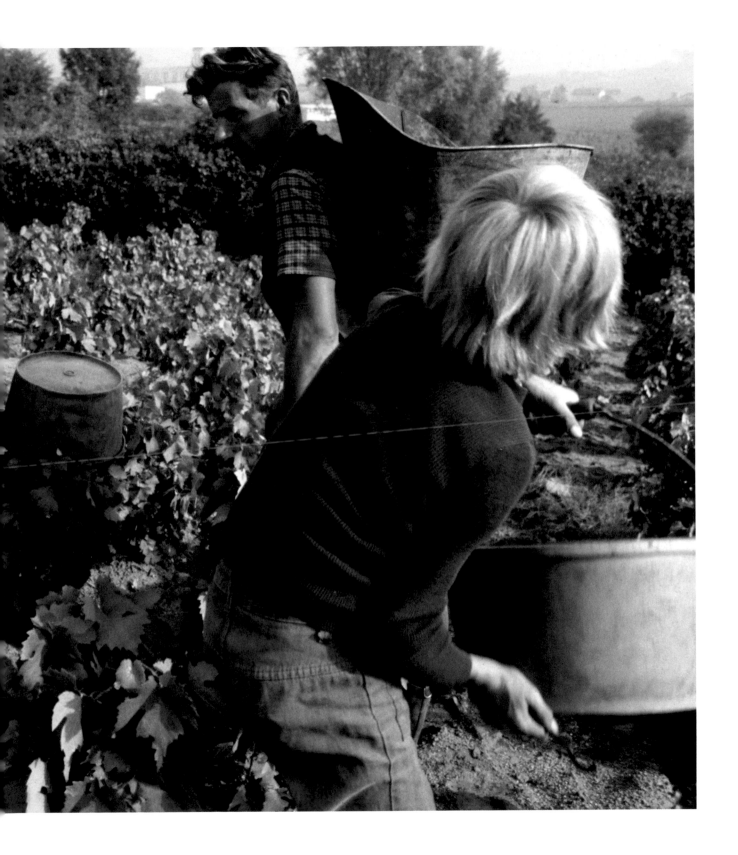

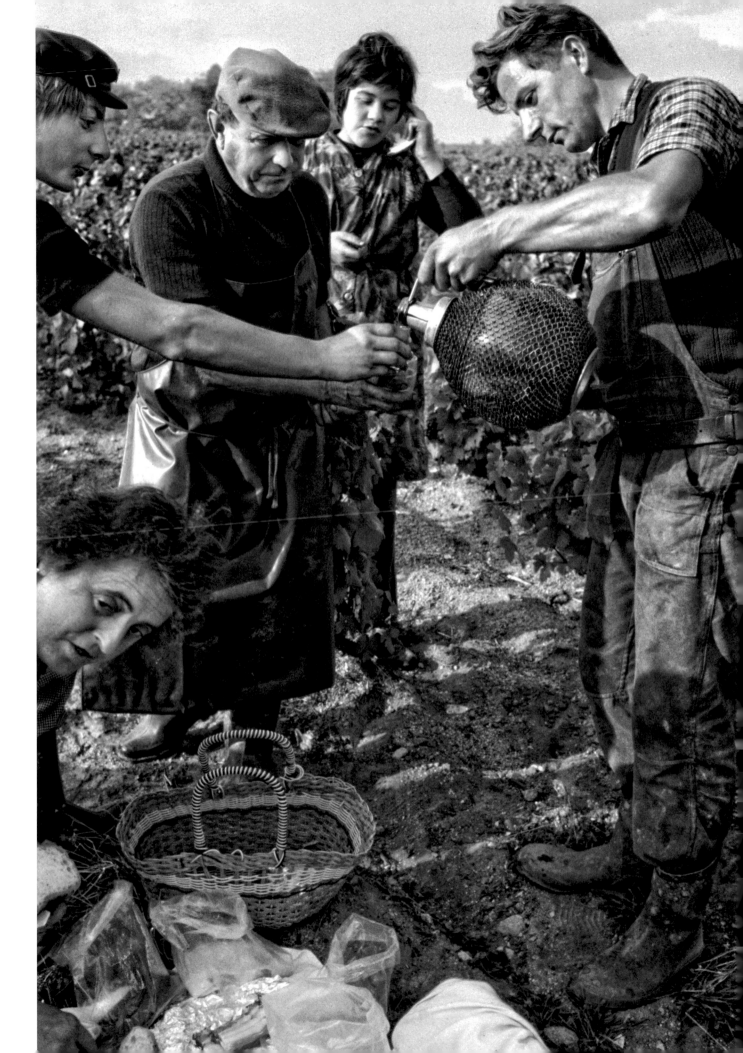

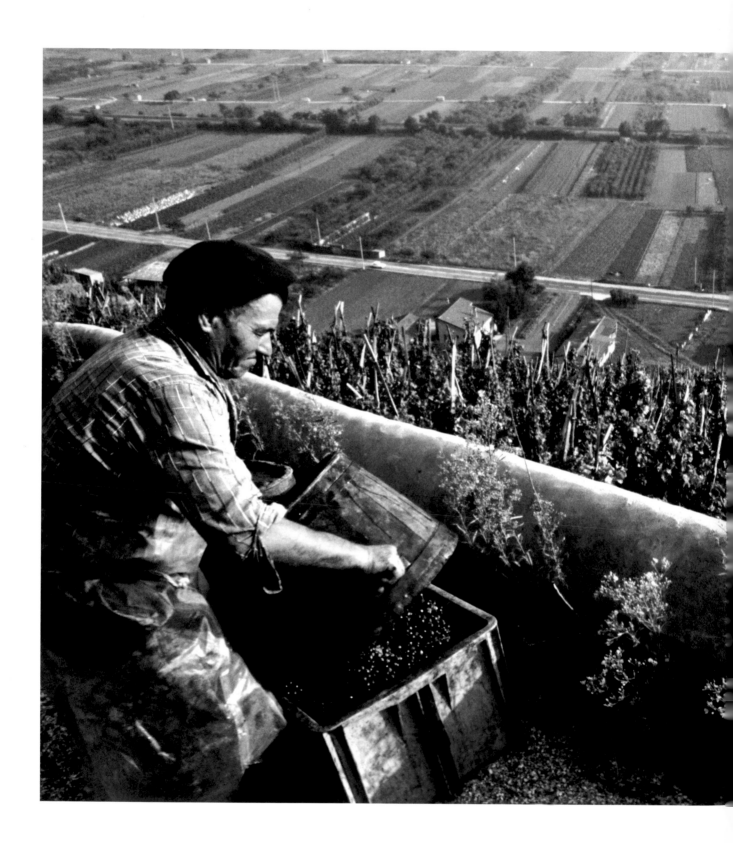

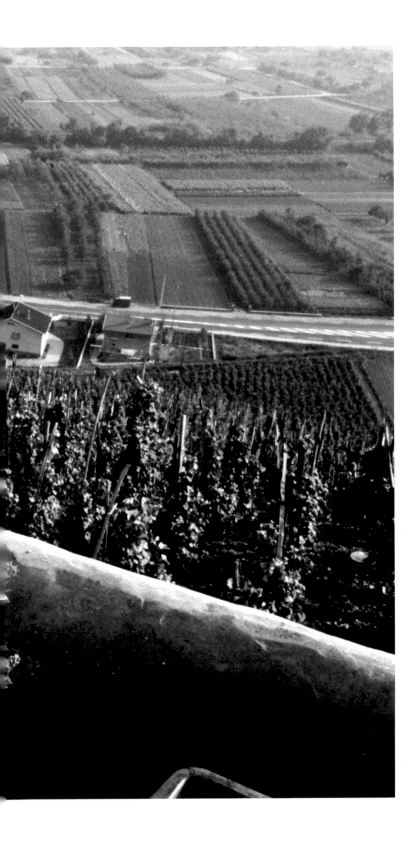

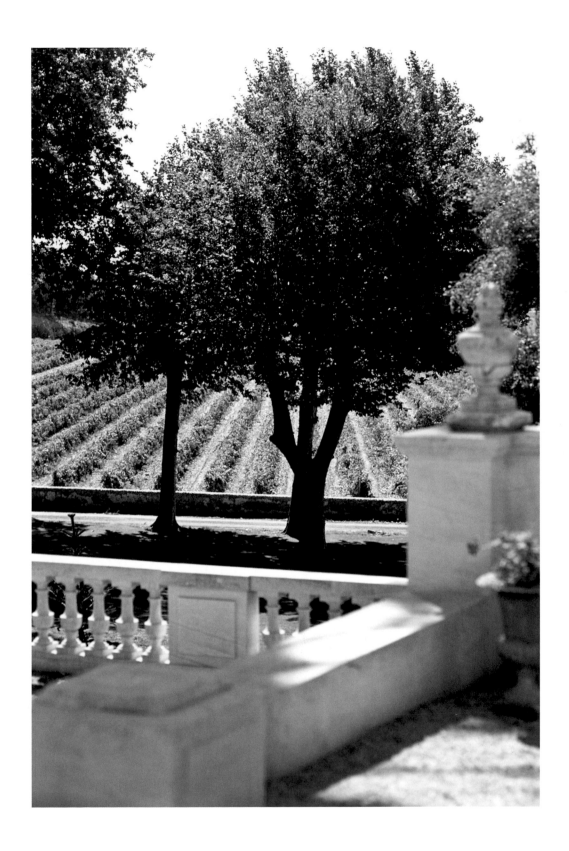

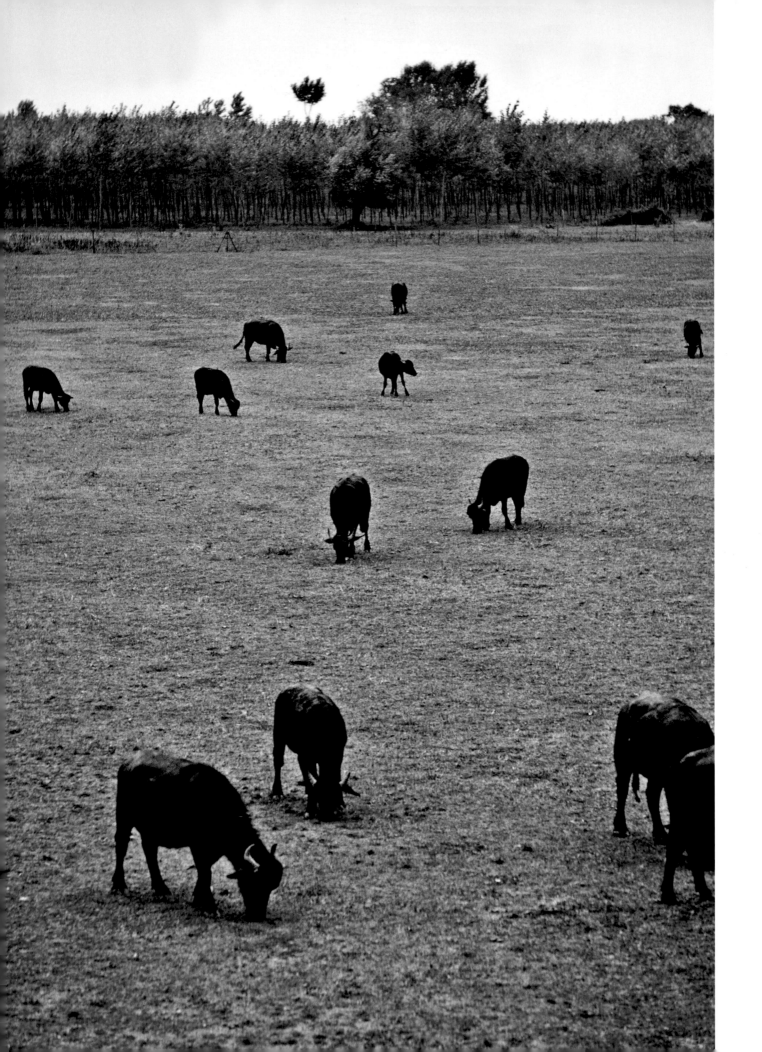

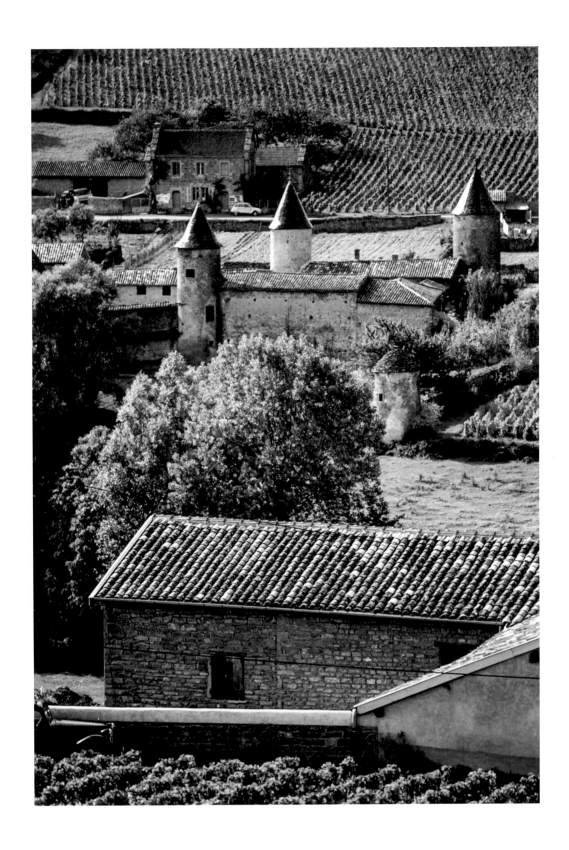

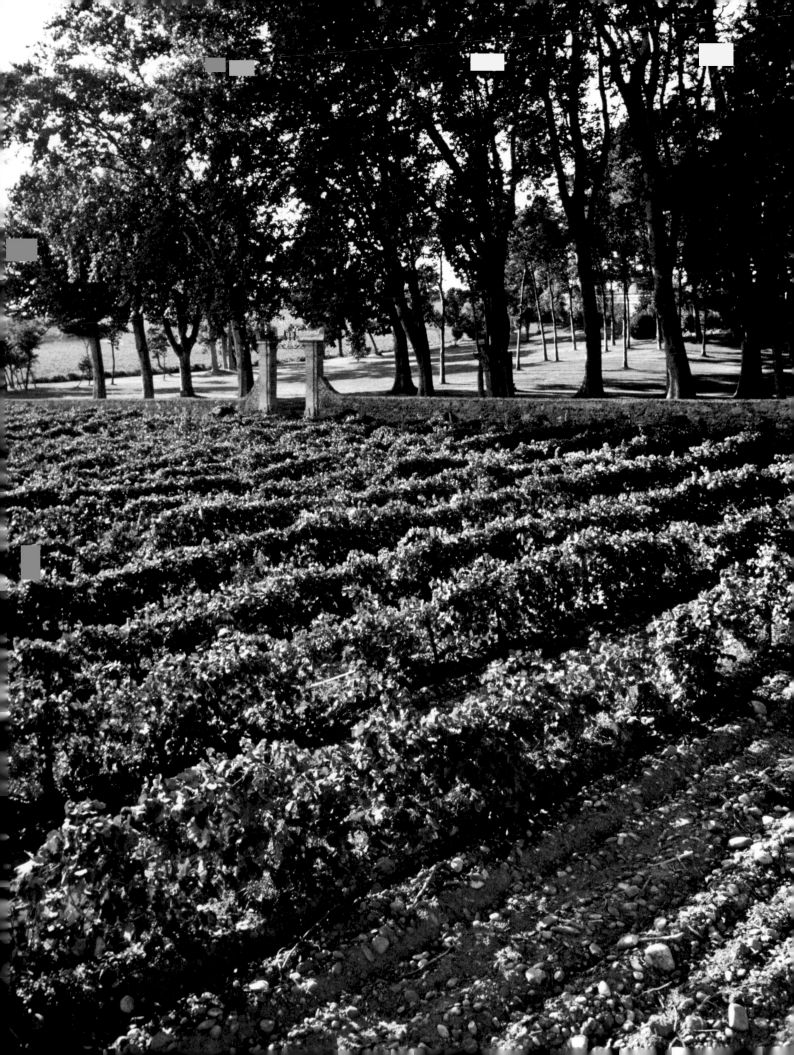

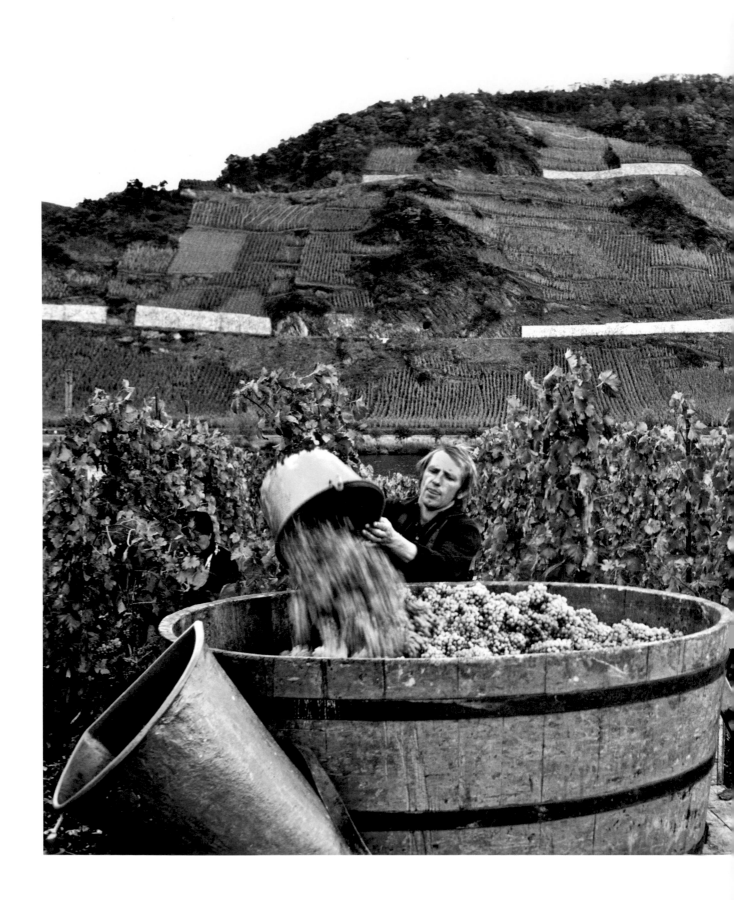

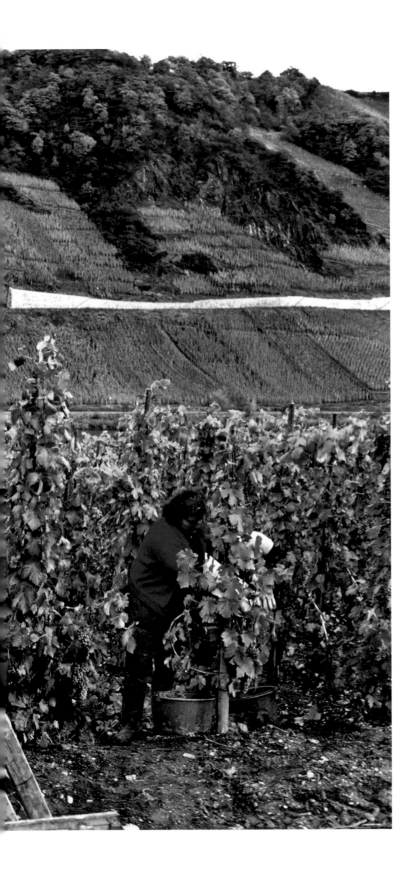

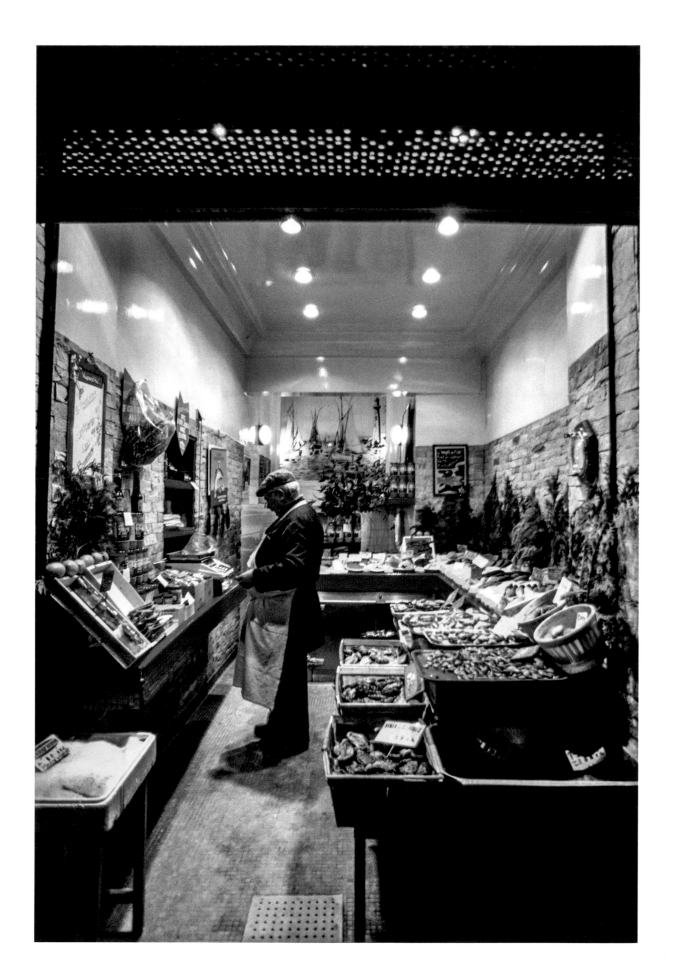

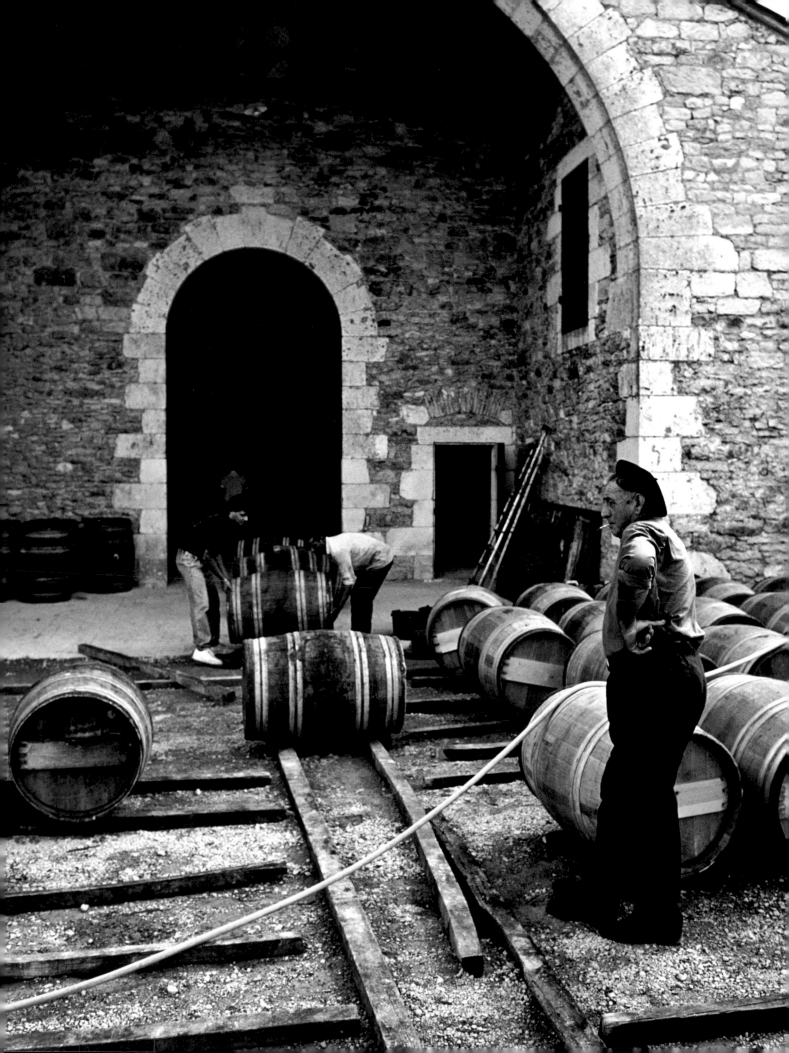

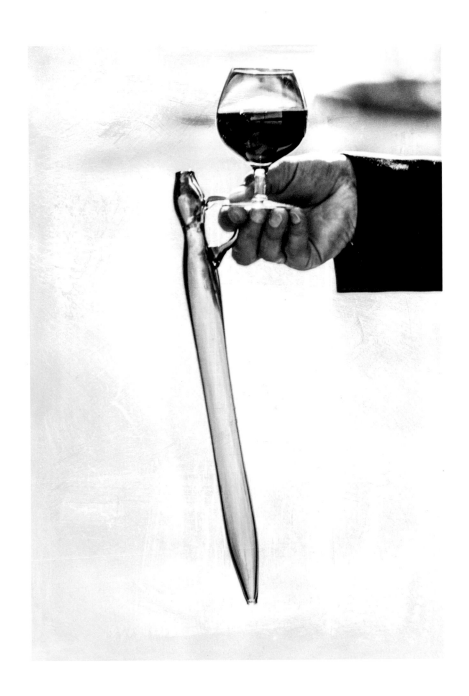

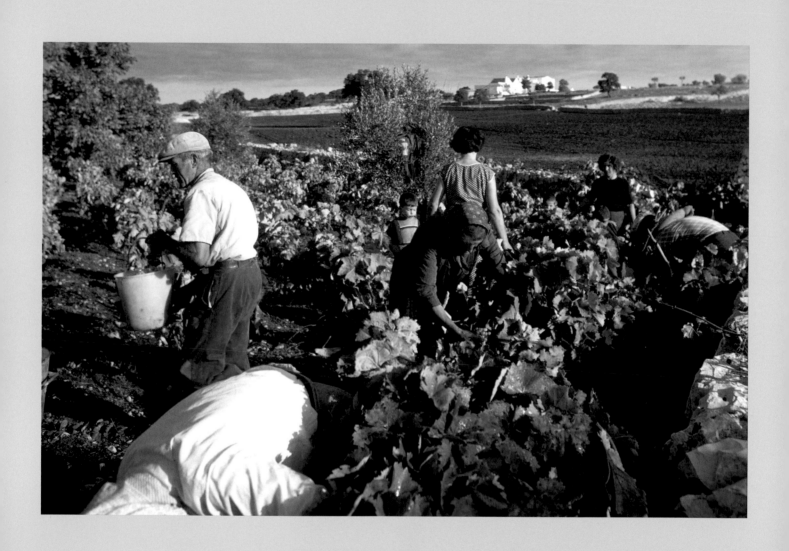

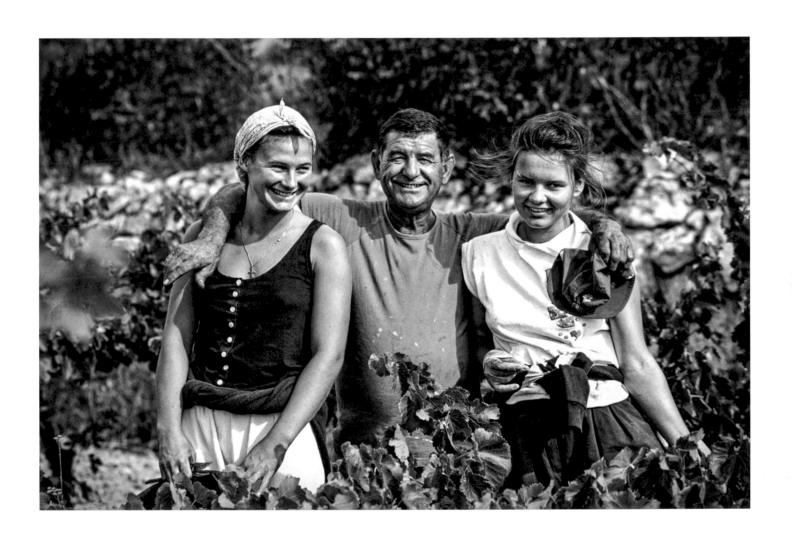

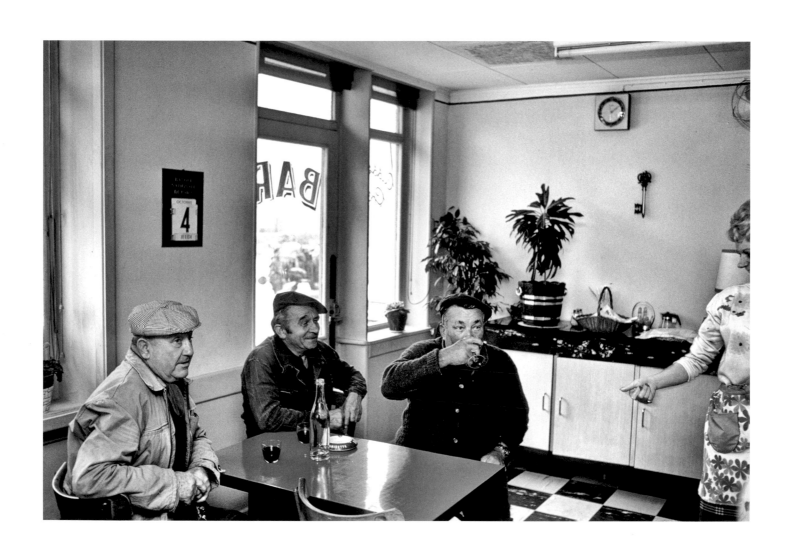

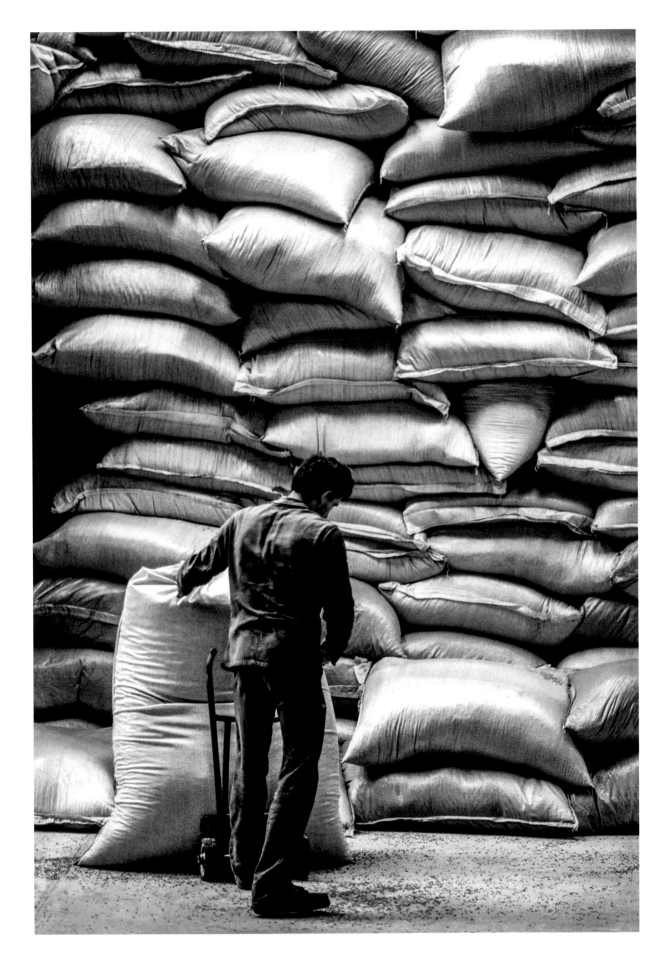

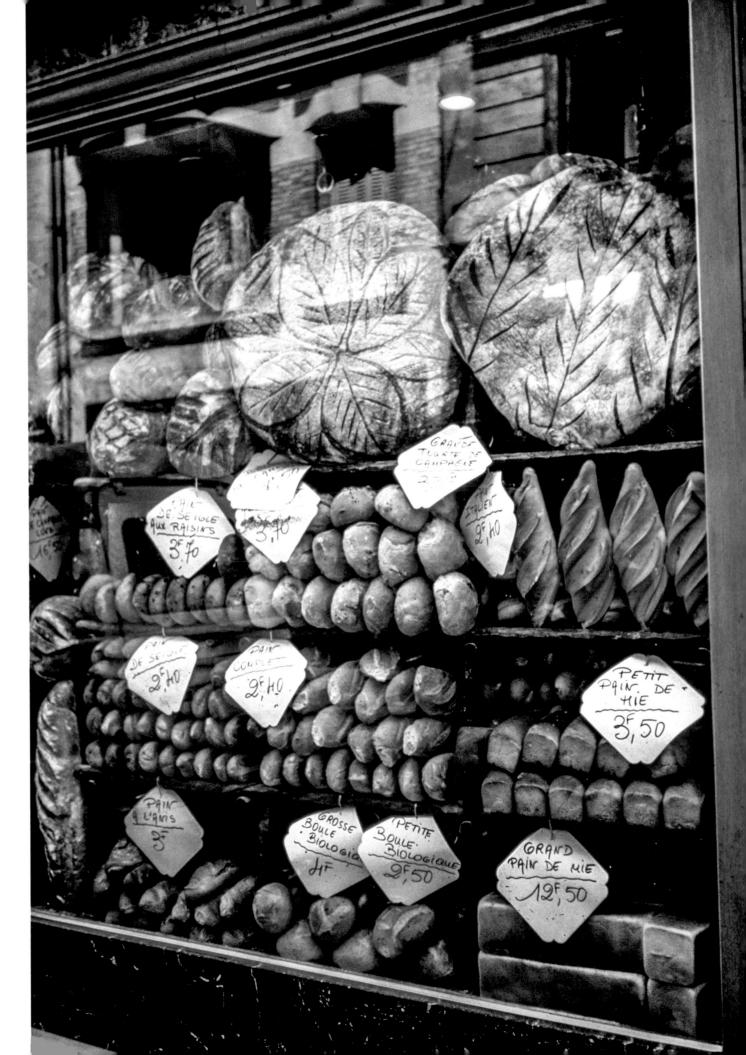

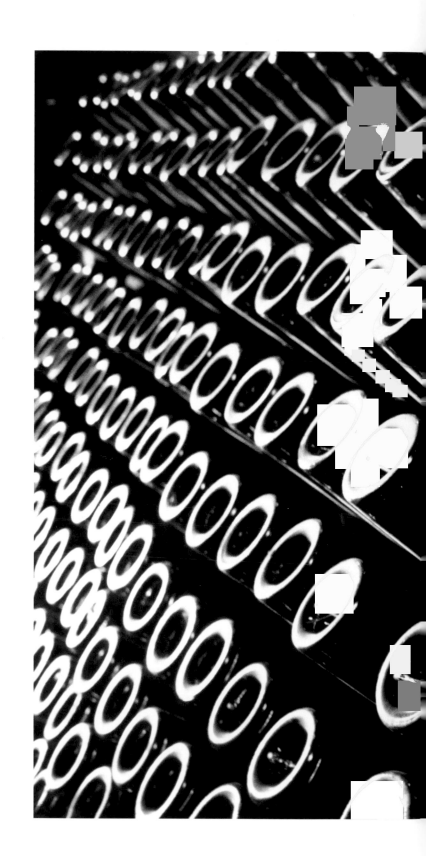

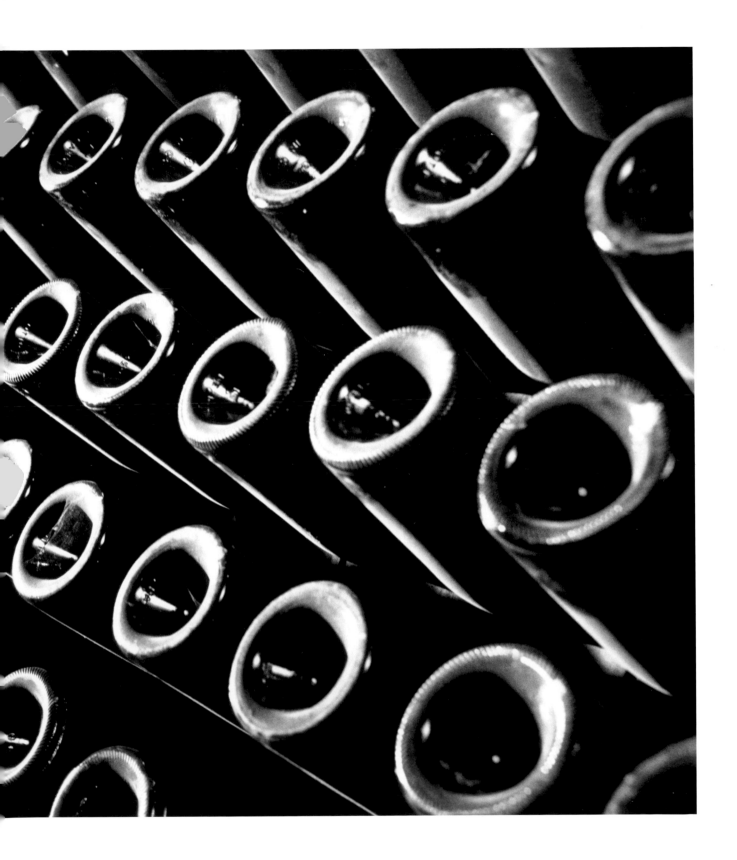

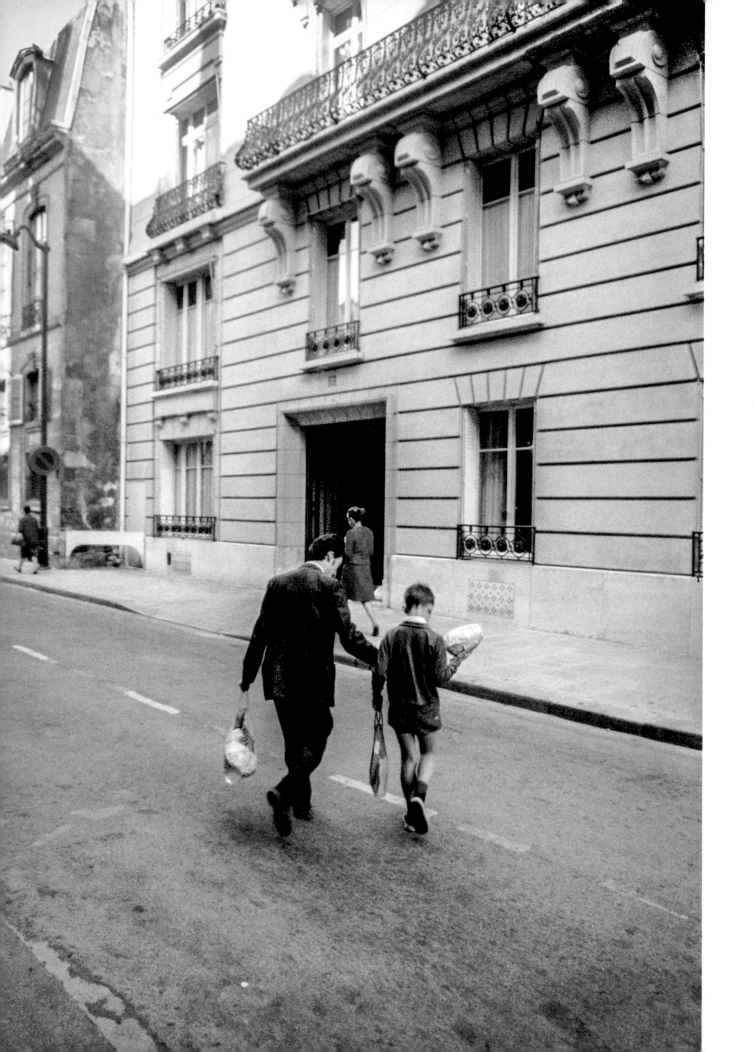

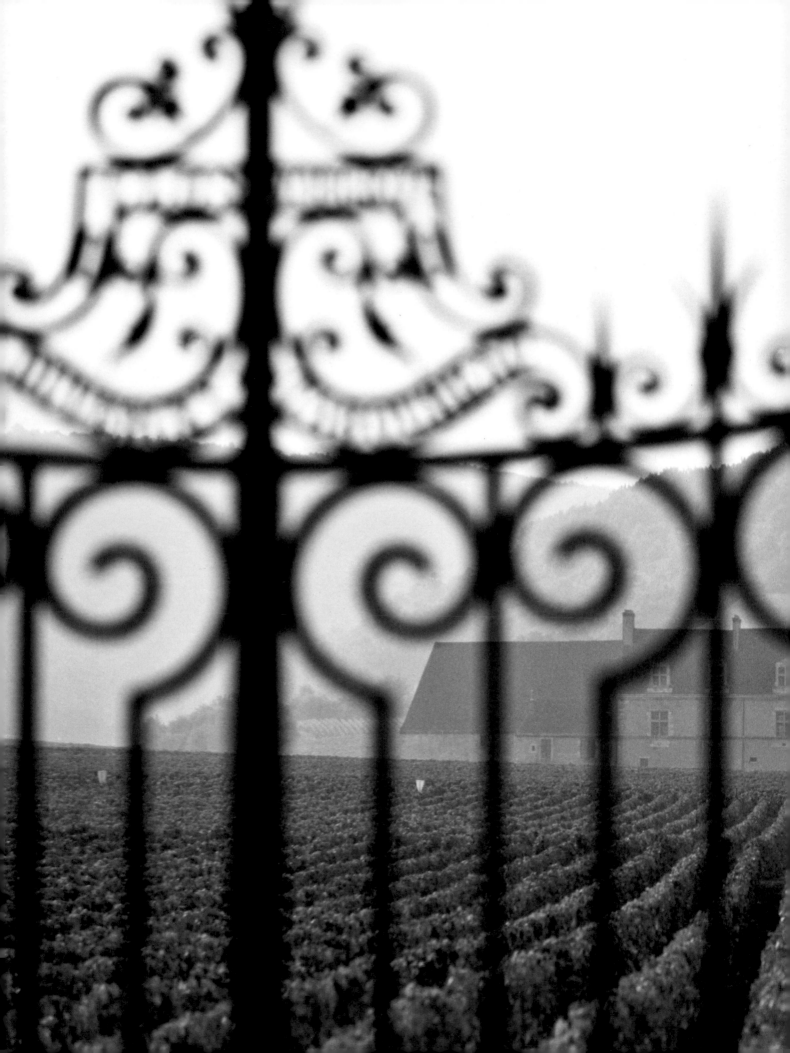

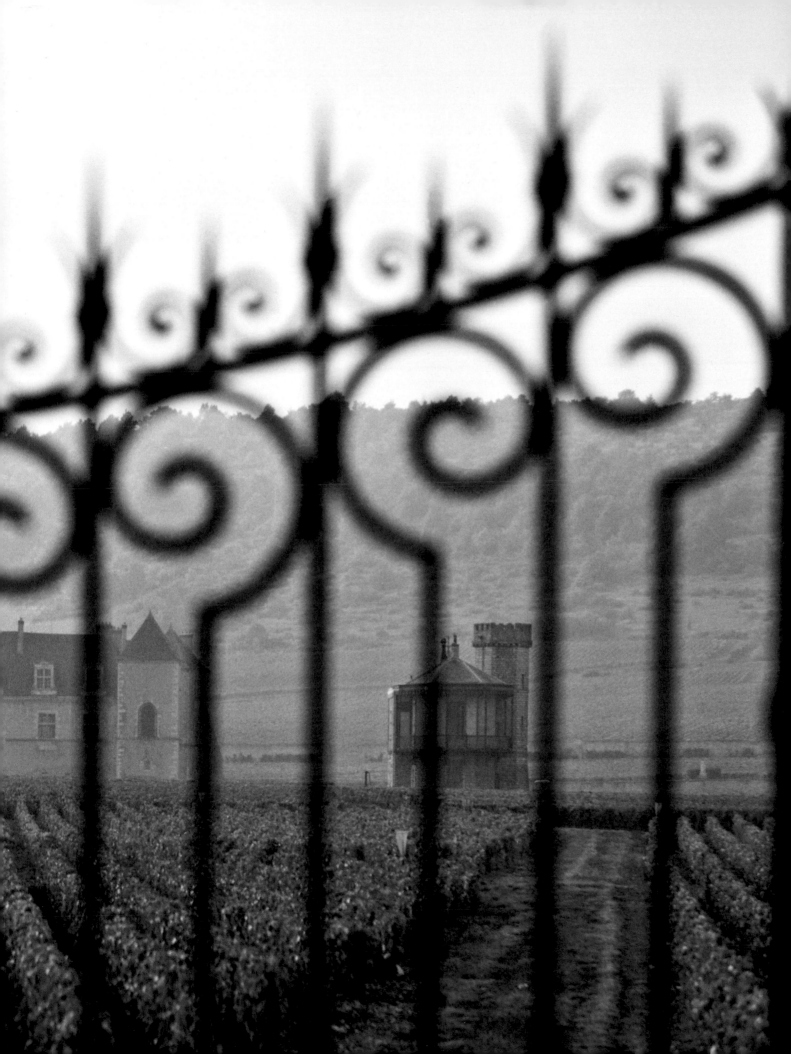

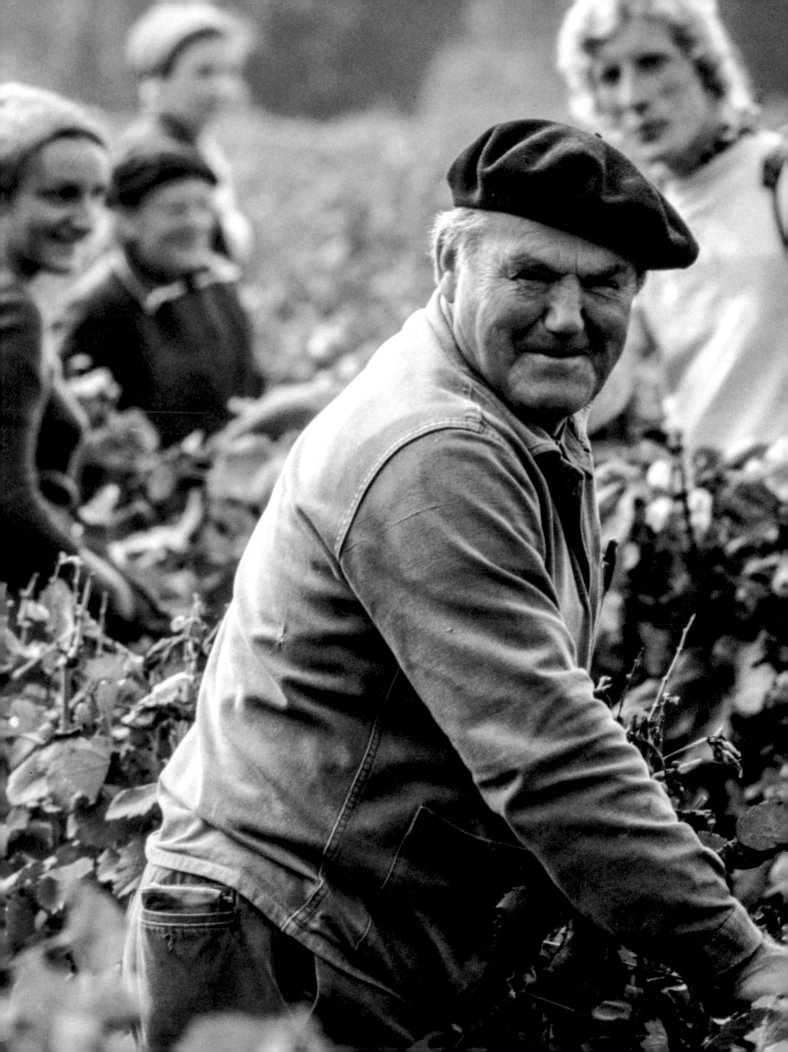

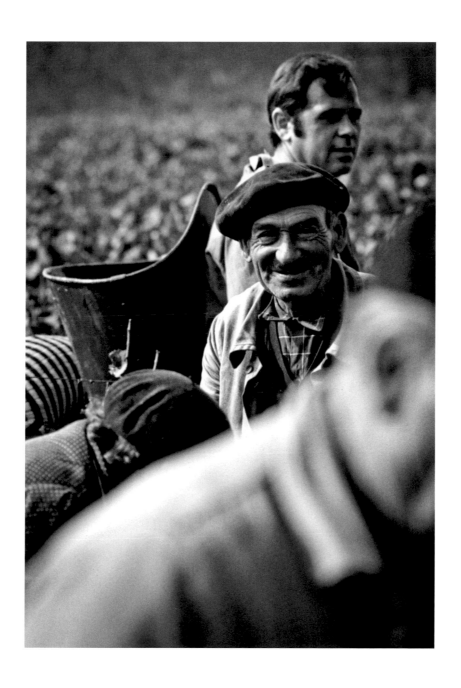

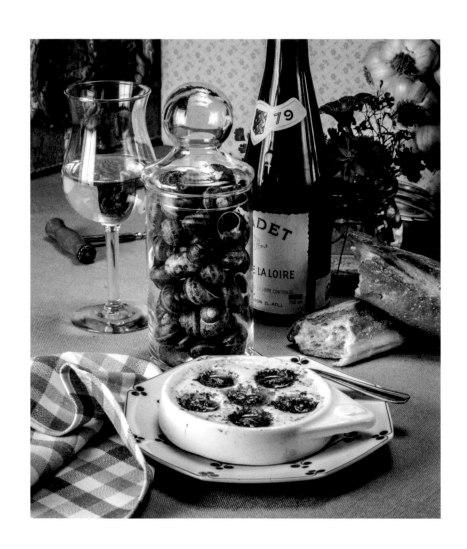

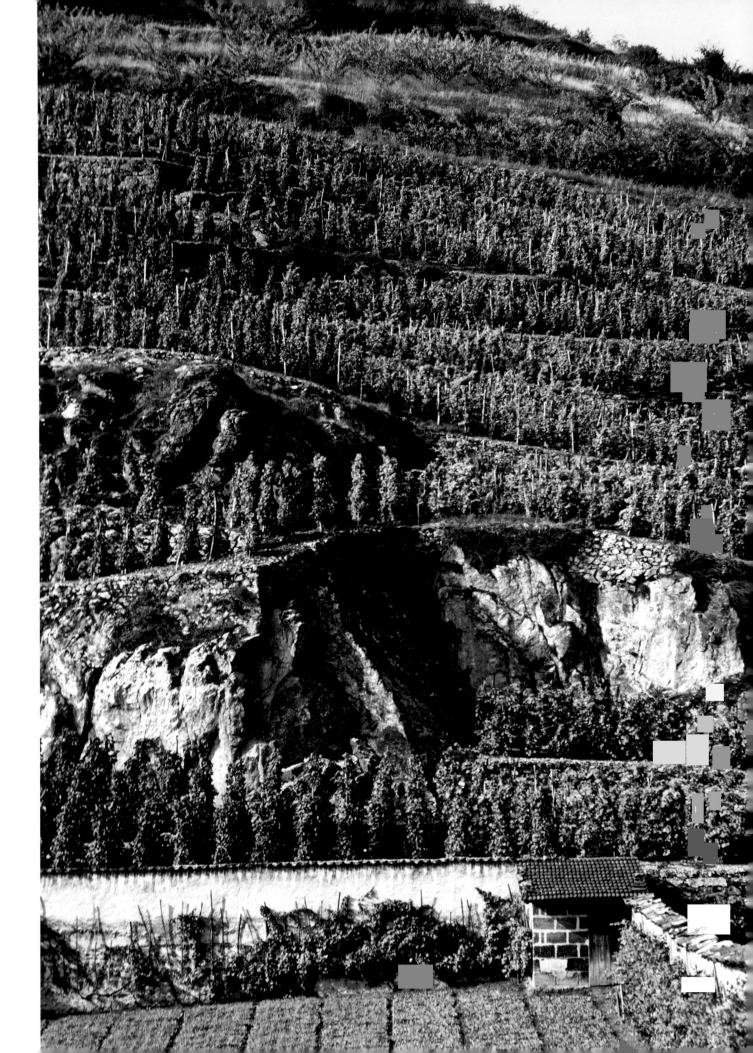

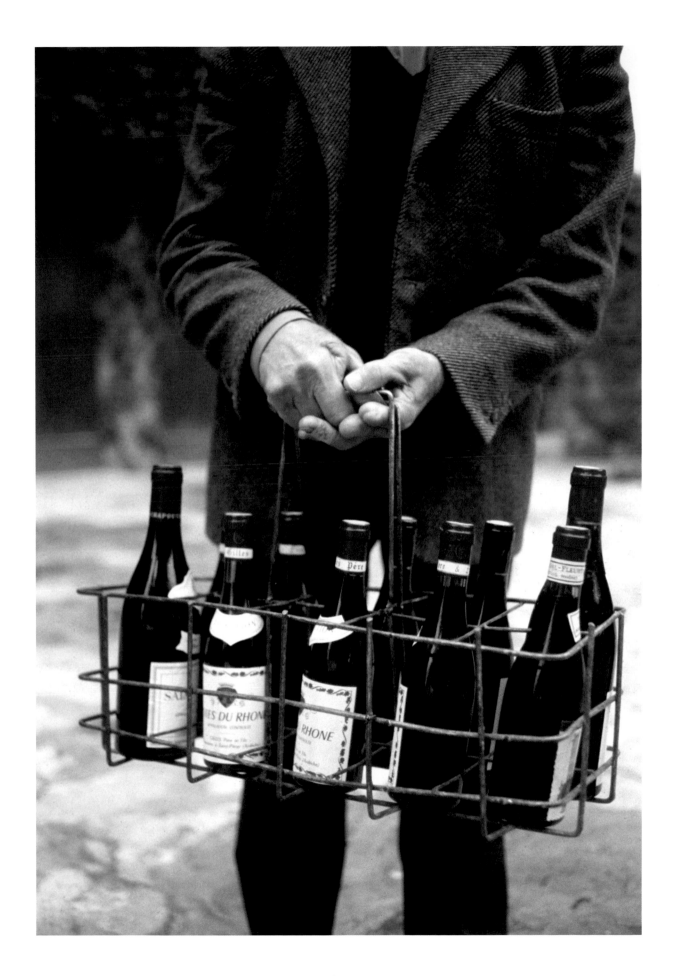

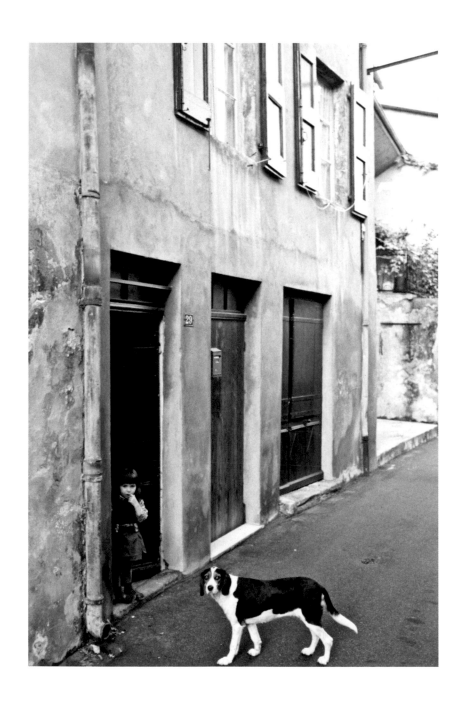

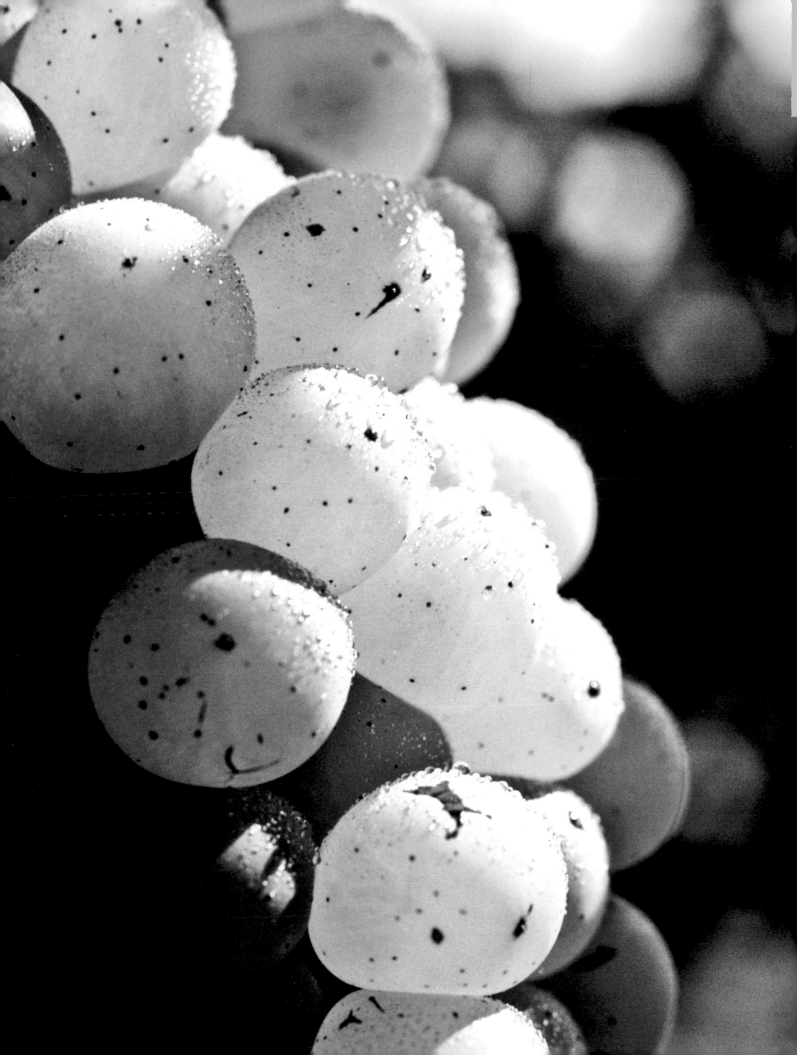

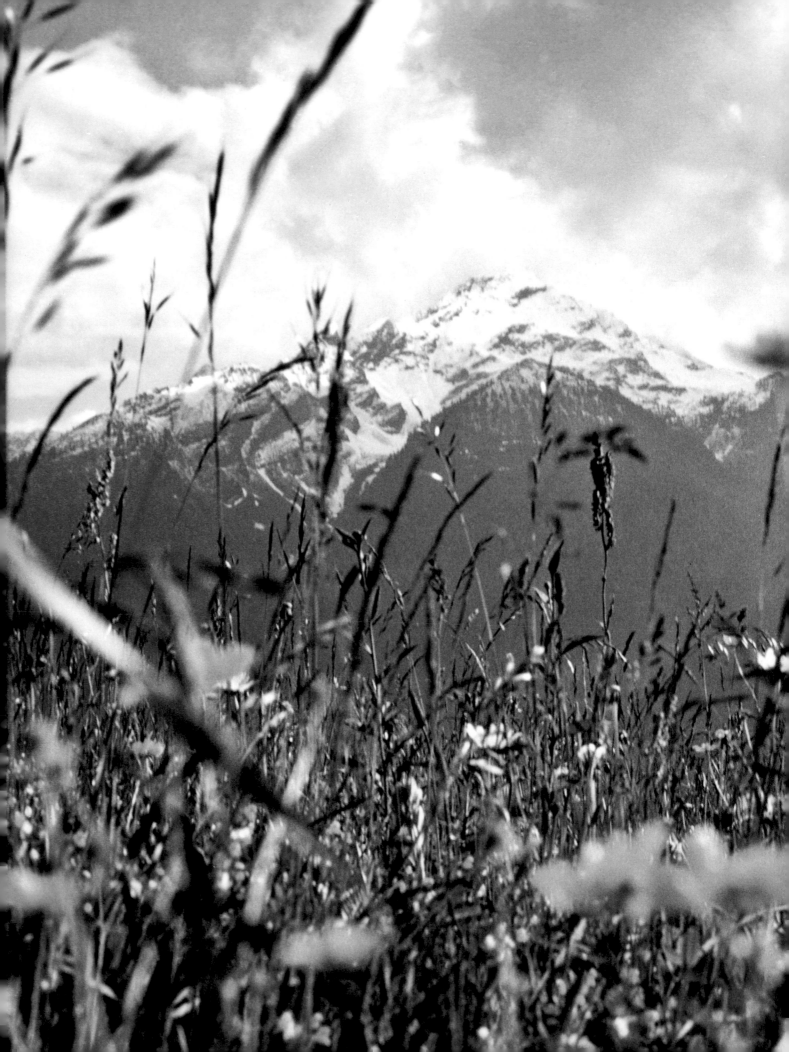

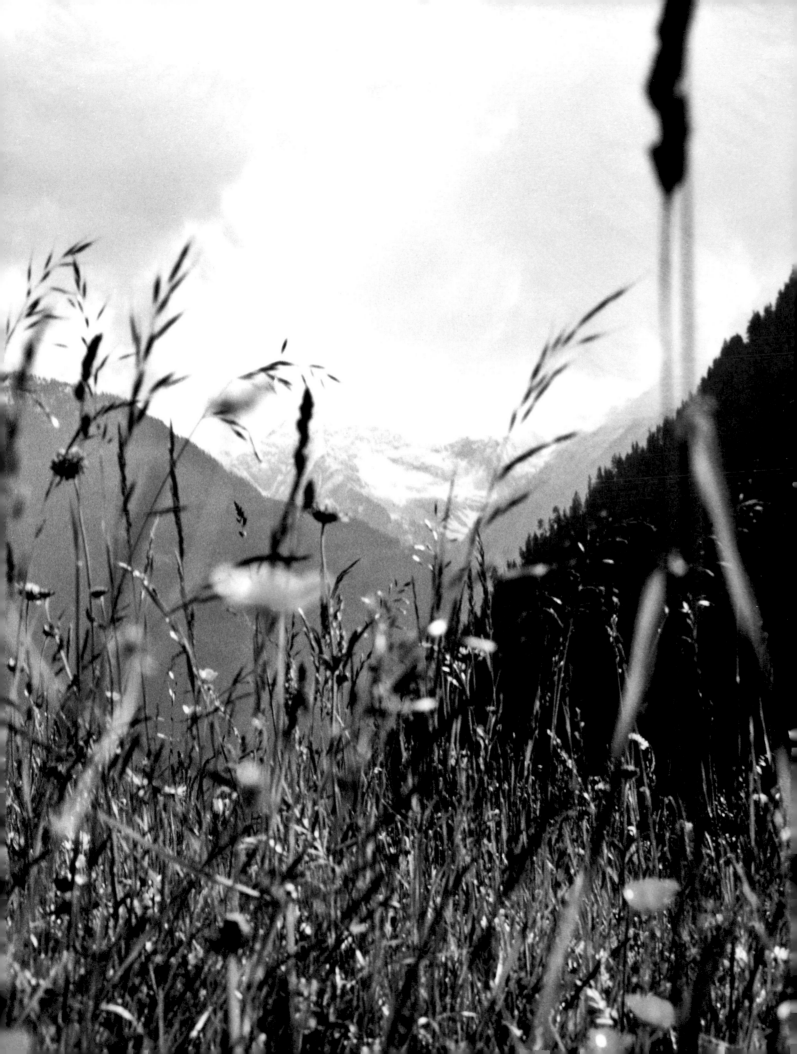

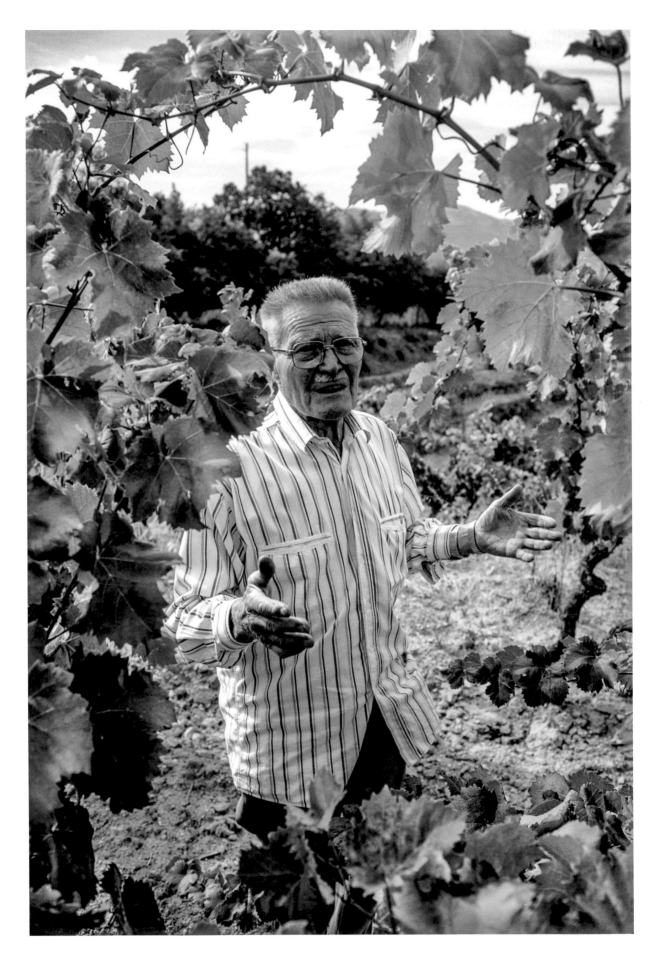

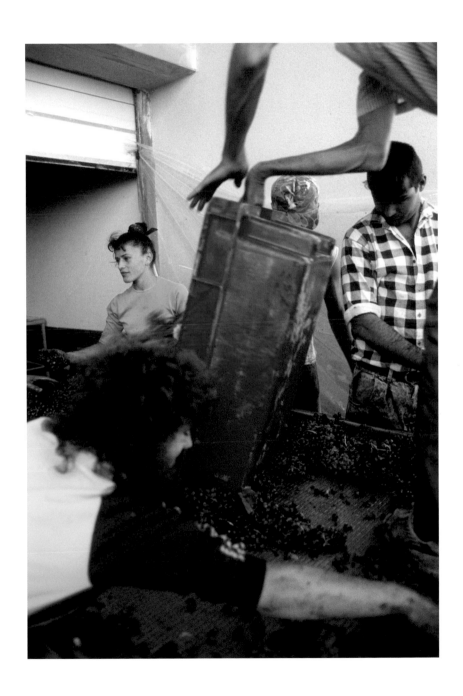

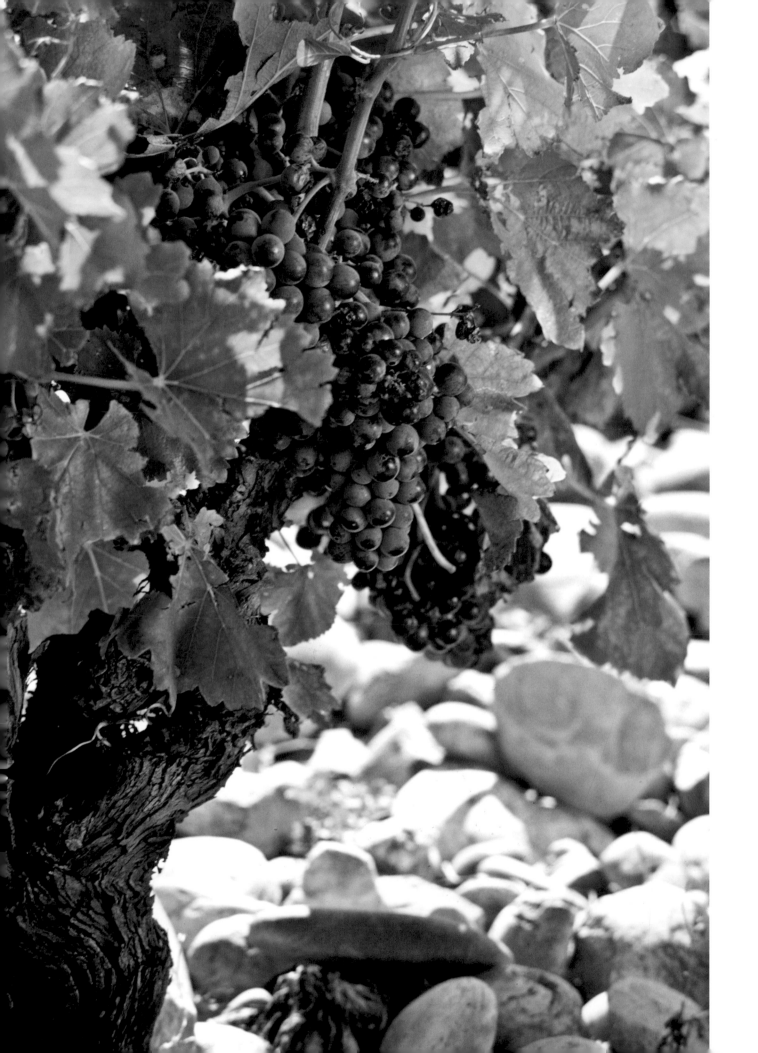

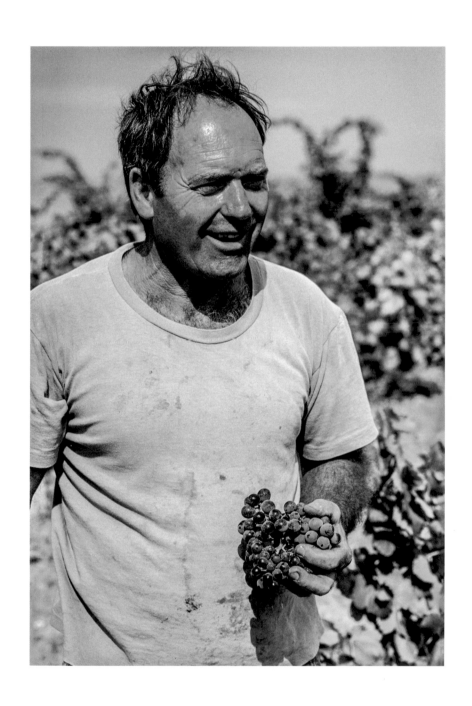

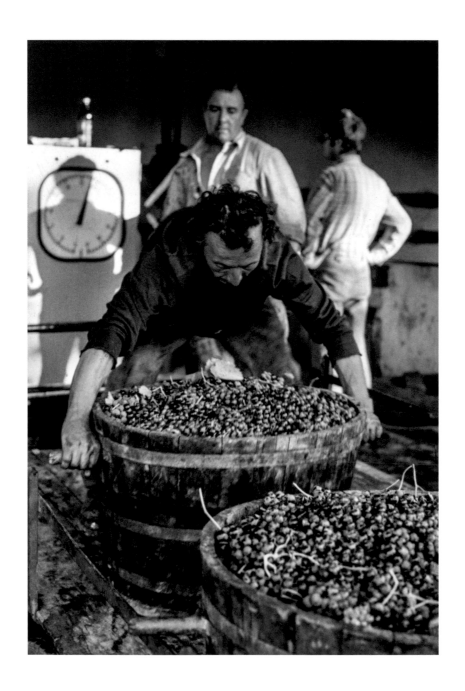

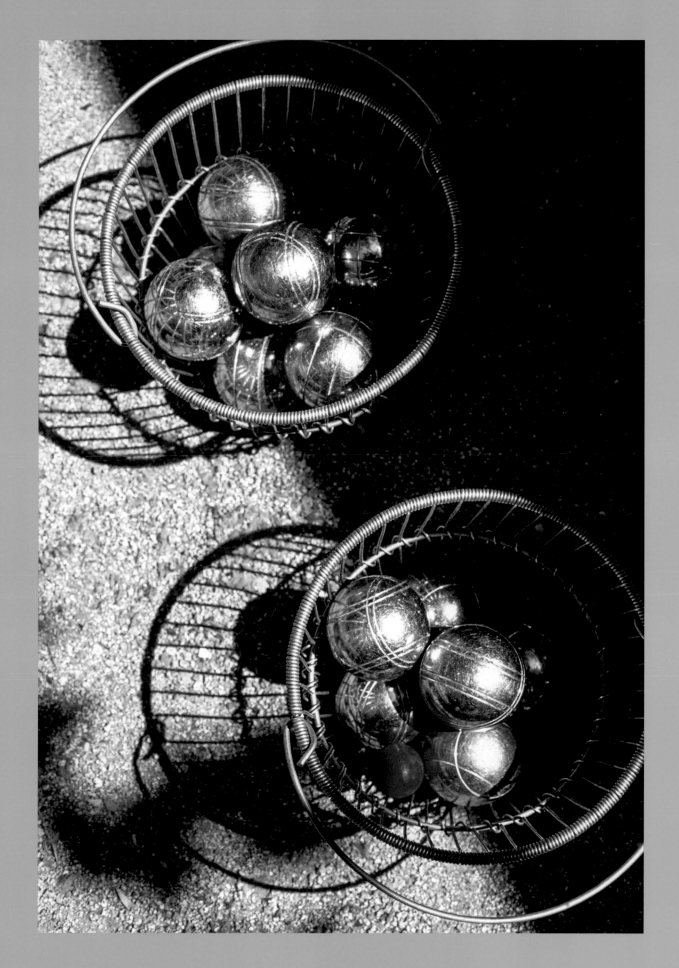

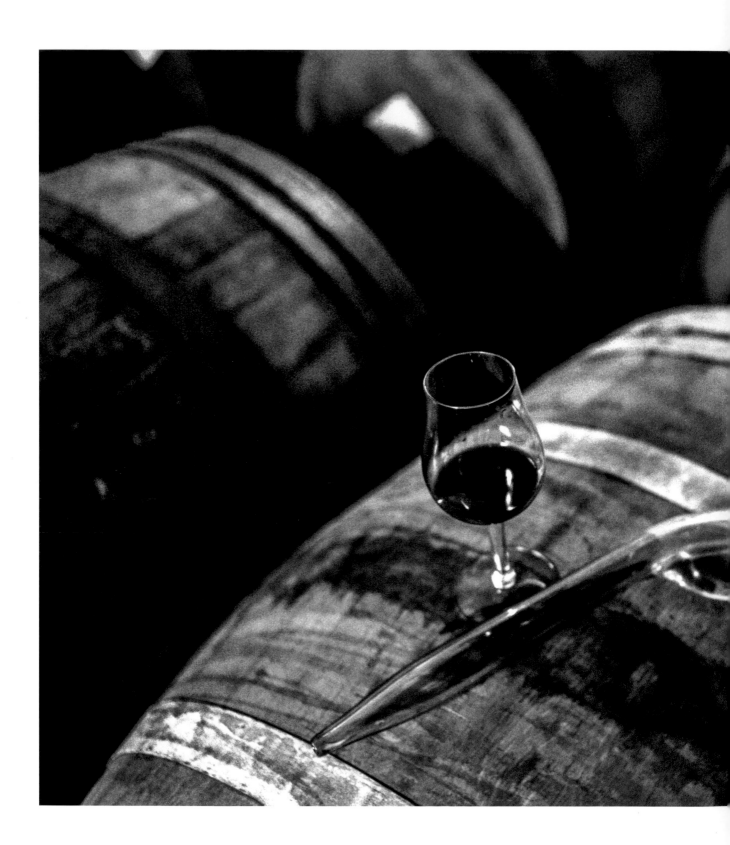

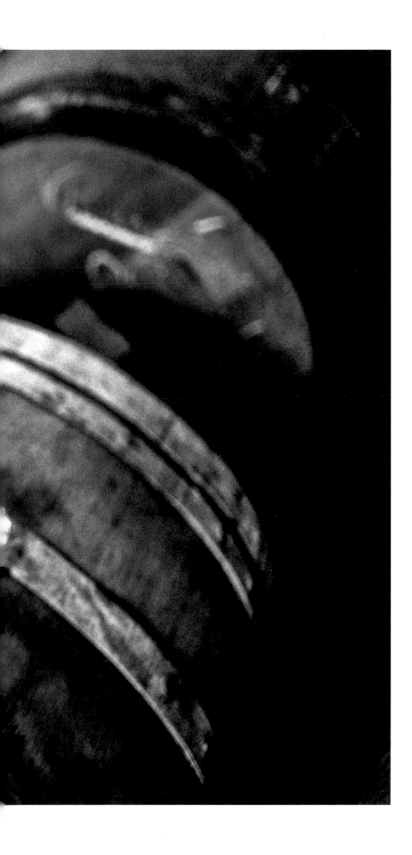

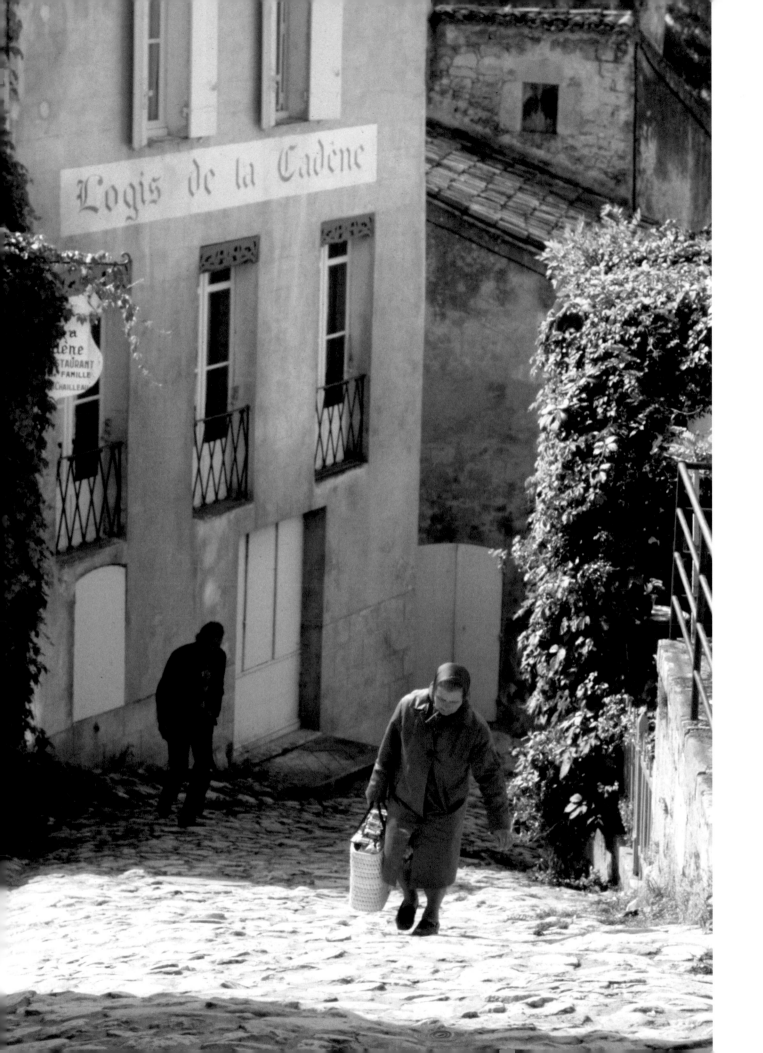

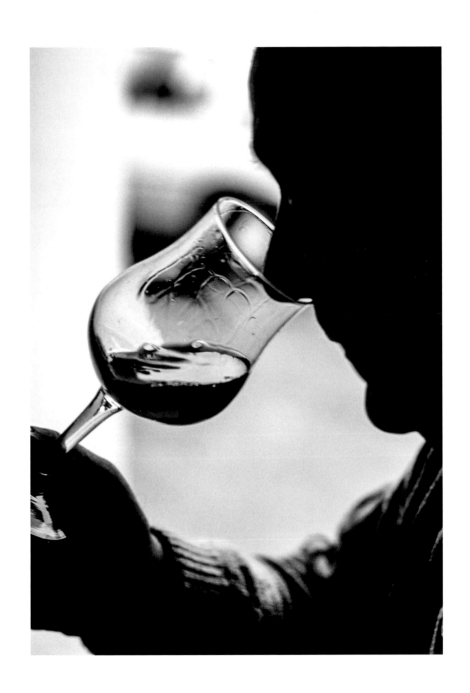

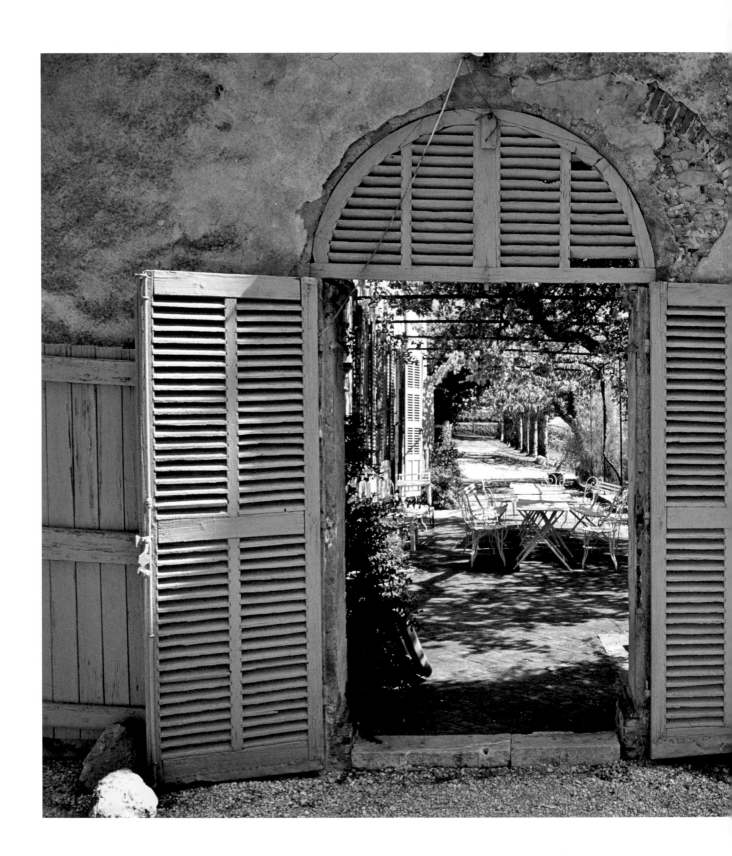

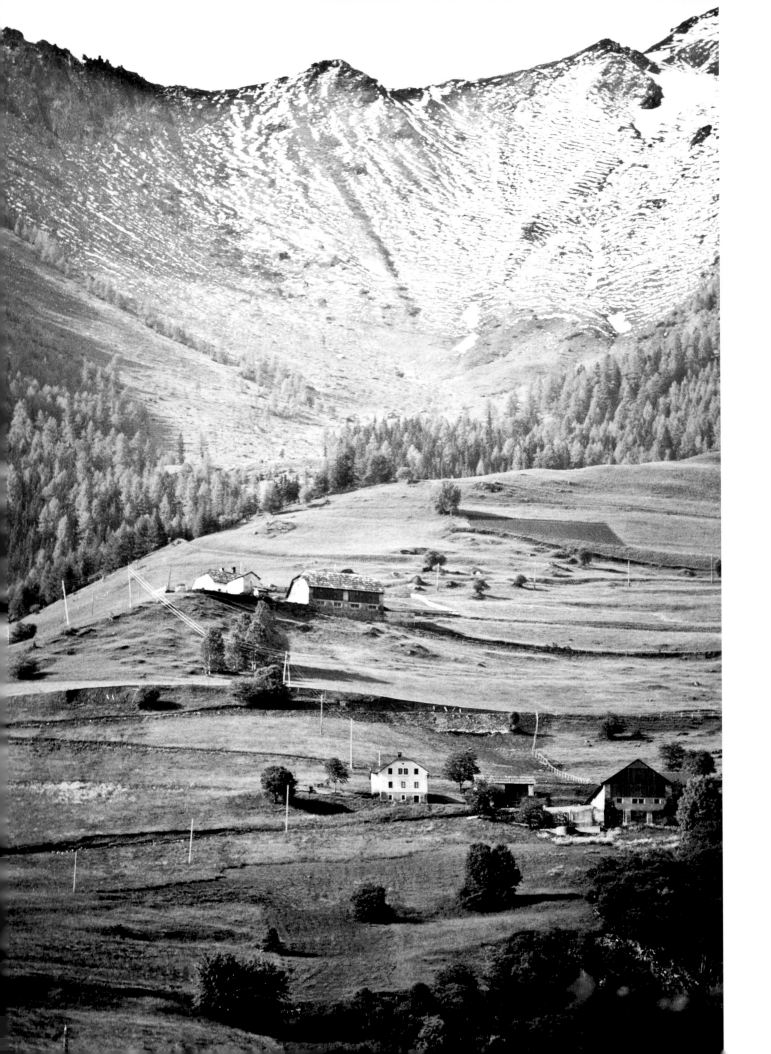

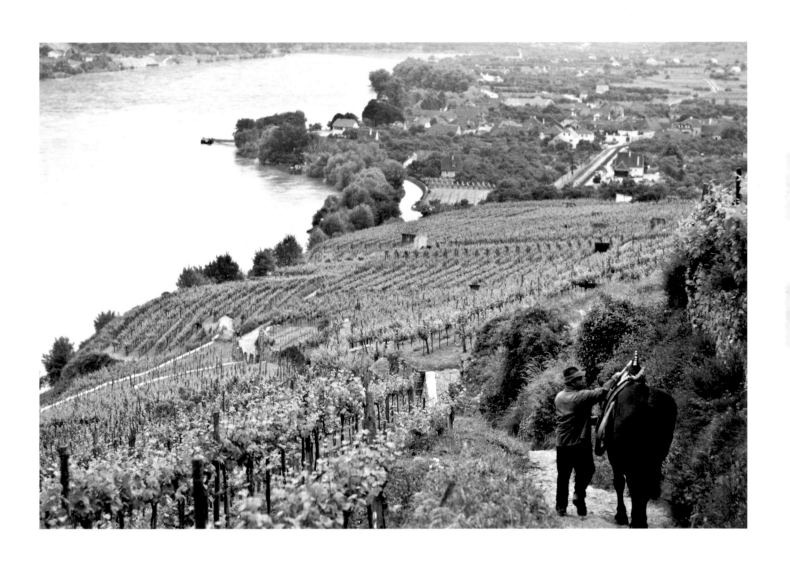

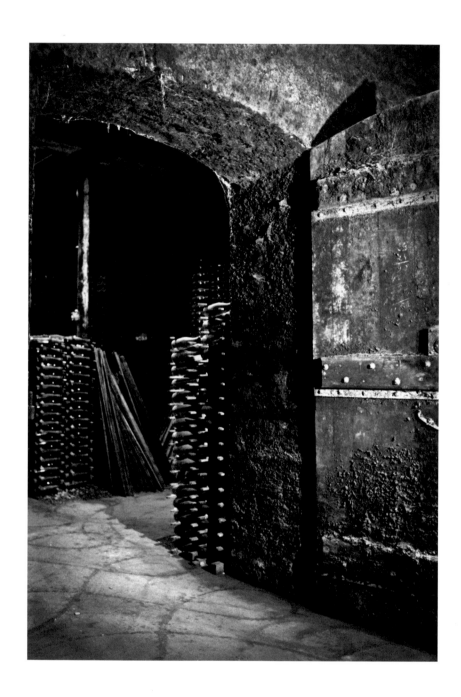

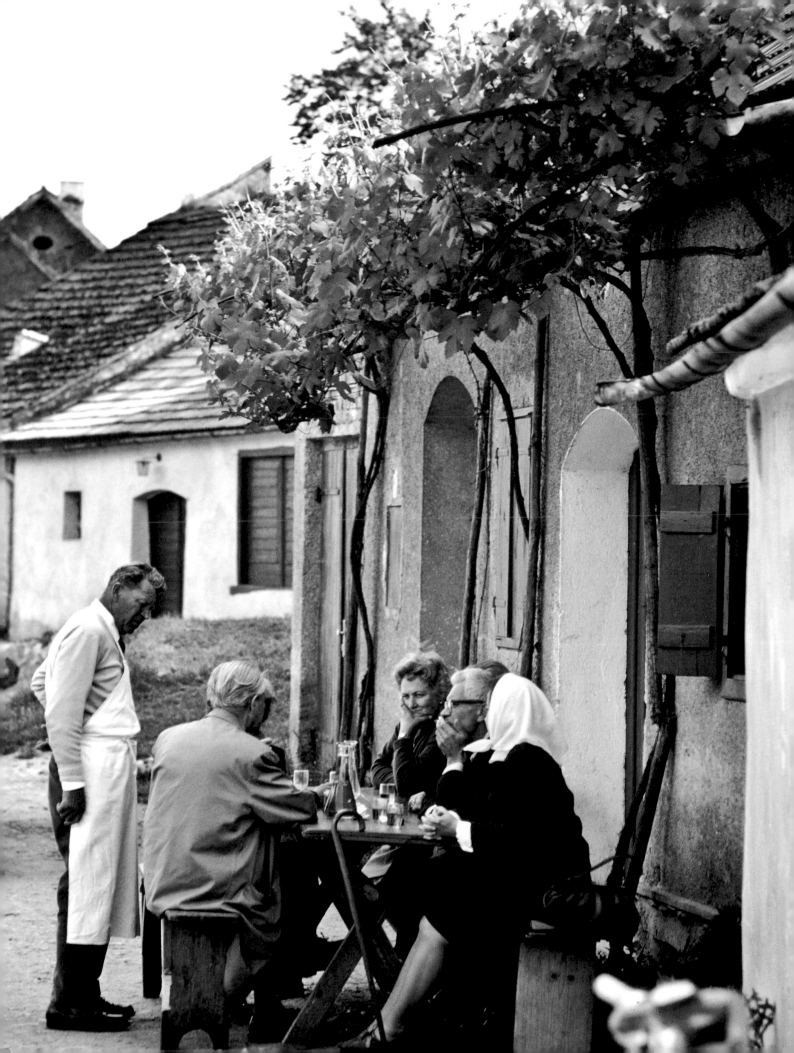

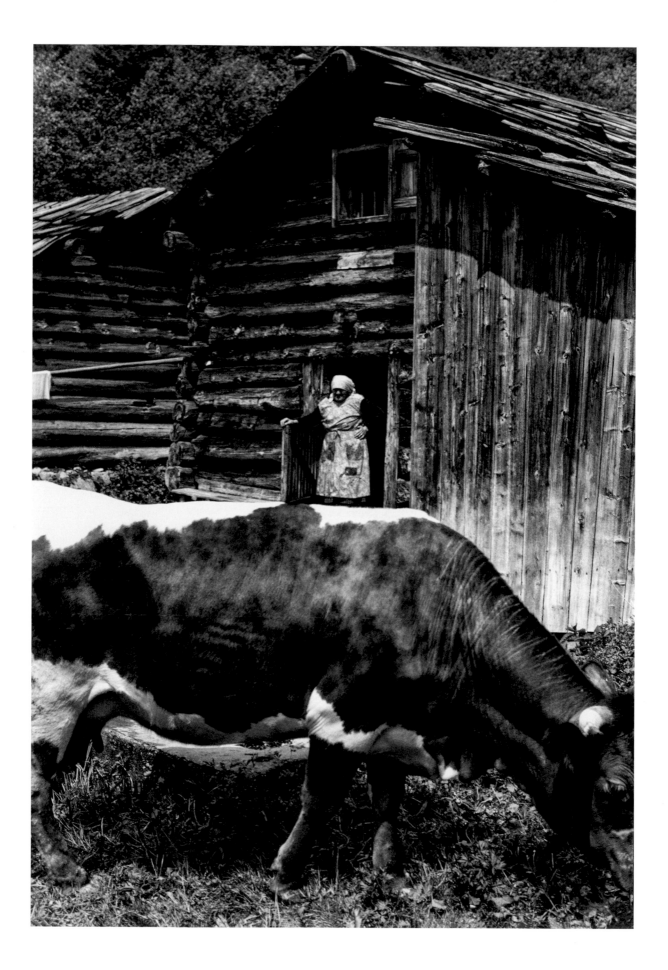

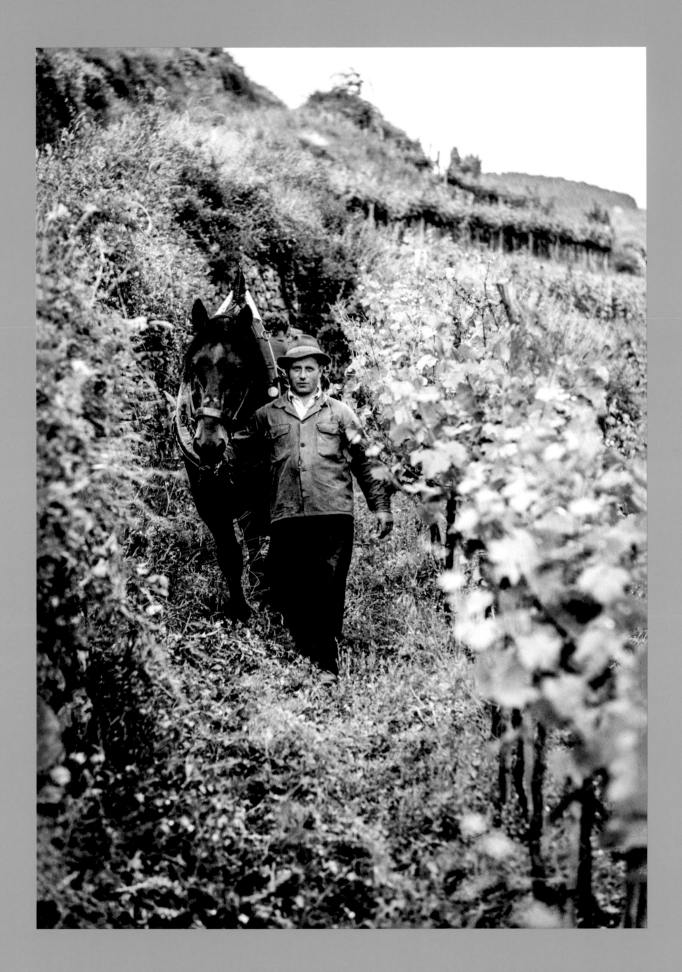

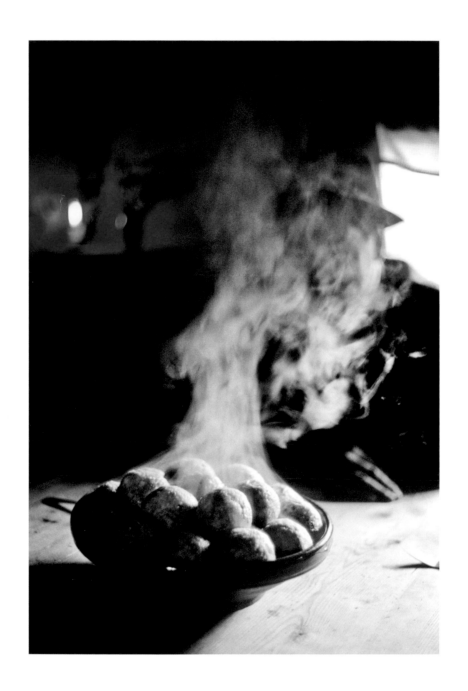

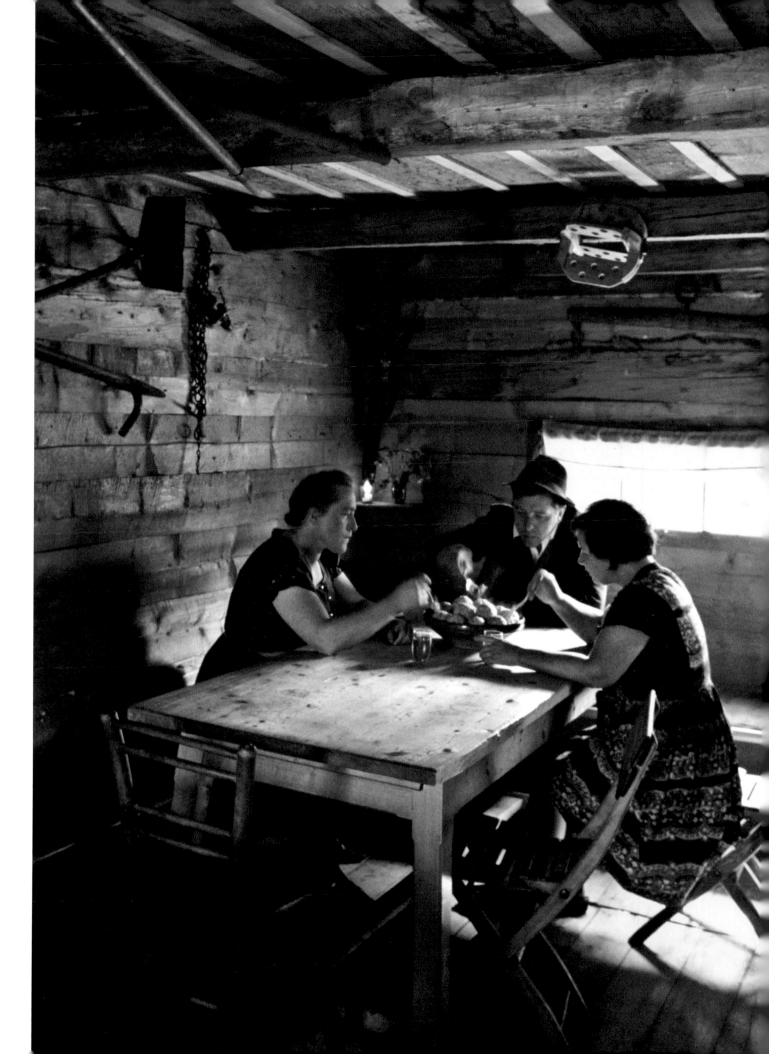

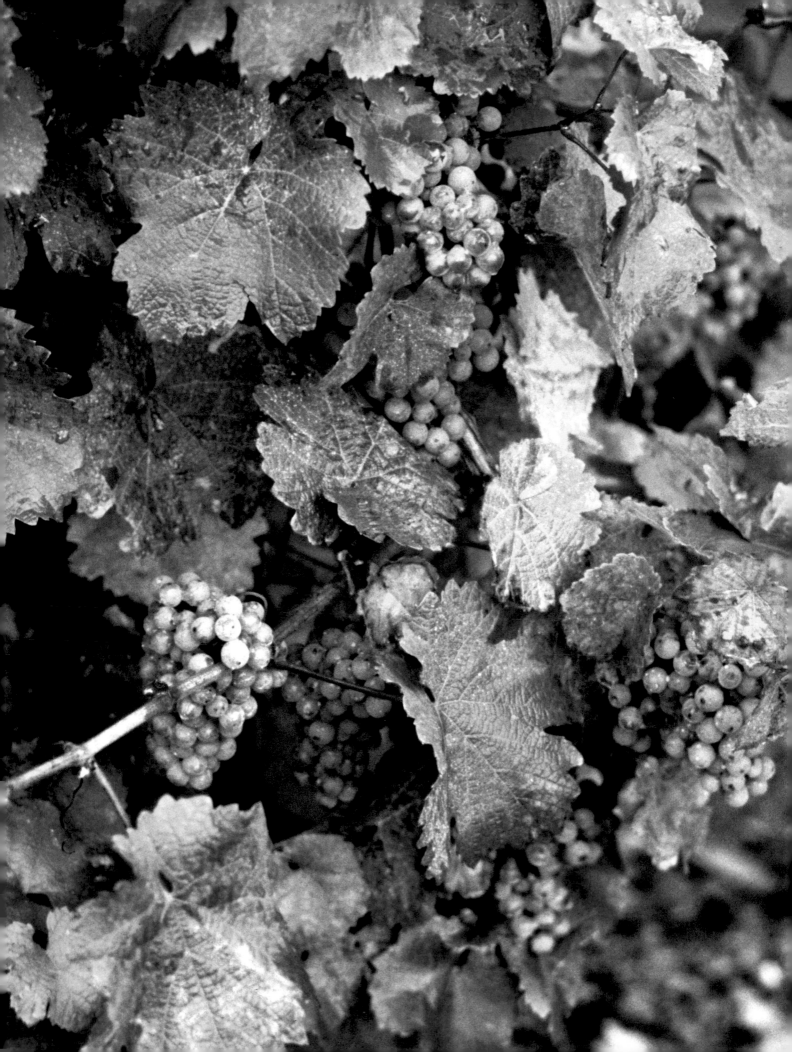

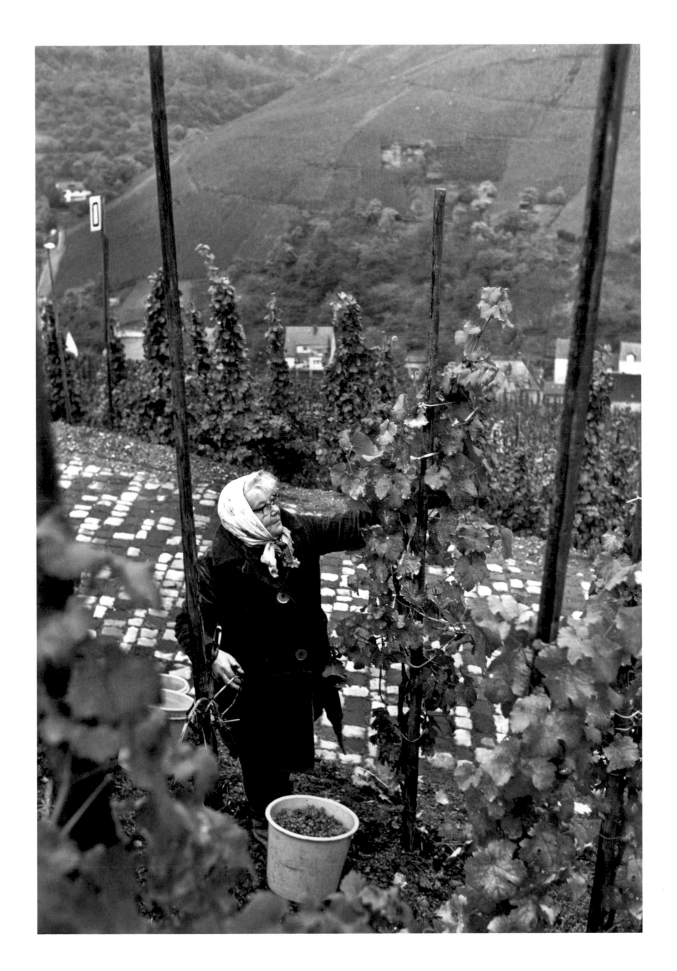

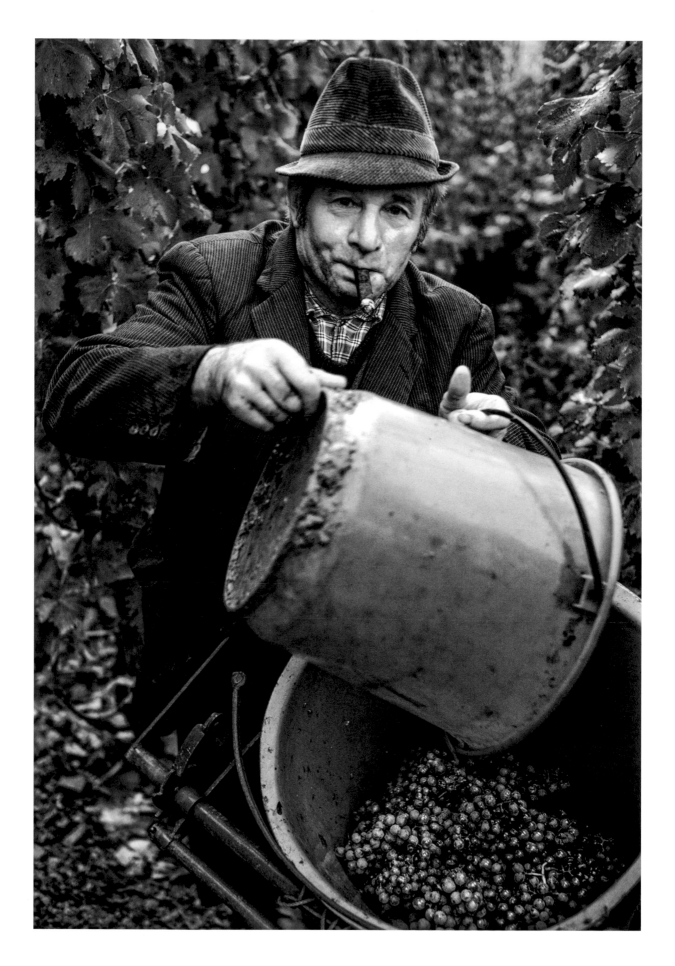

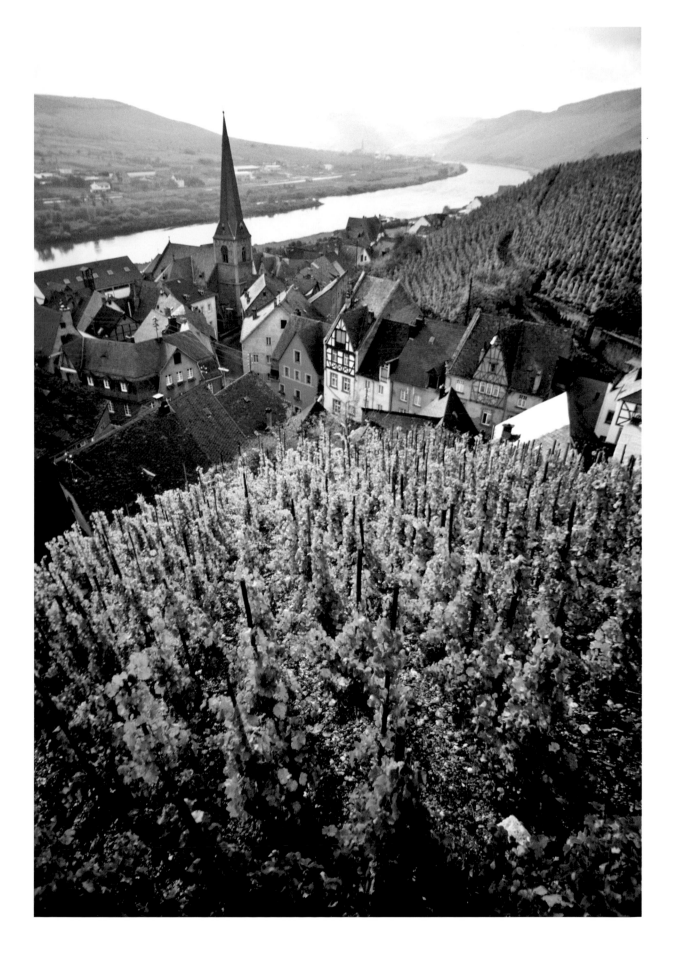

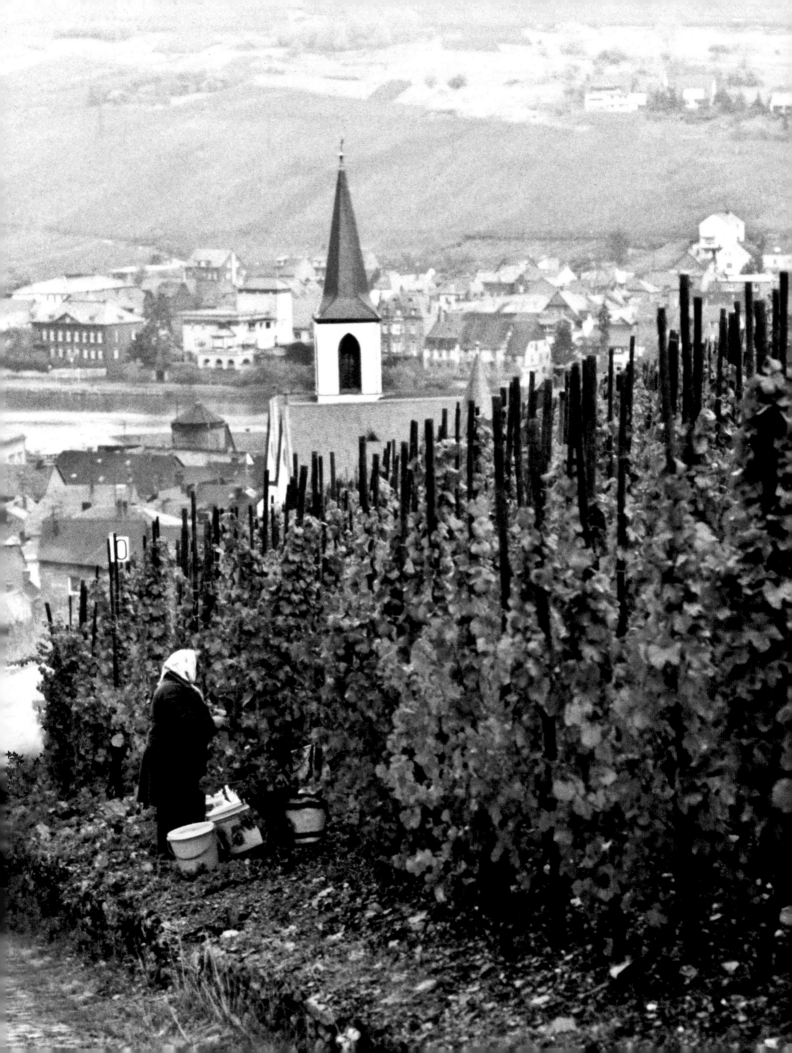

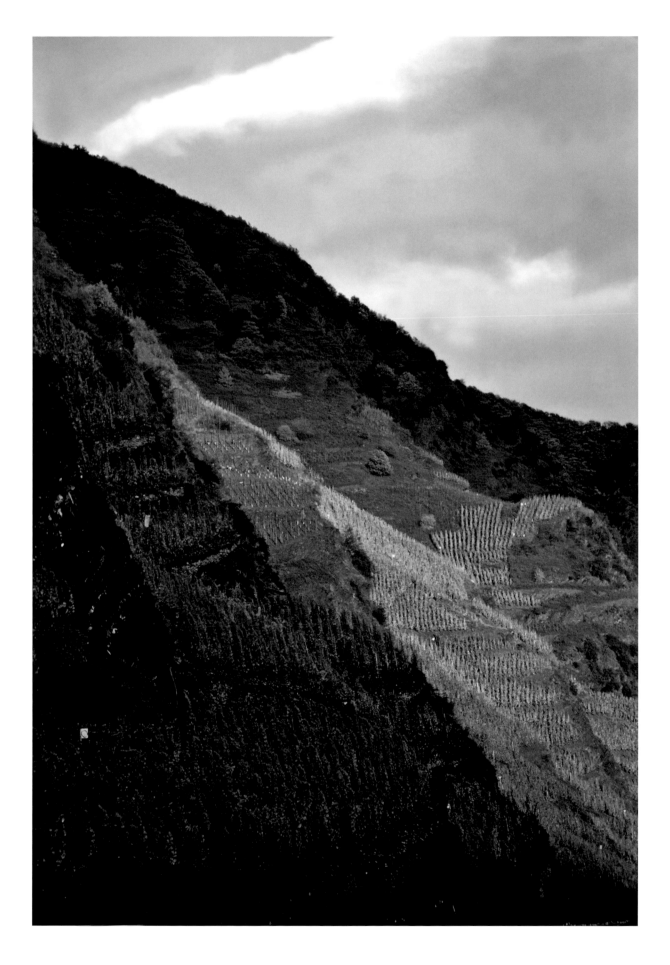

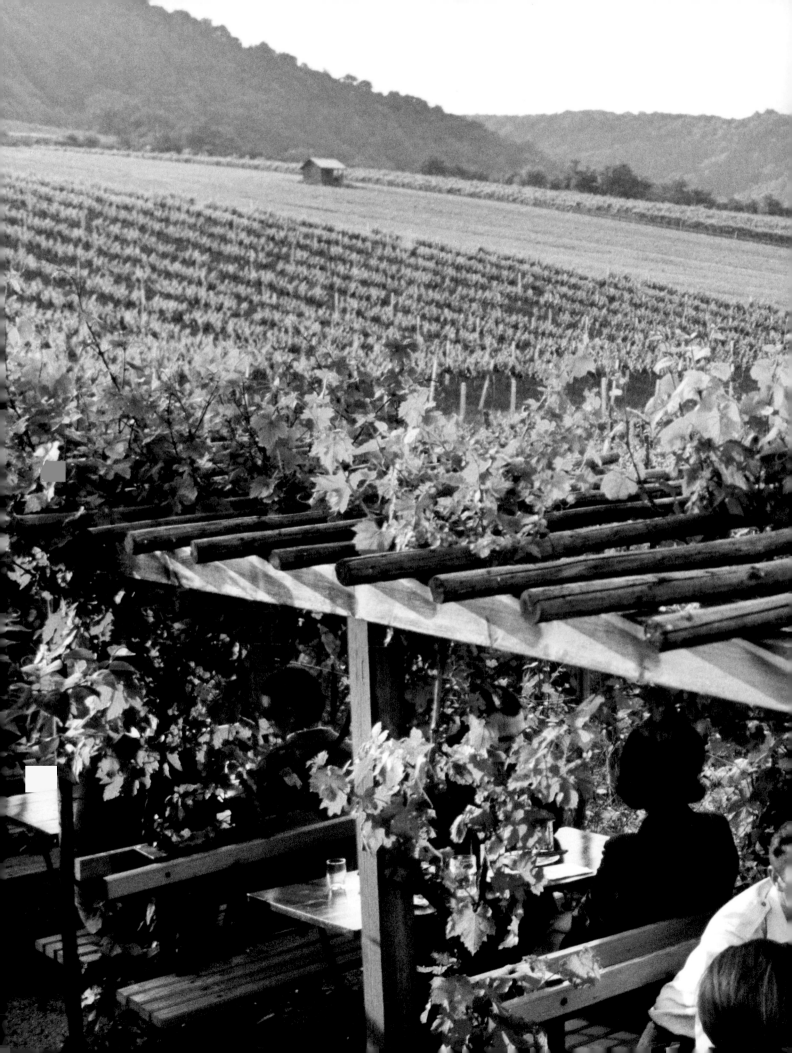

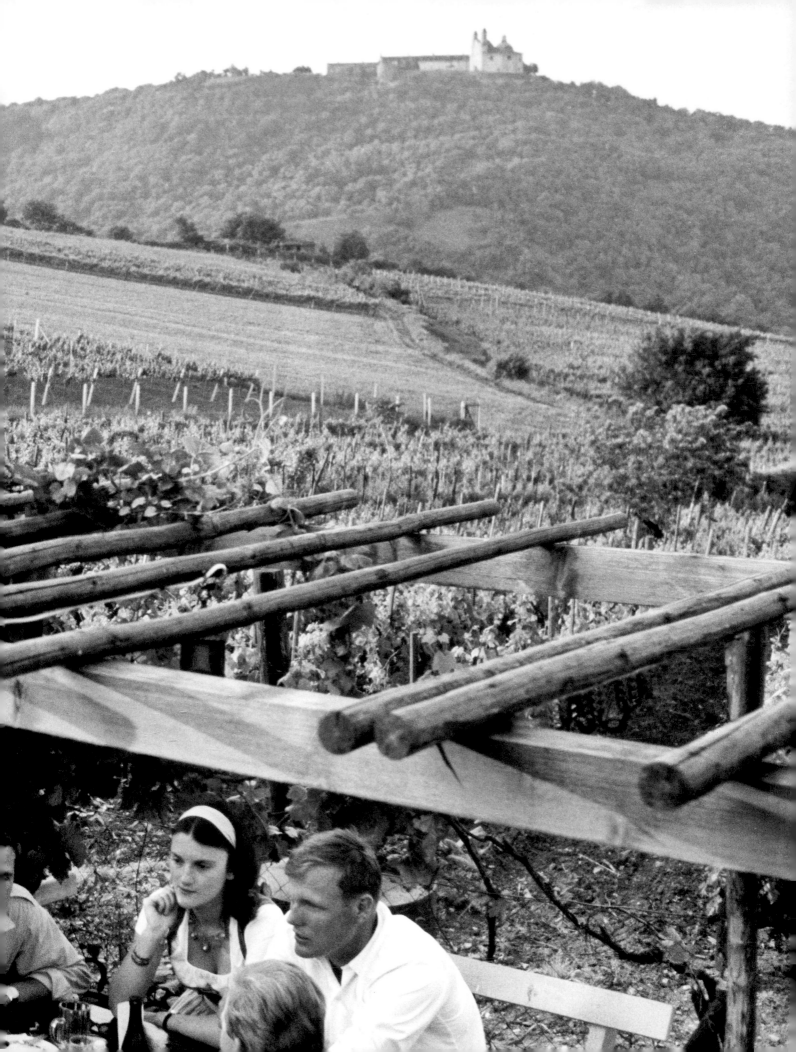

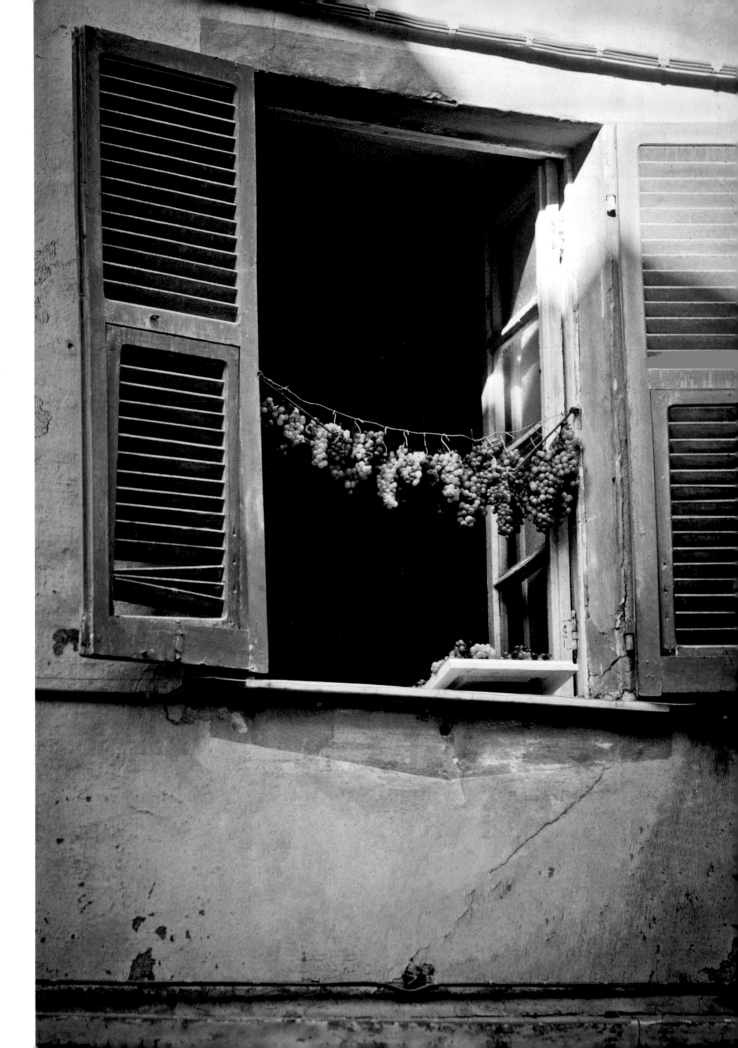

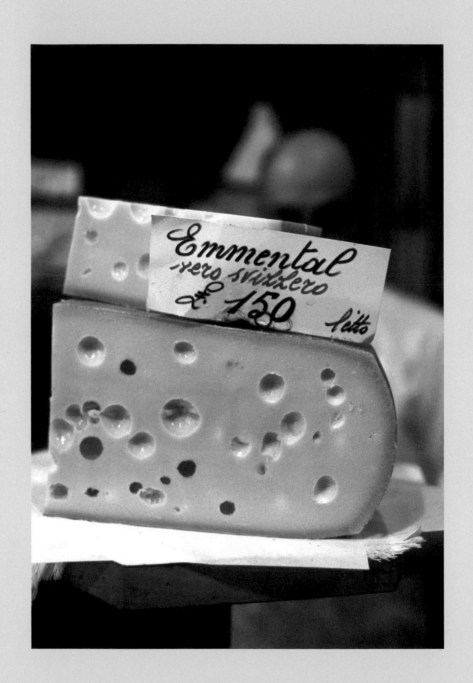

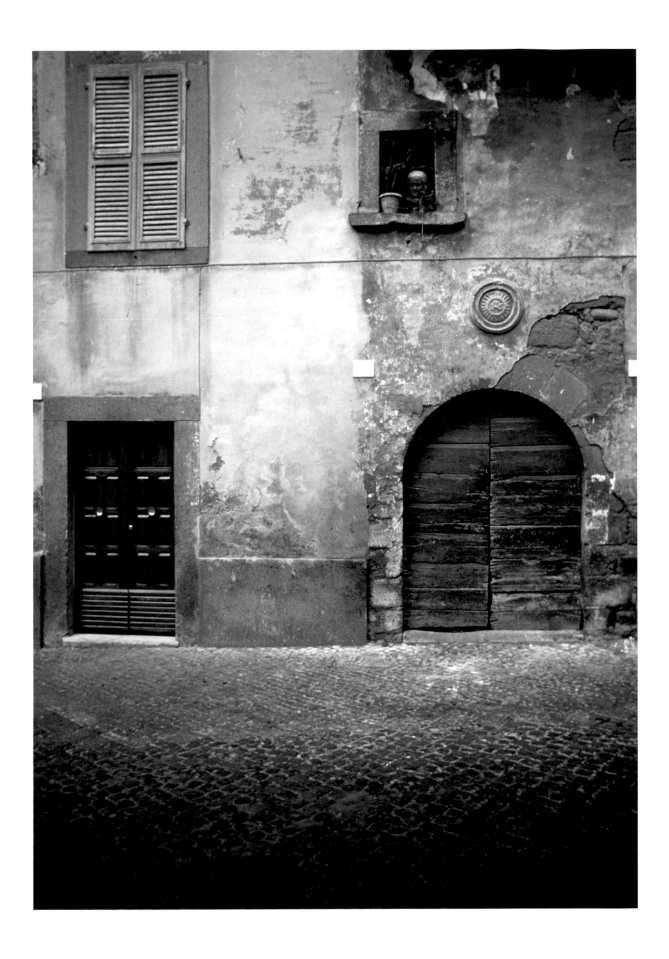

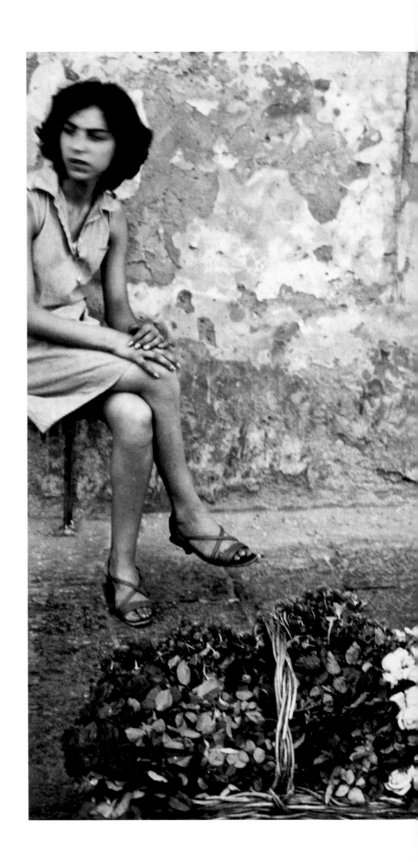

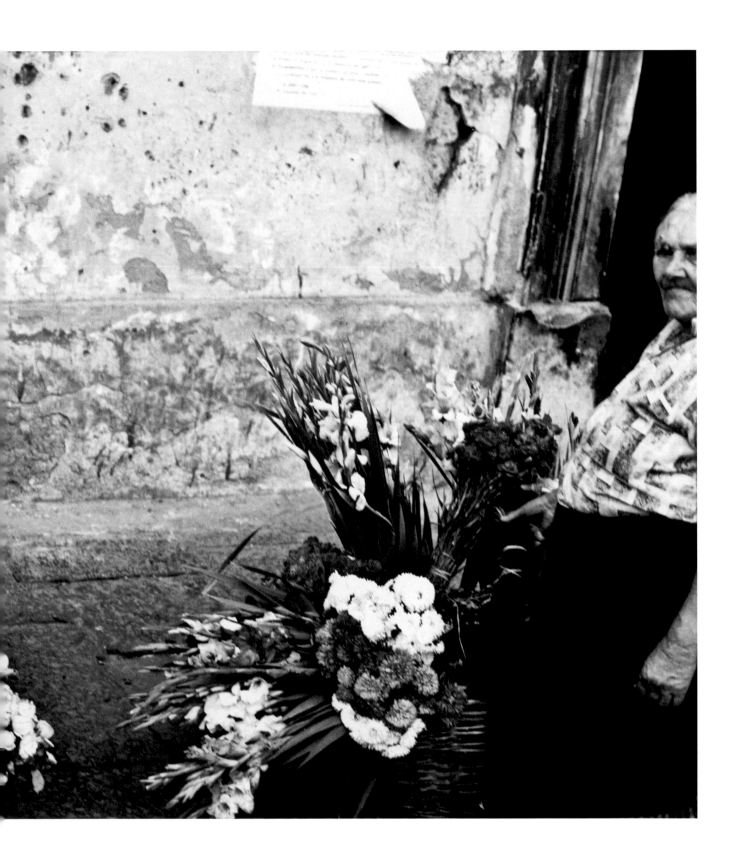

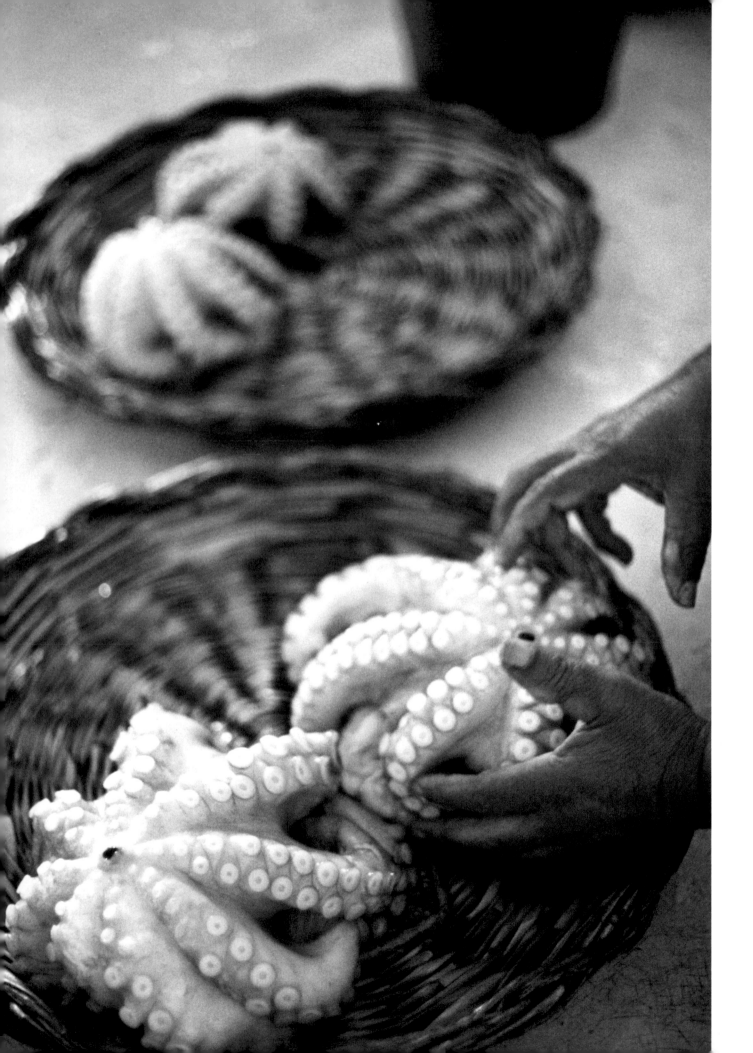

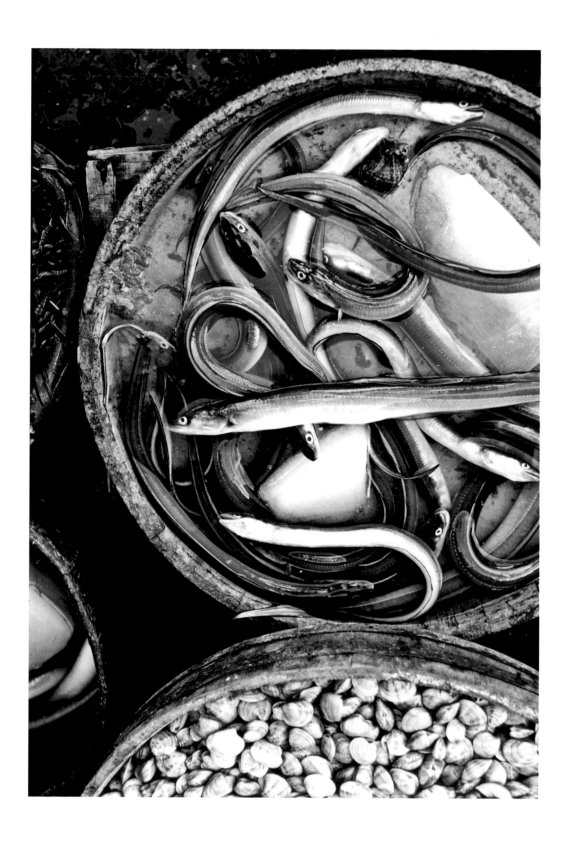

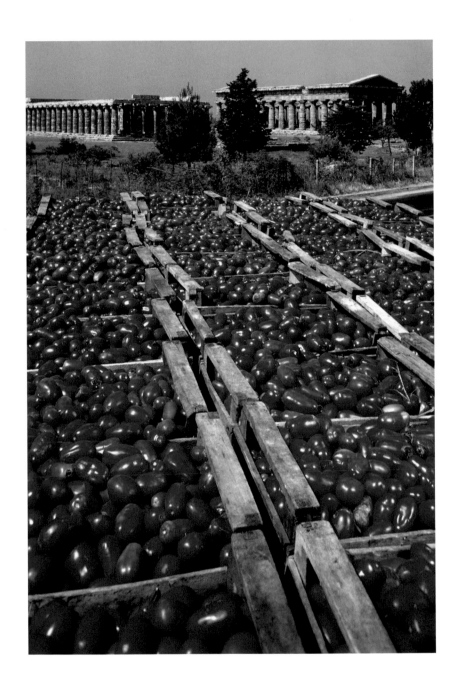

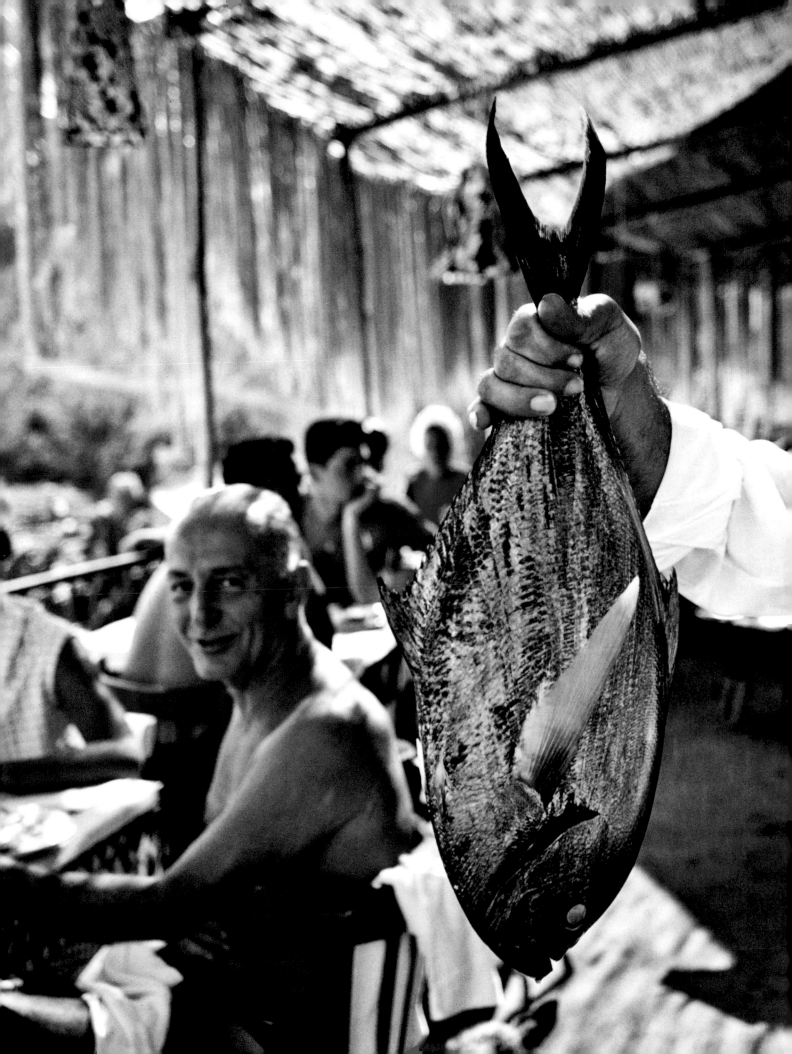

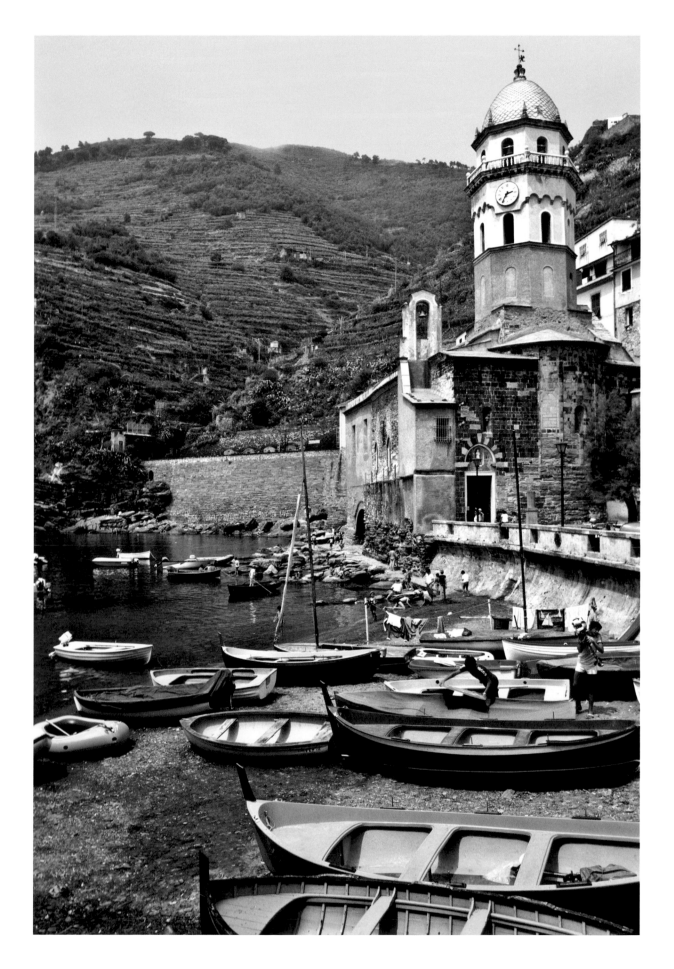

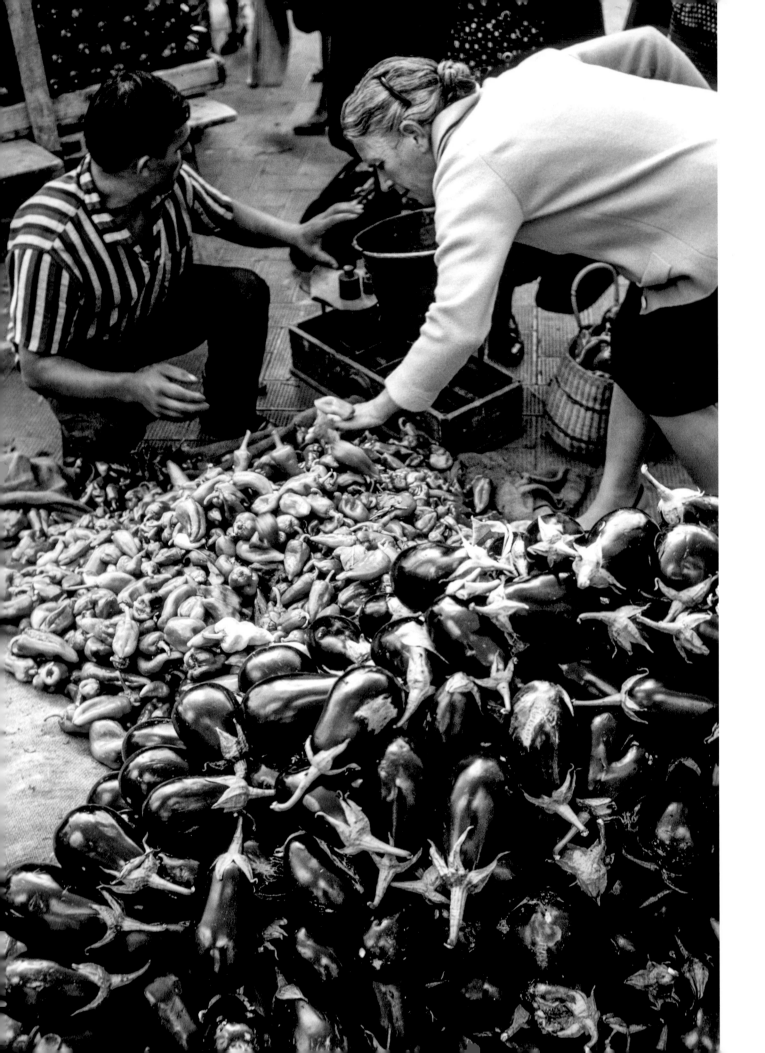

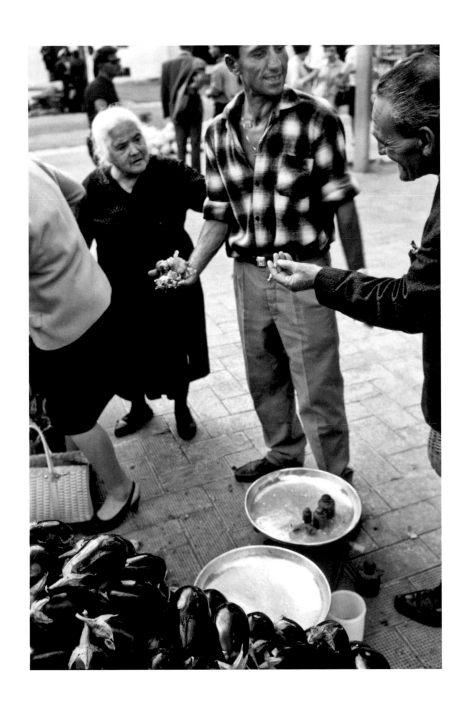

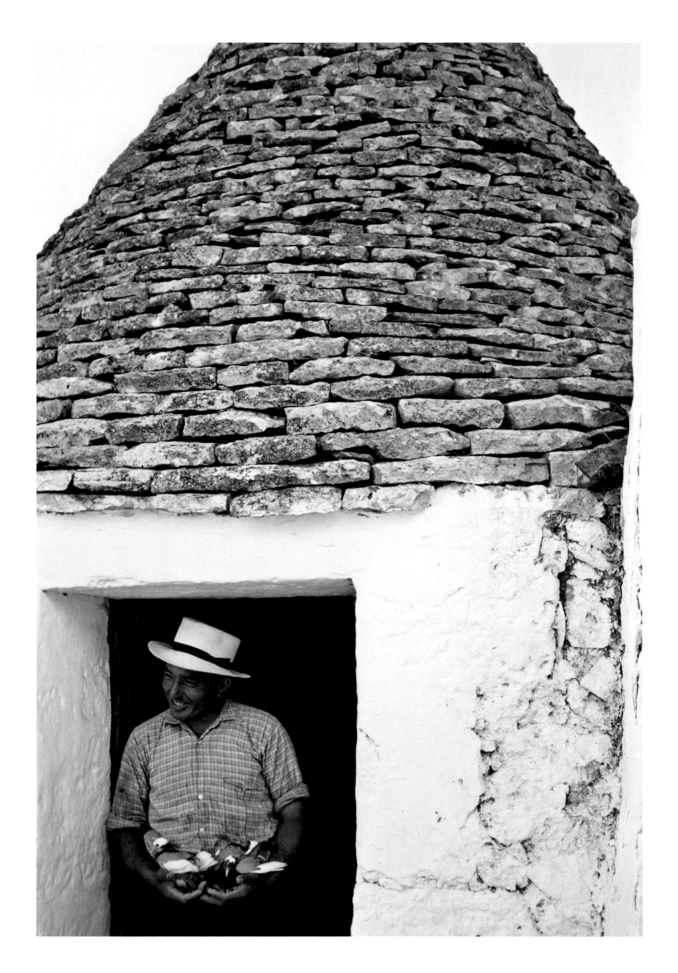

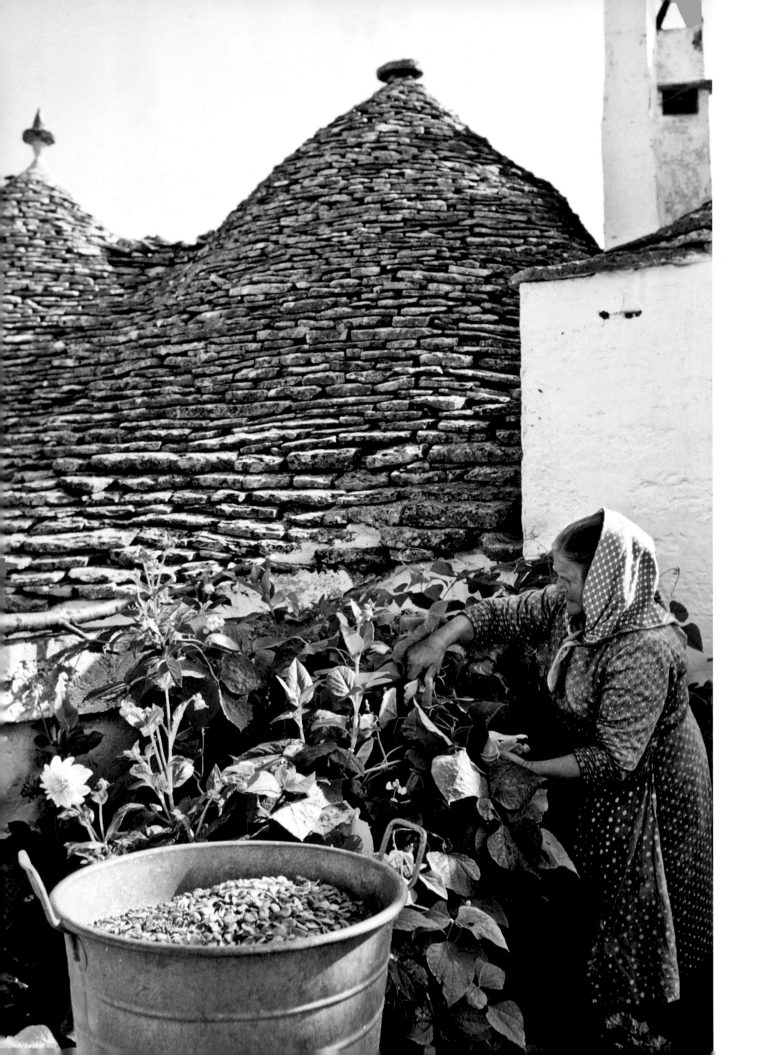

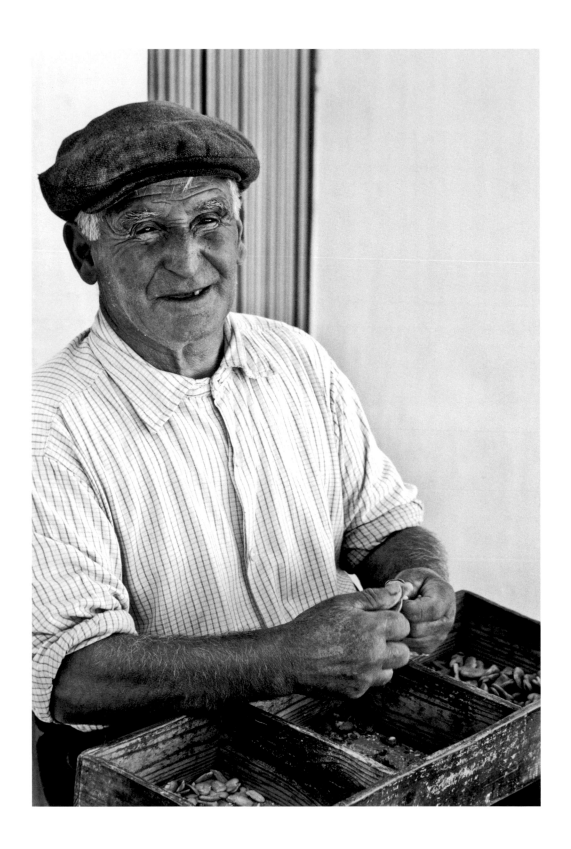

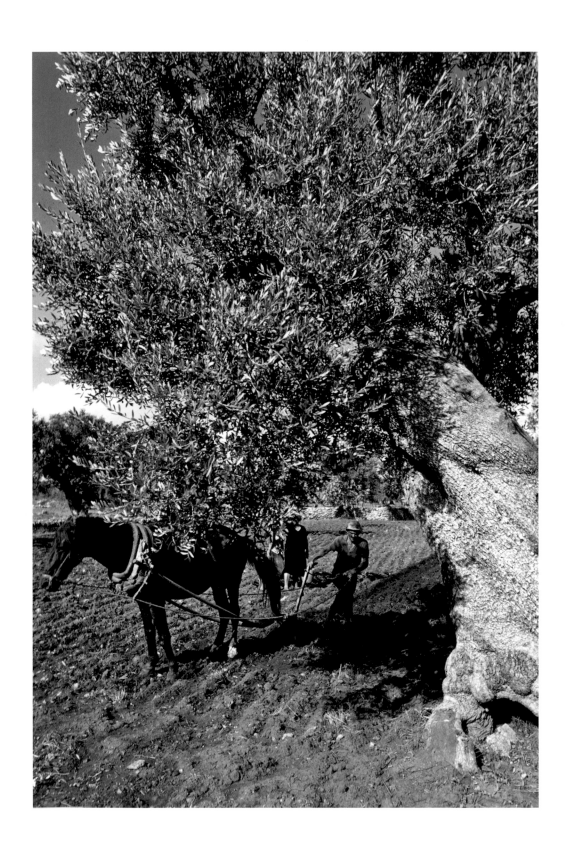

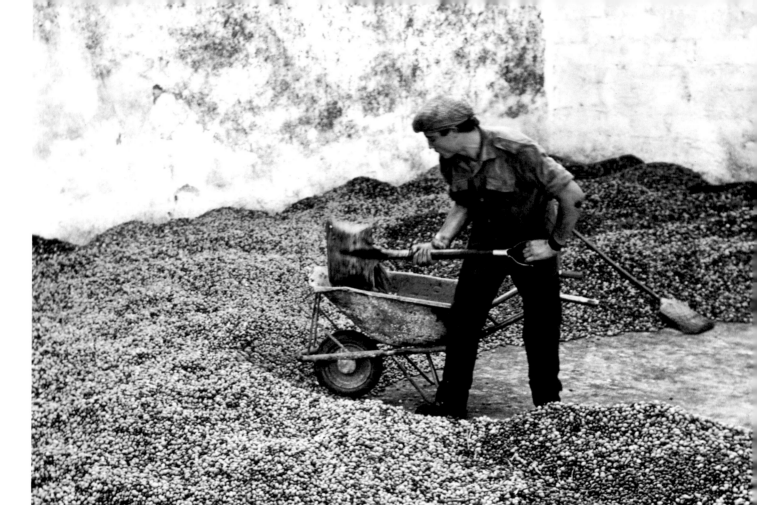

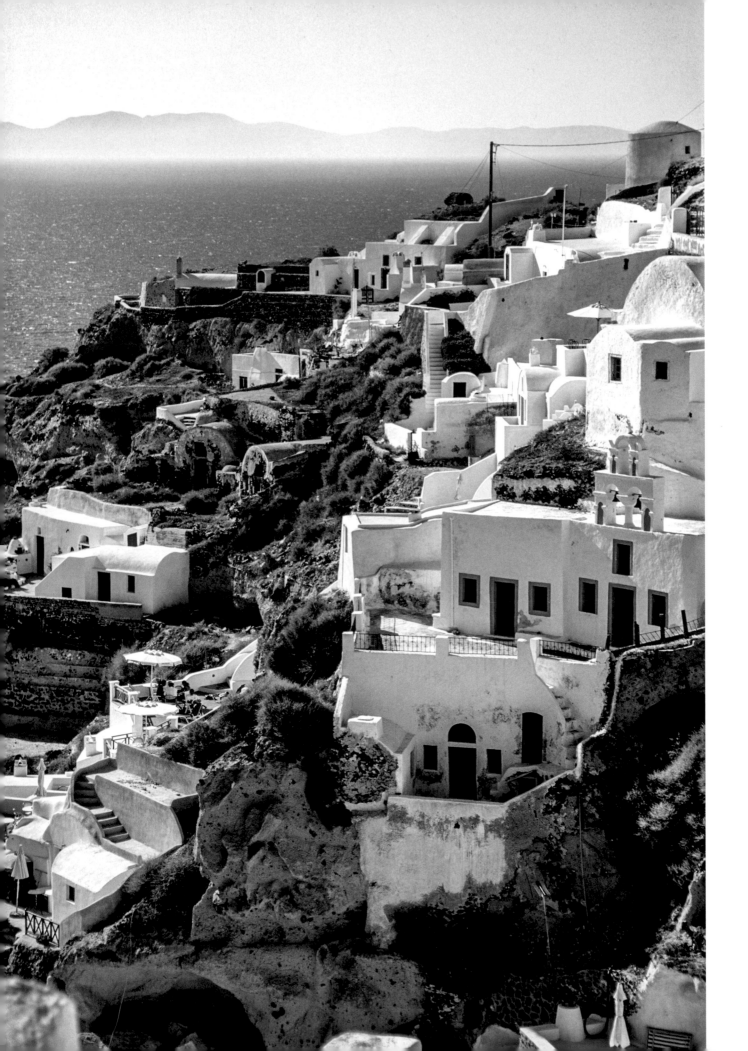

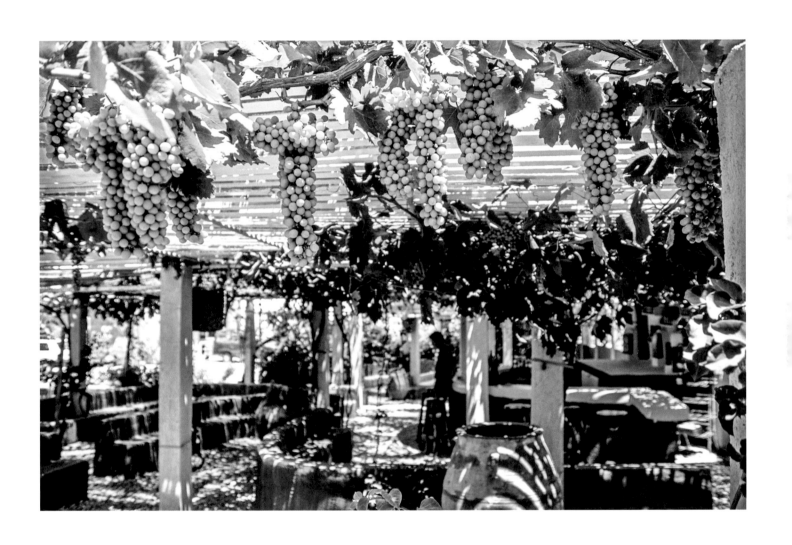

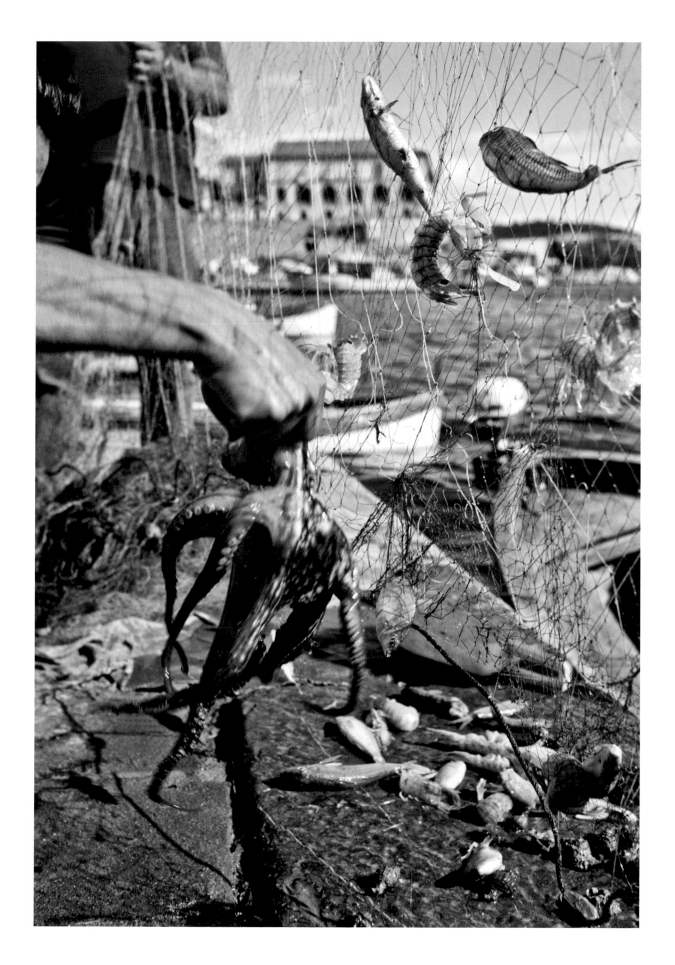

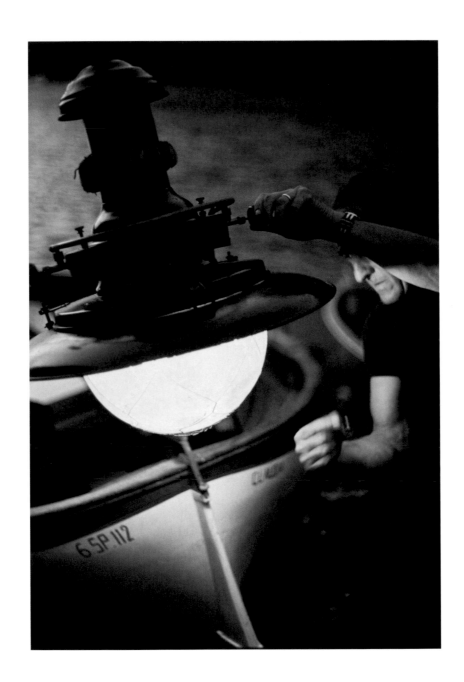

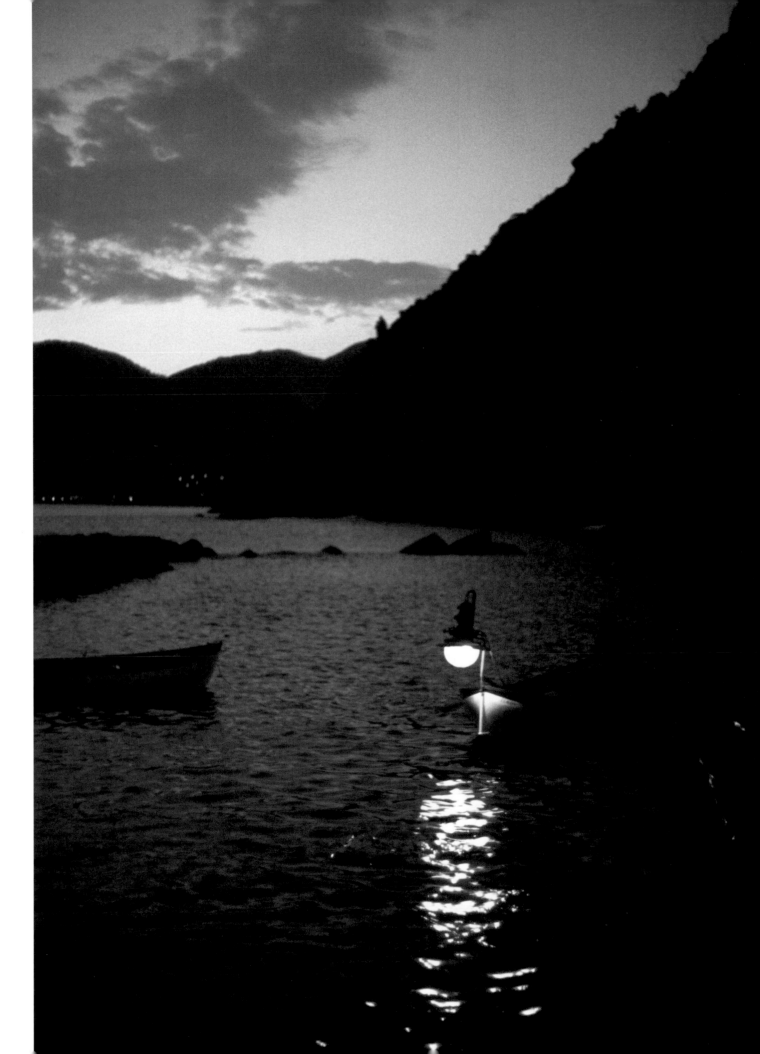

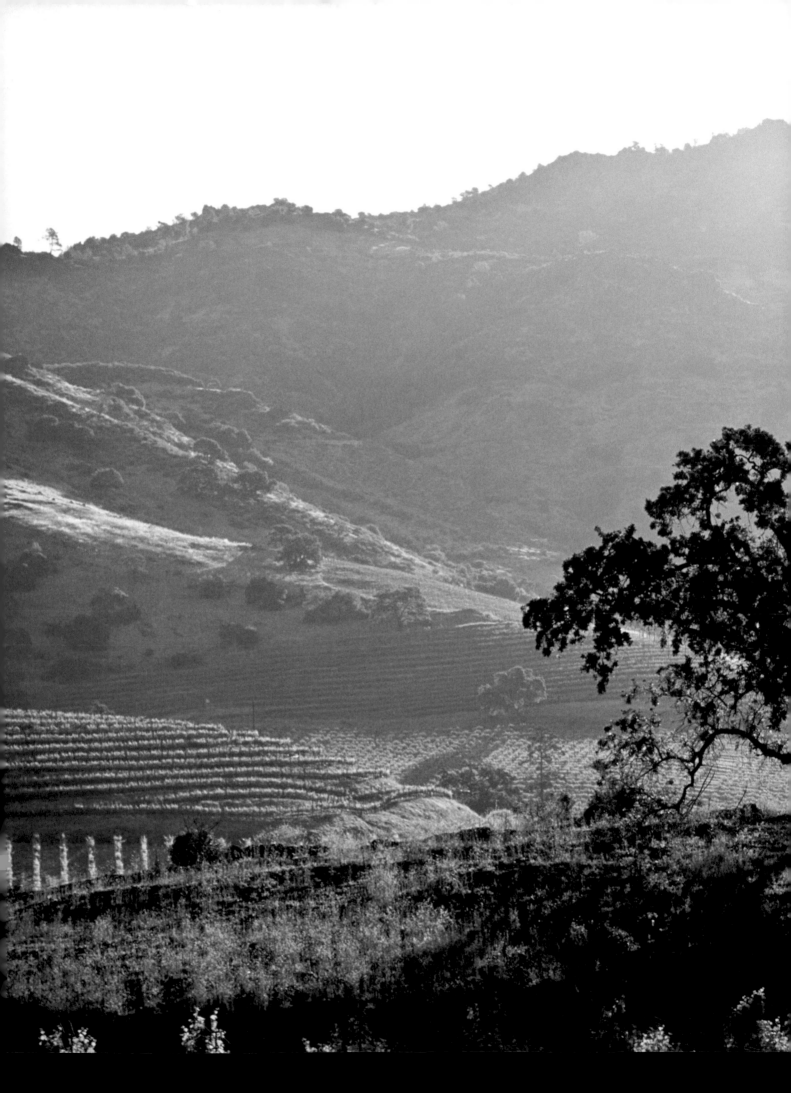

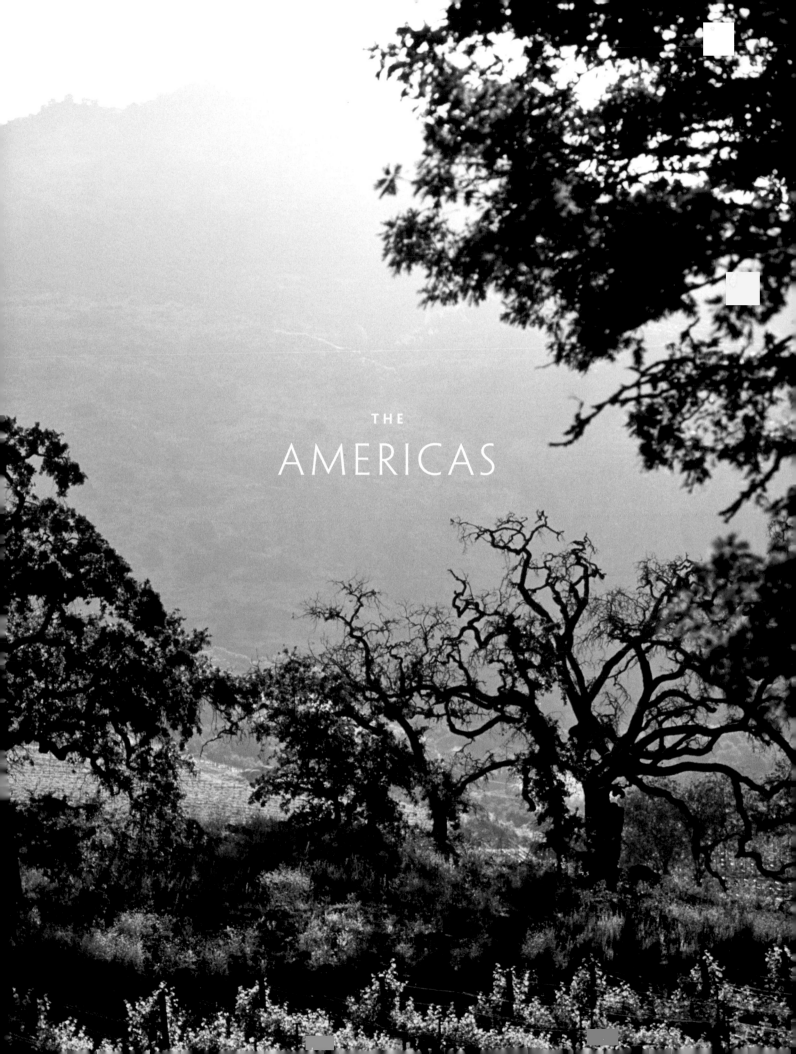

THE
AMERICAS

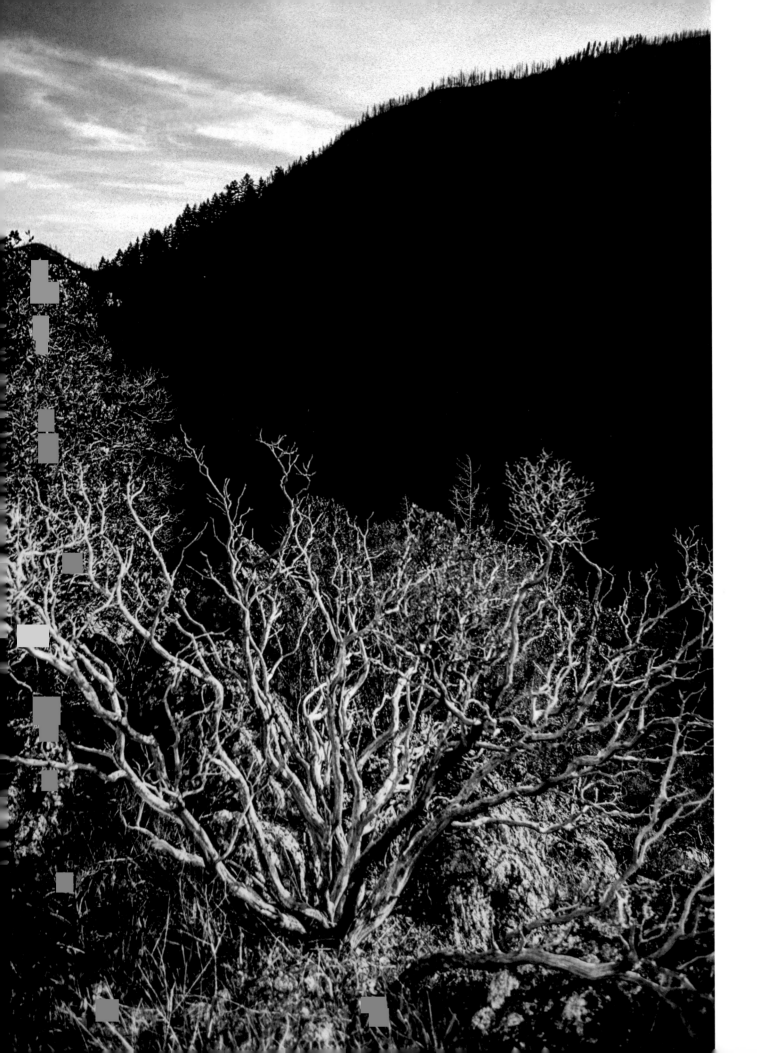

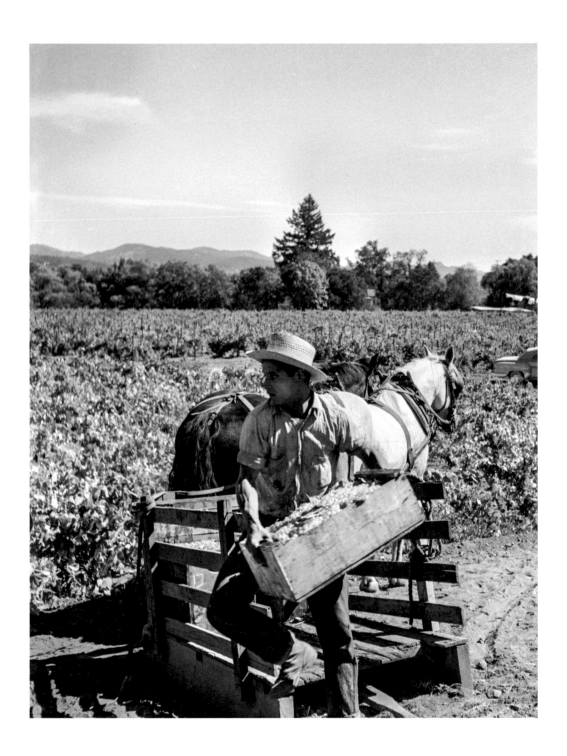

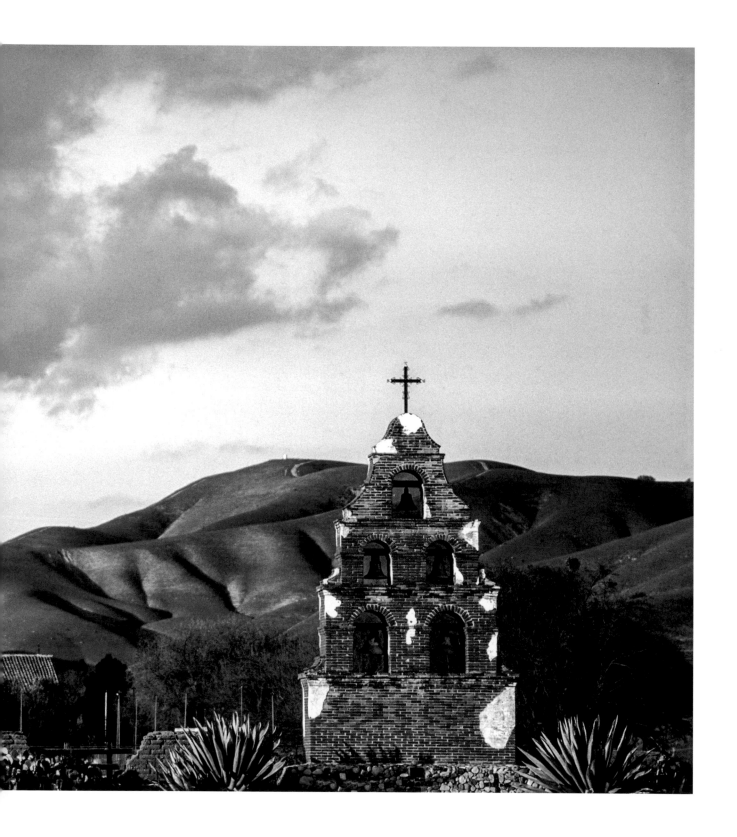

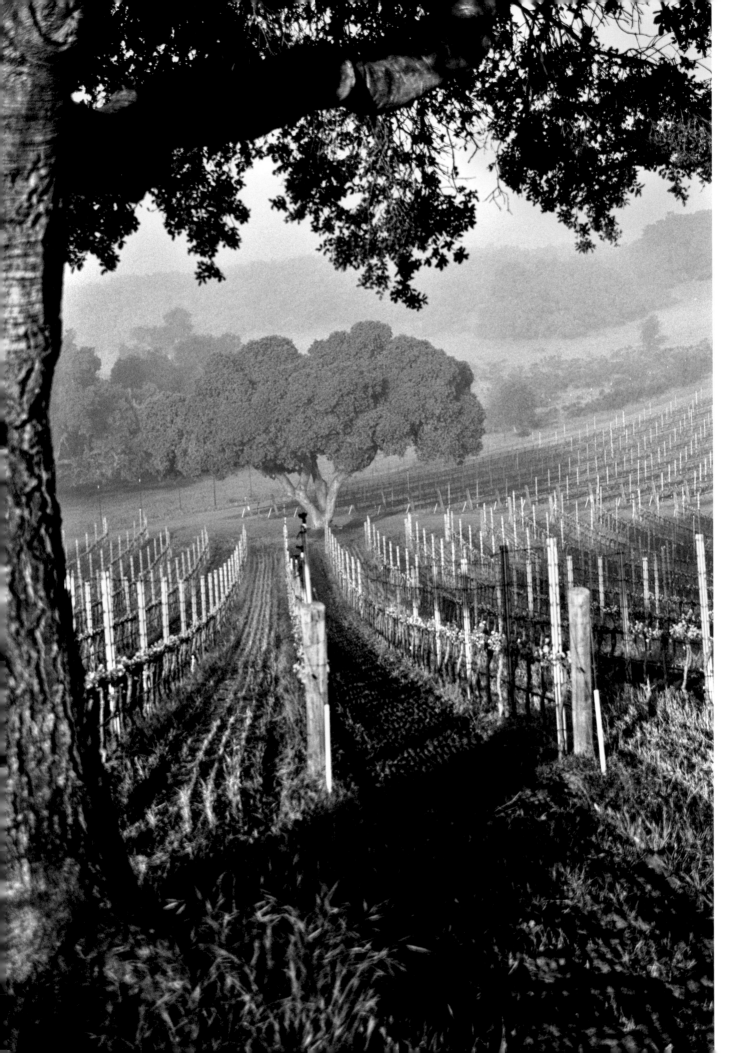

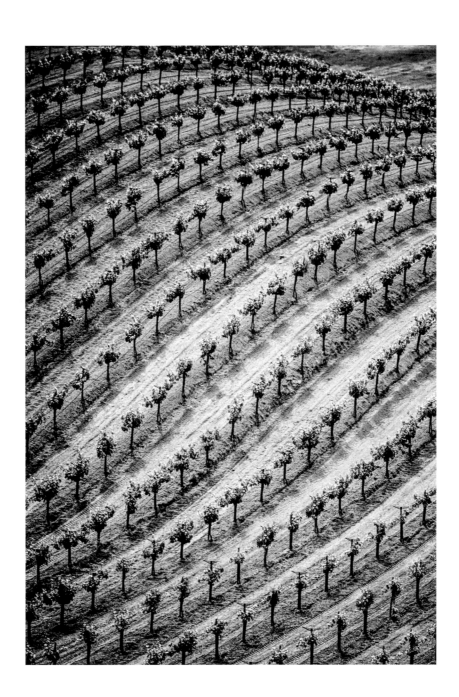

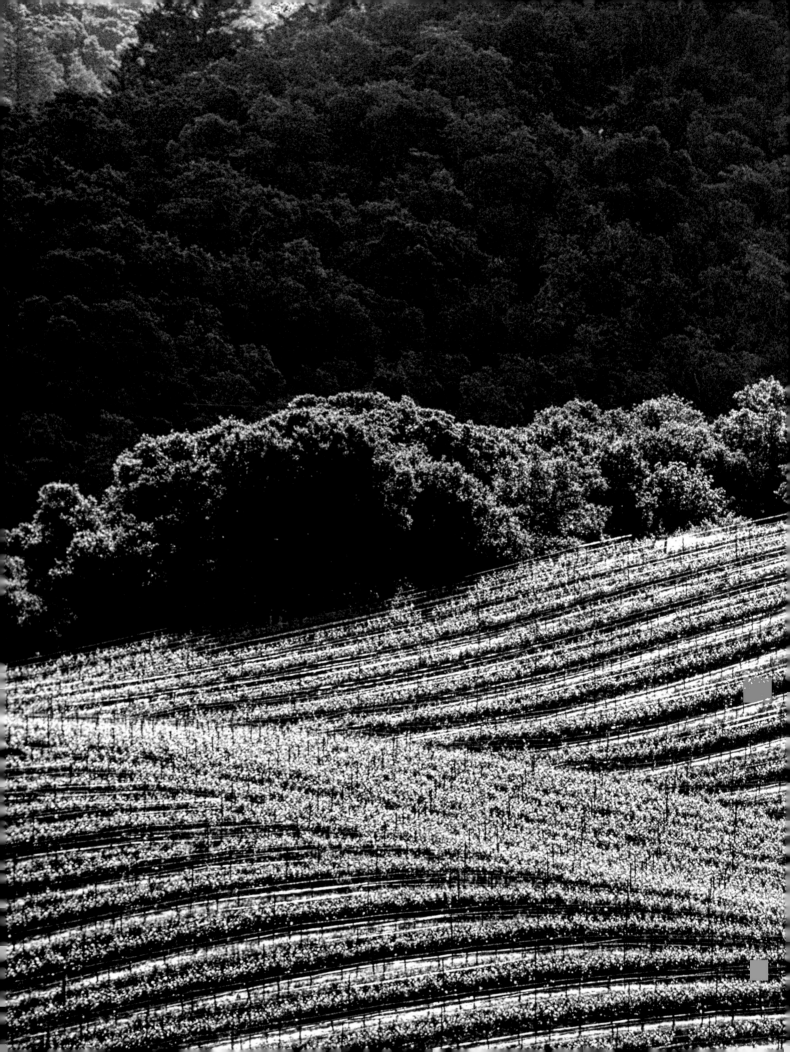

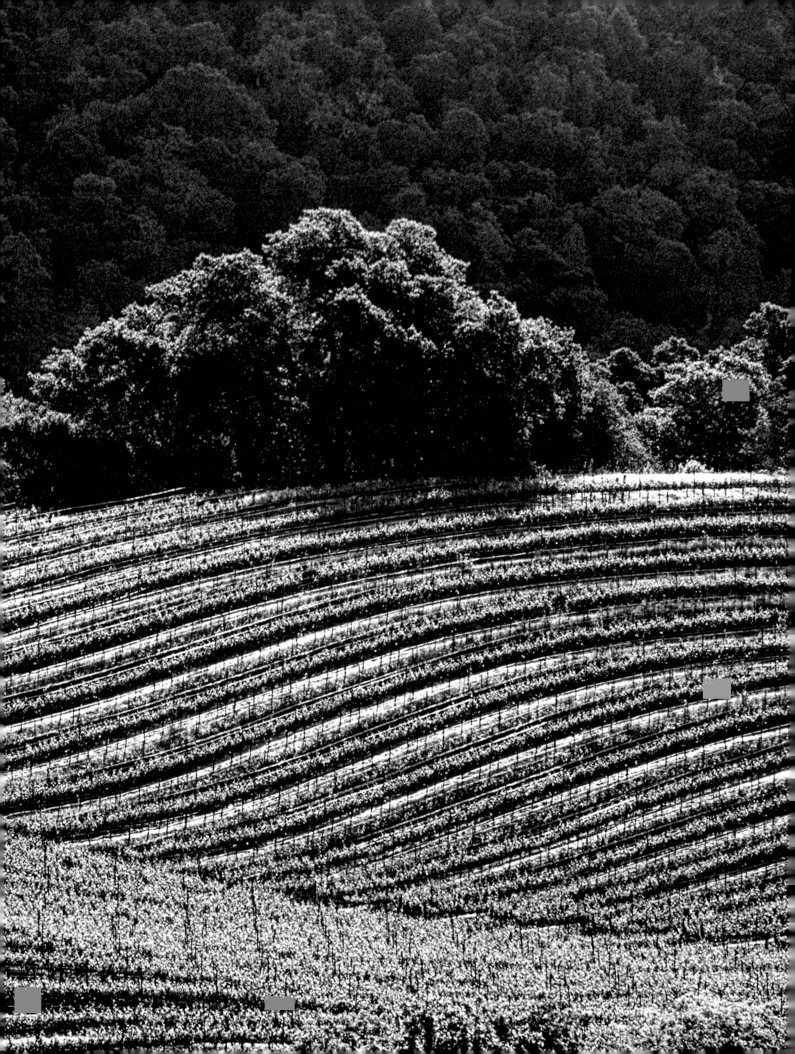

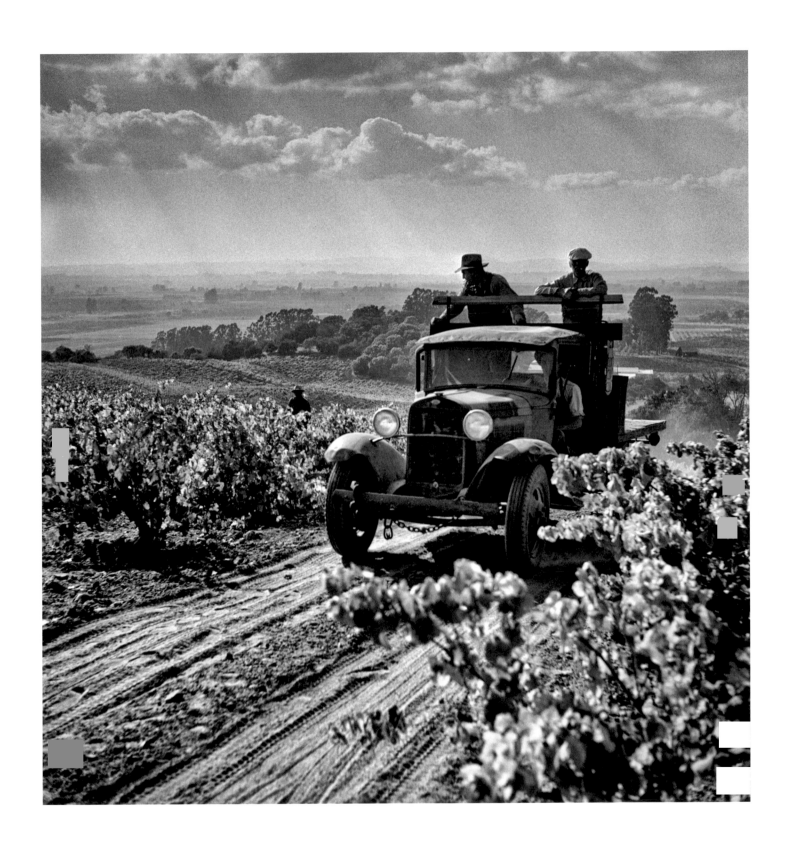

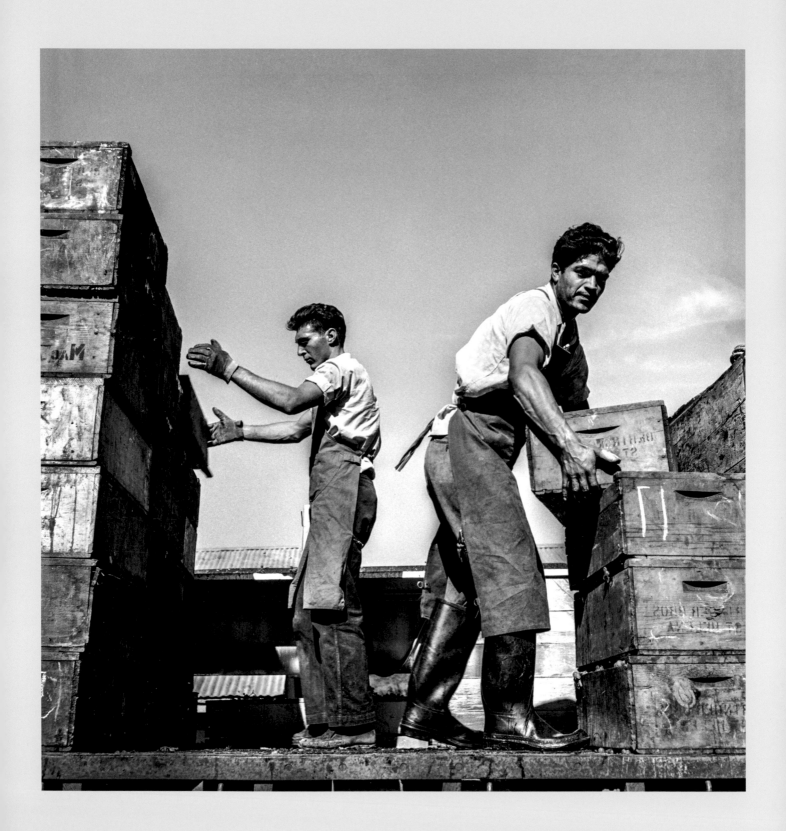

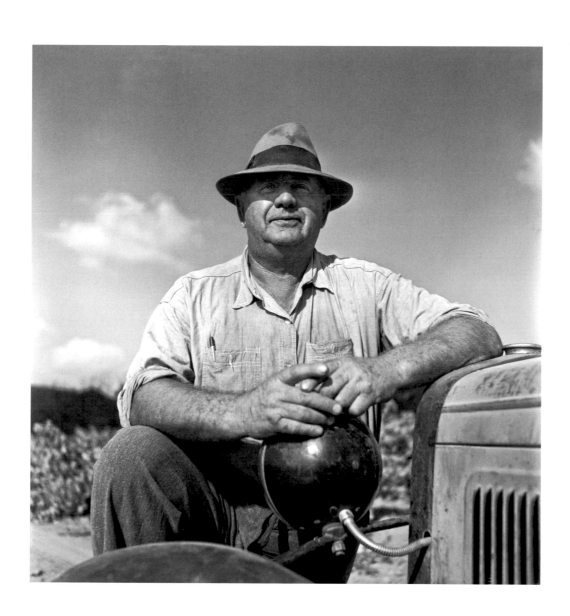

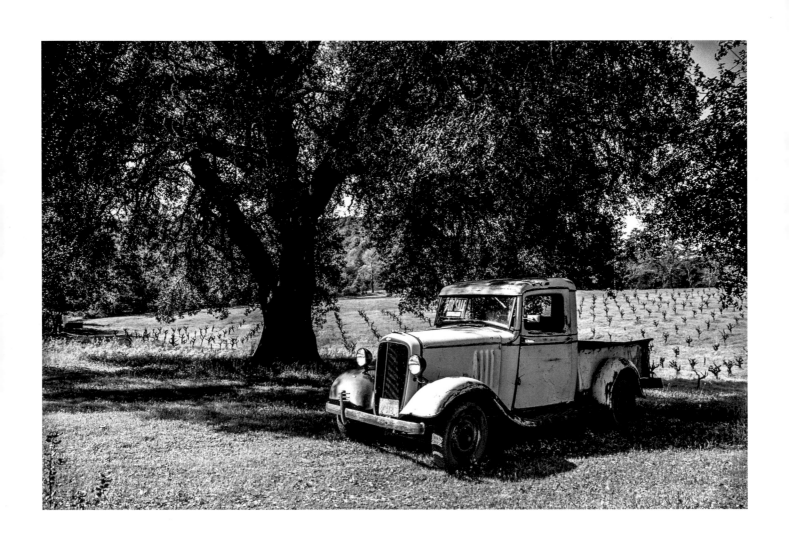

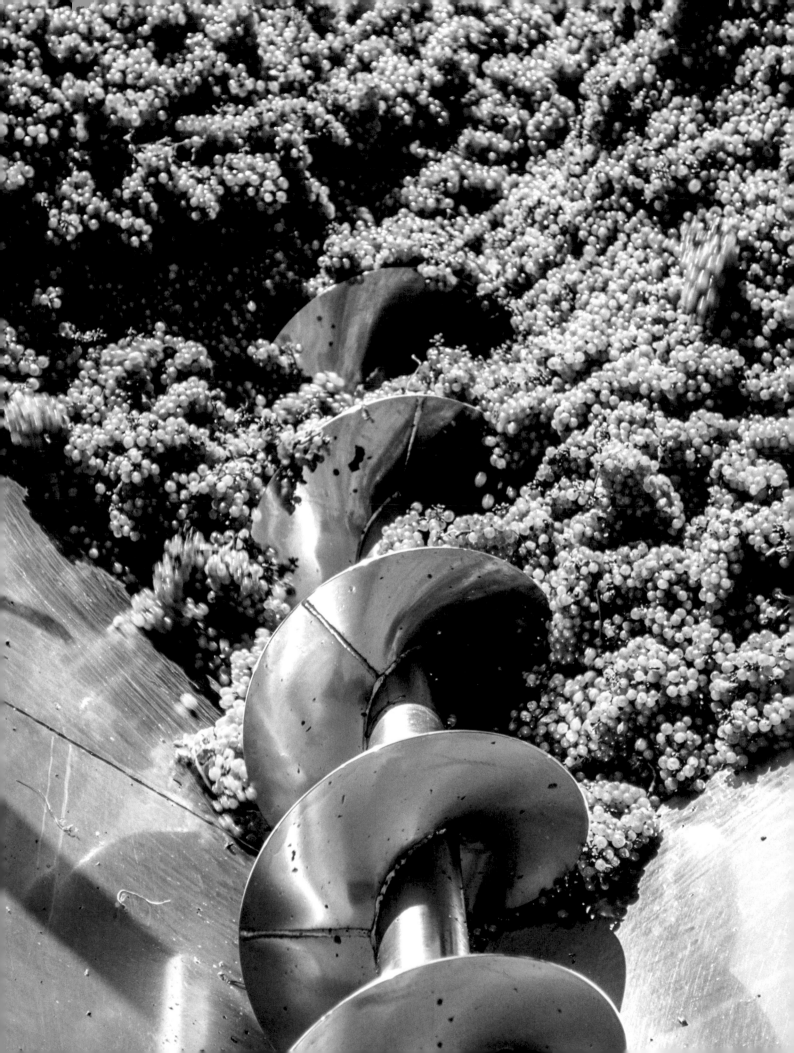

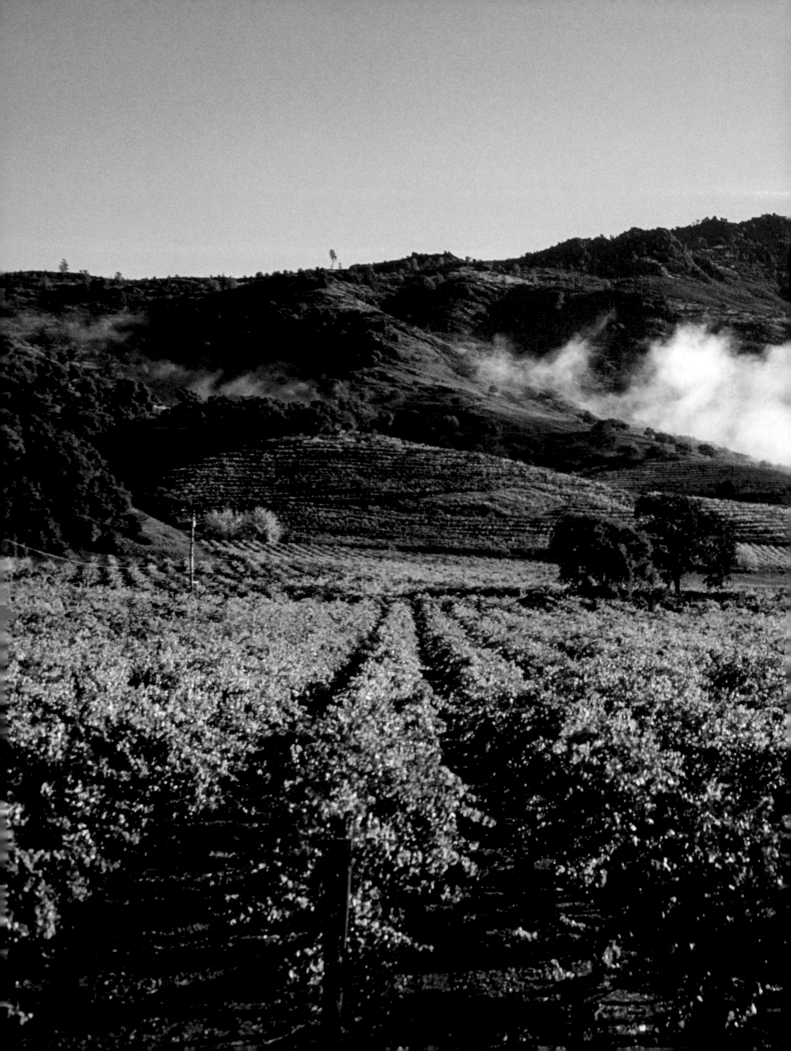

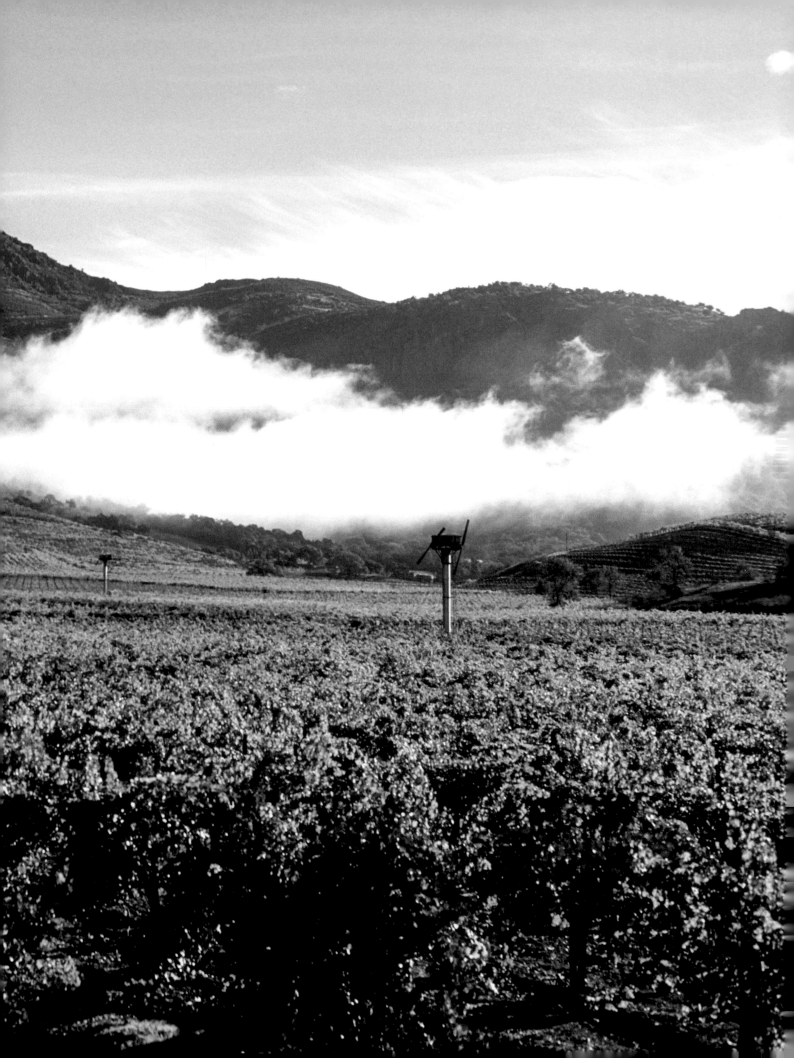

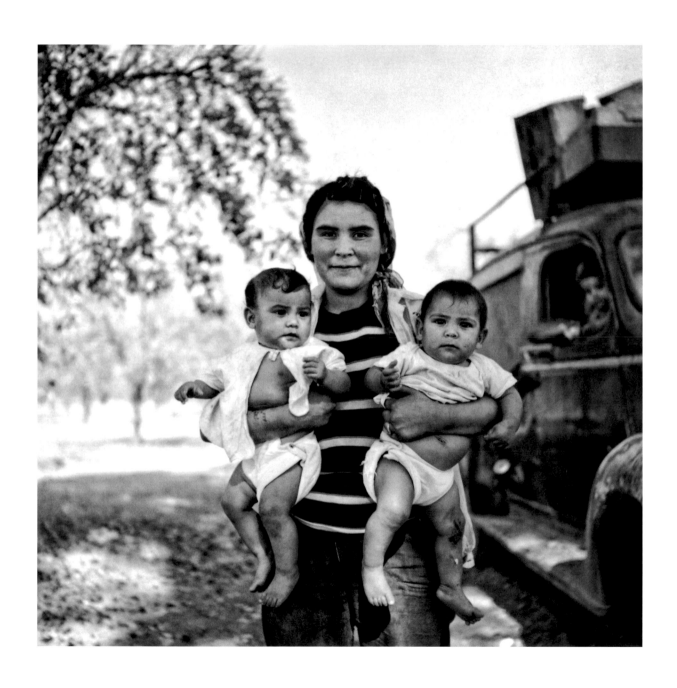

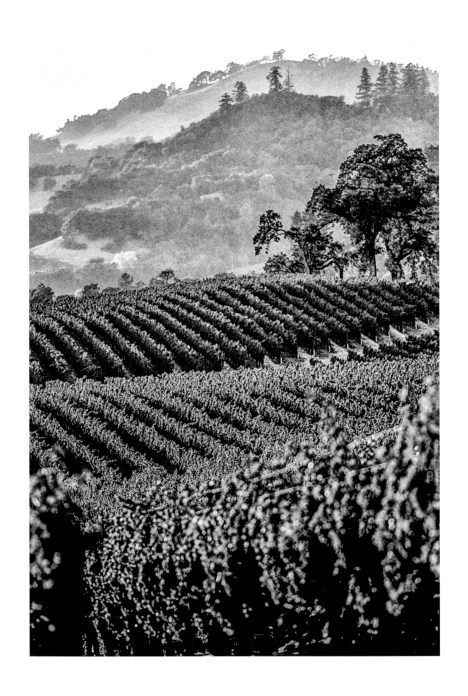

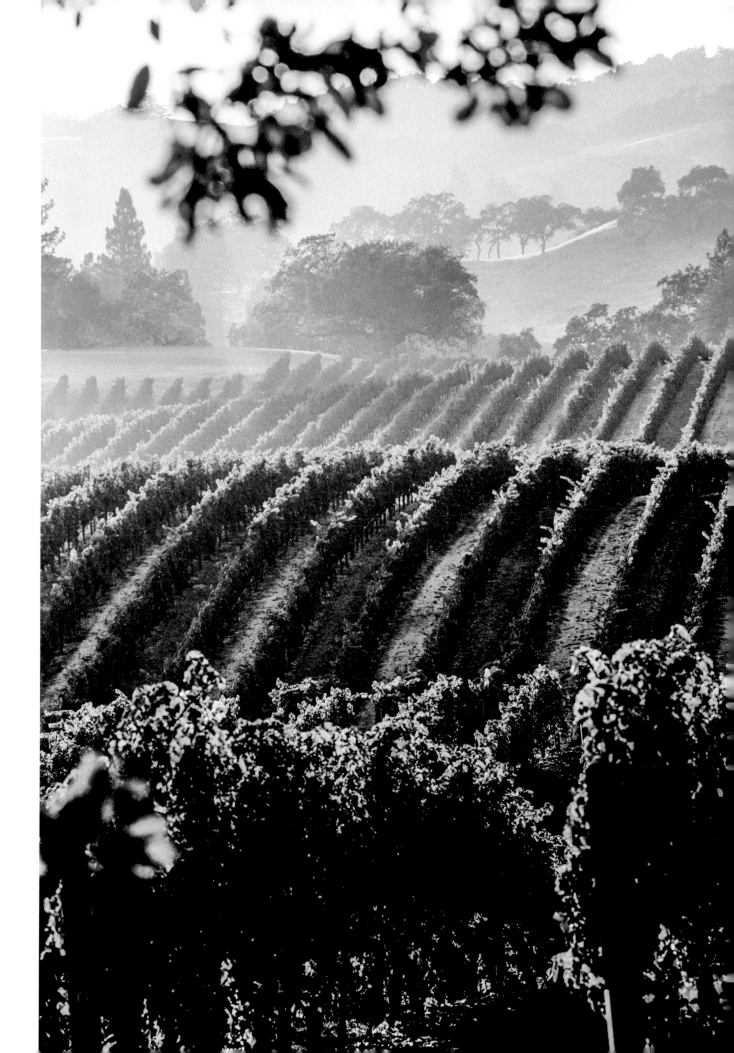

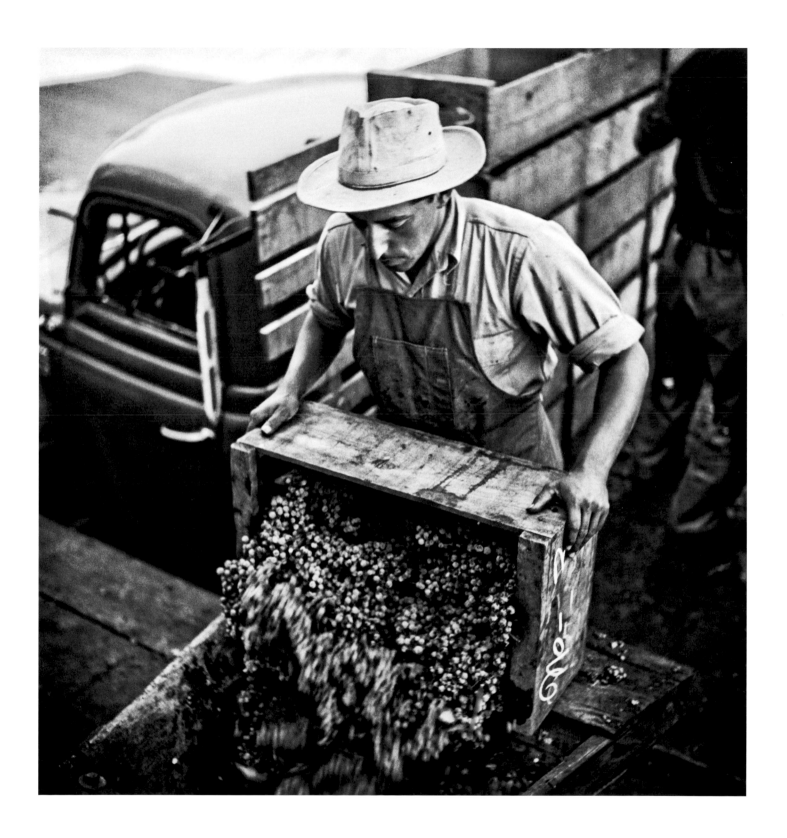

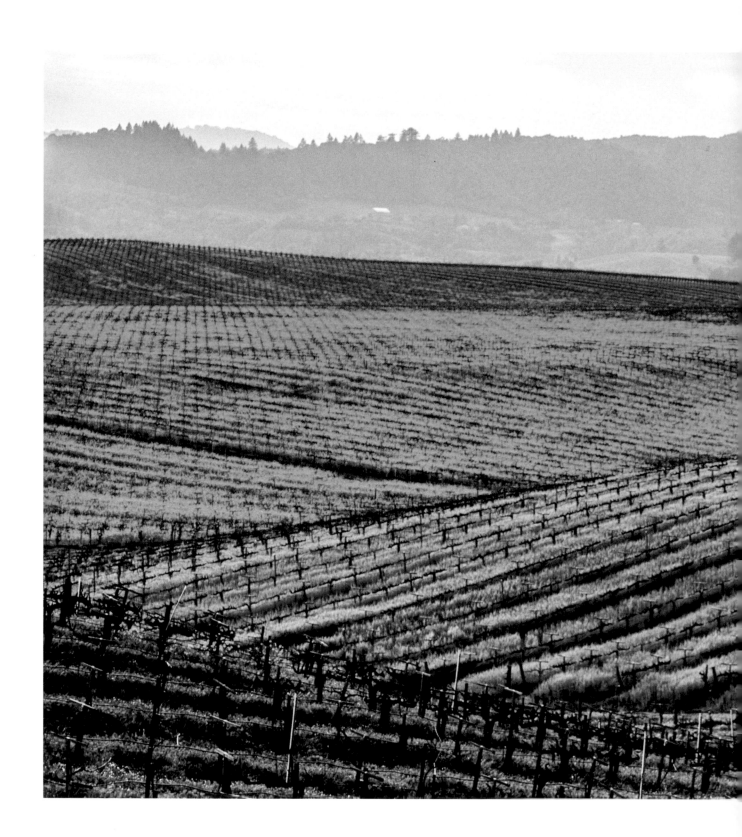

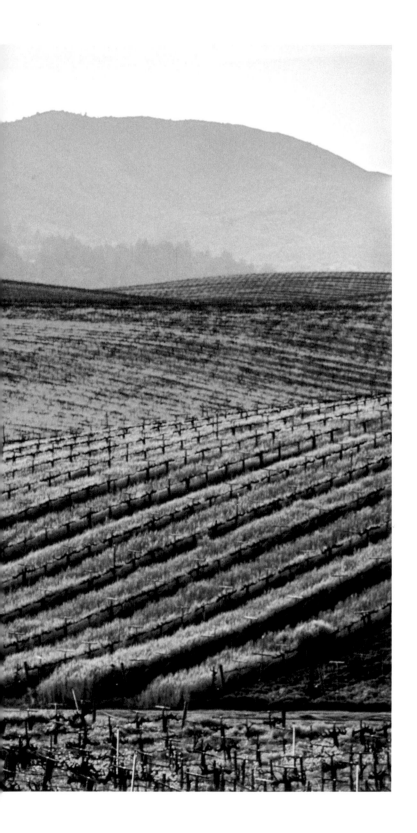

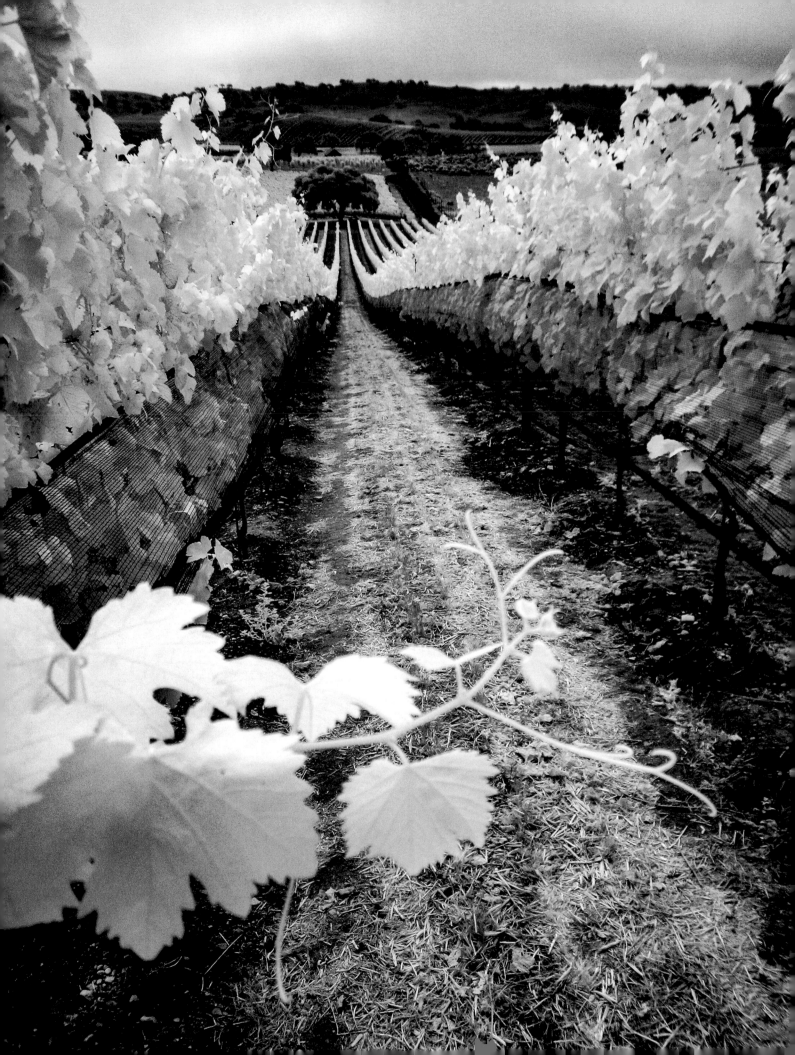

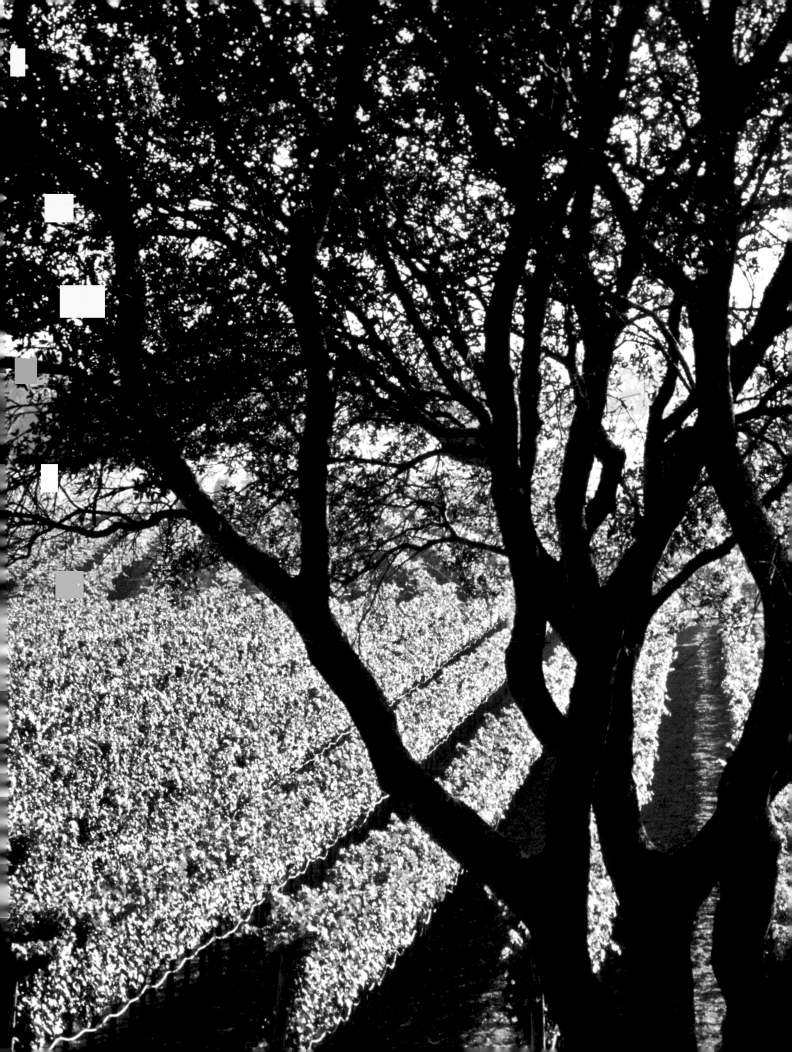

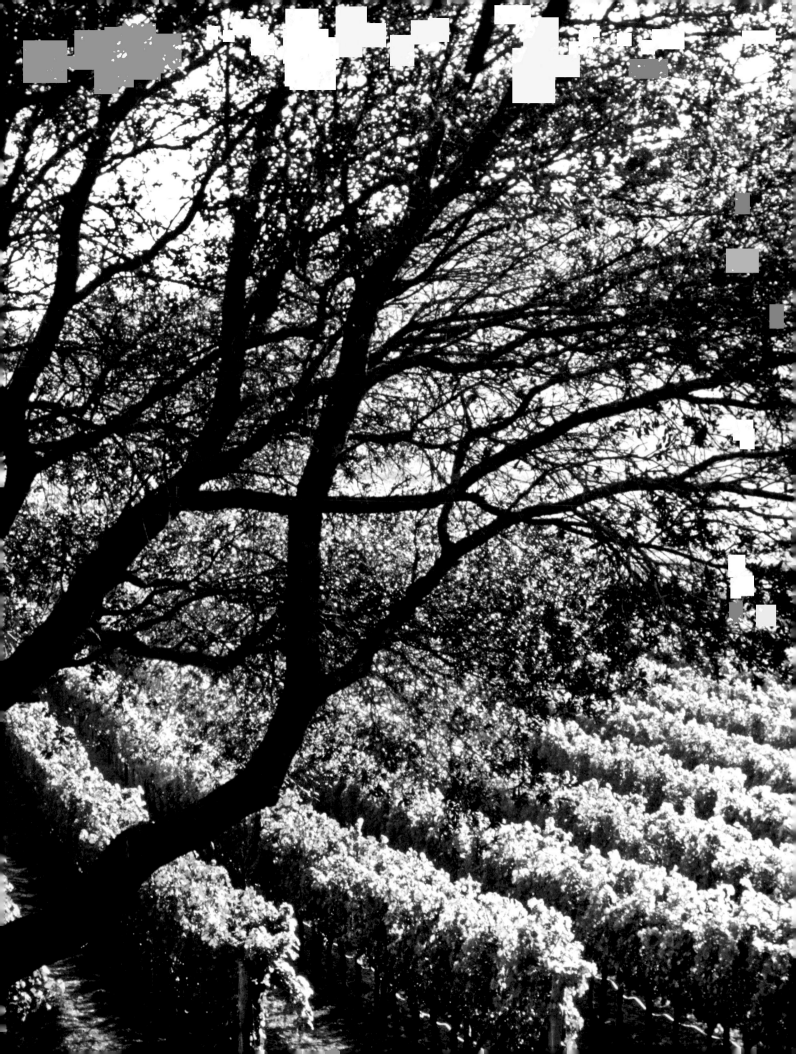

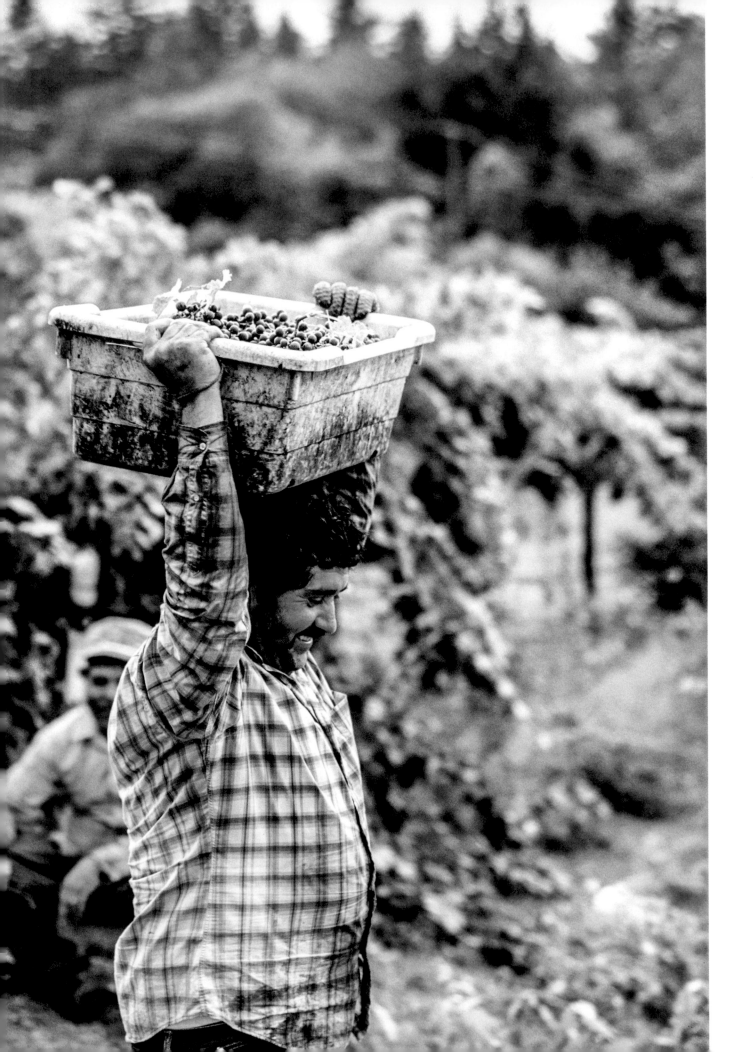

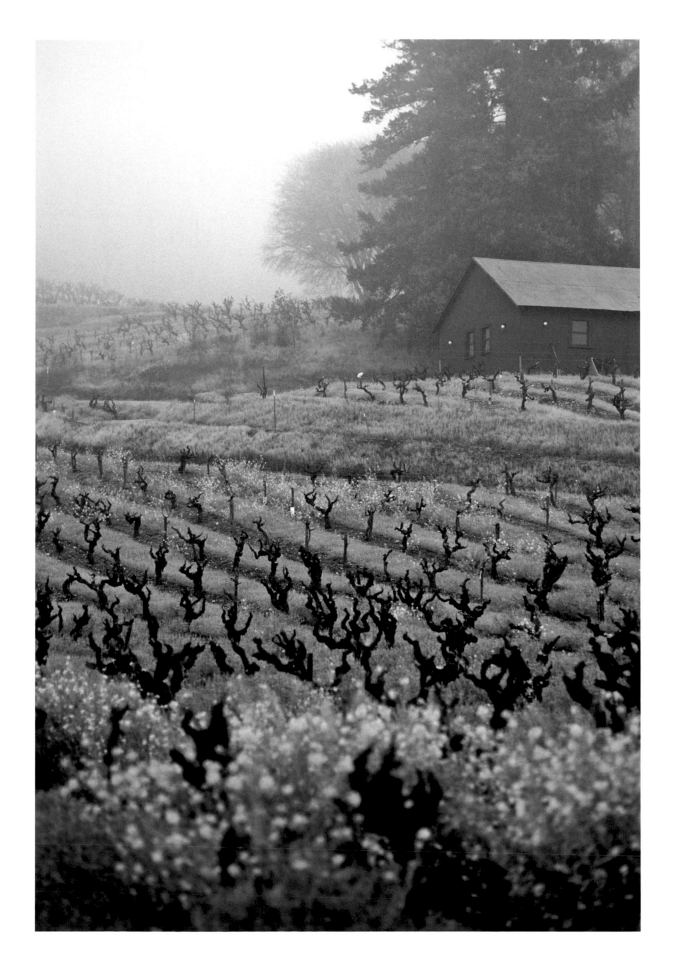

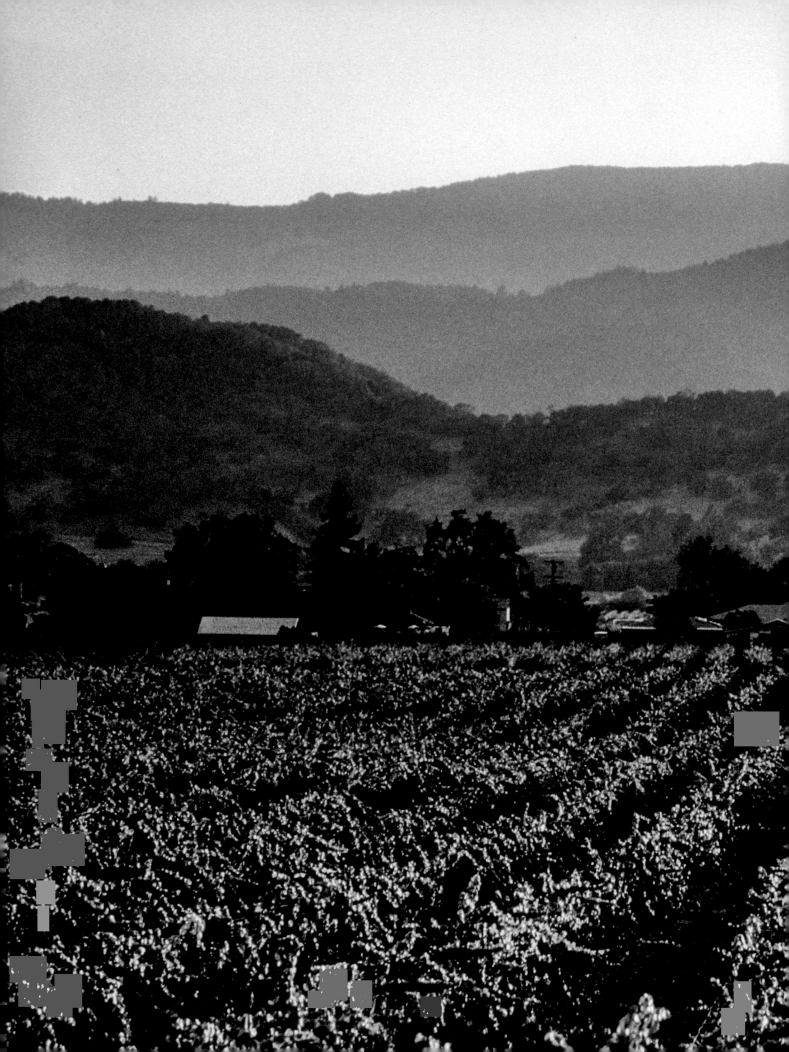

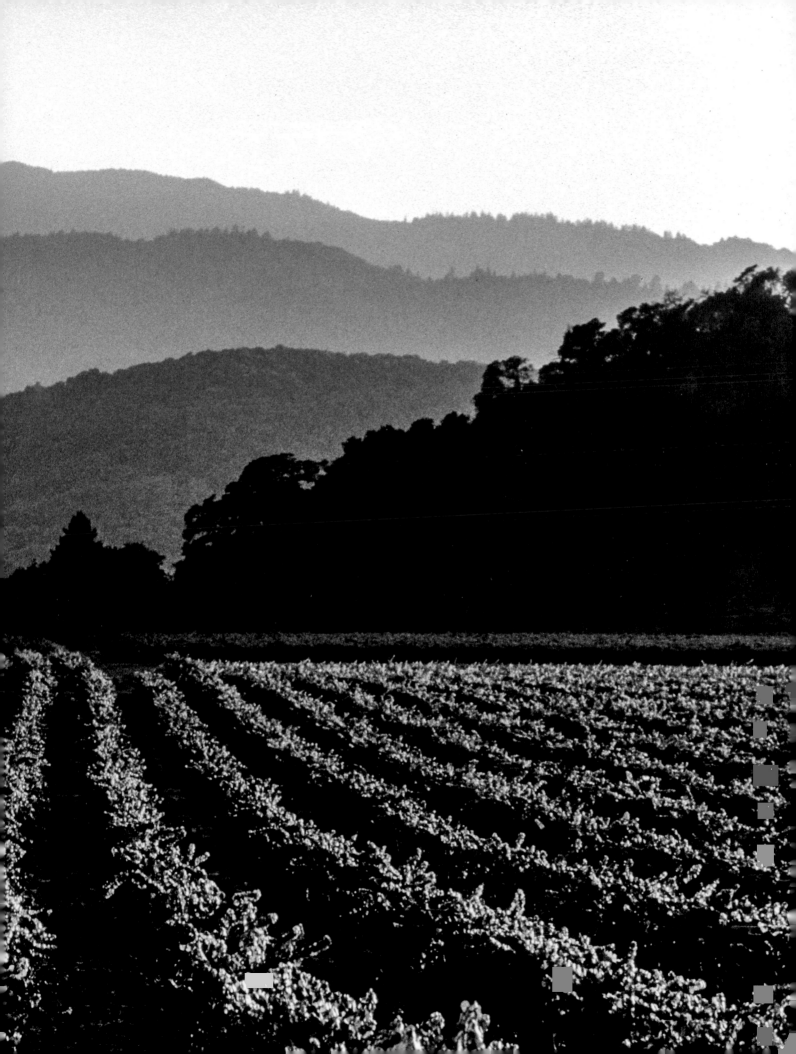

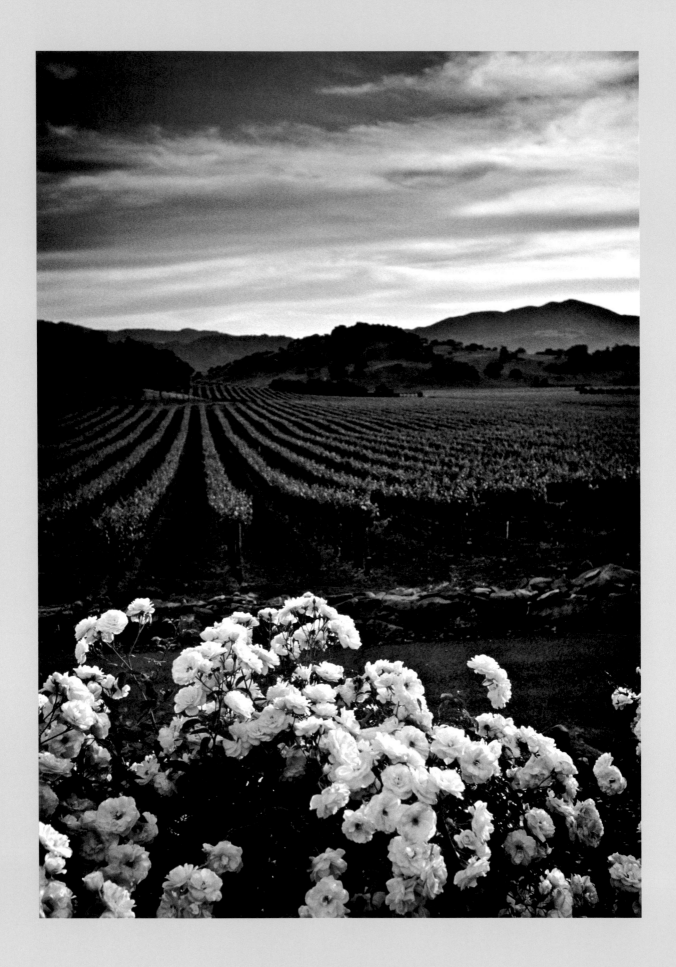

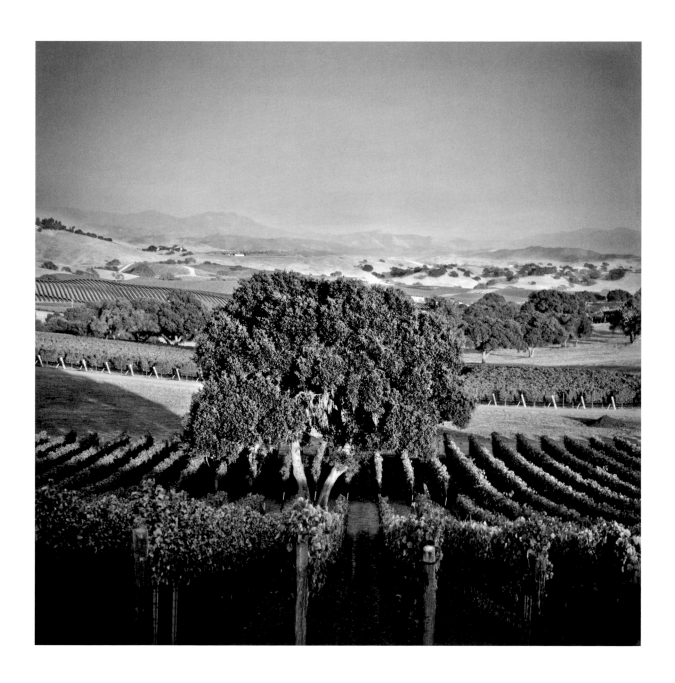

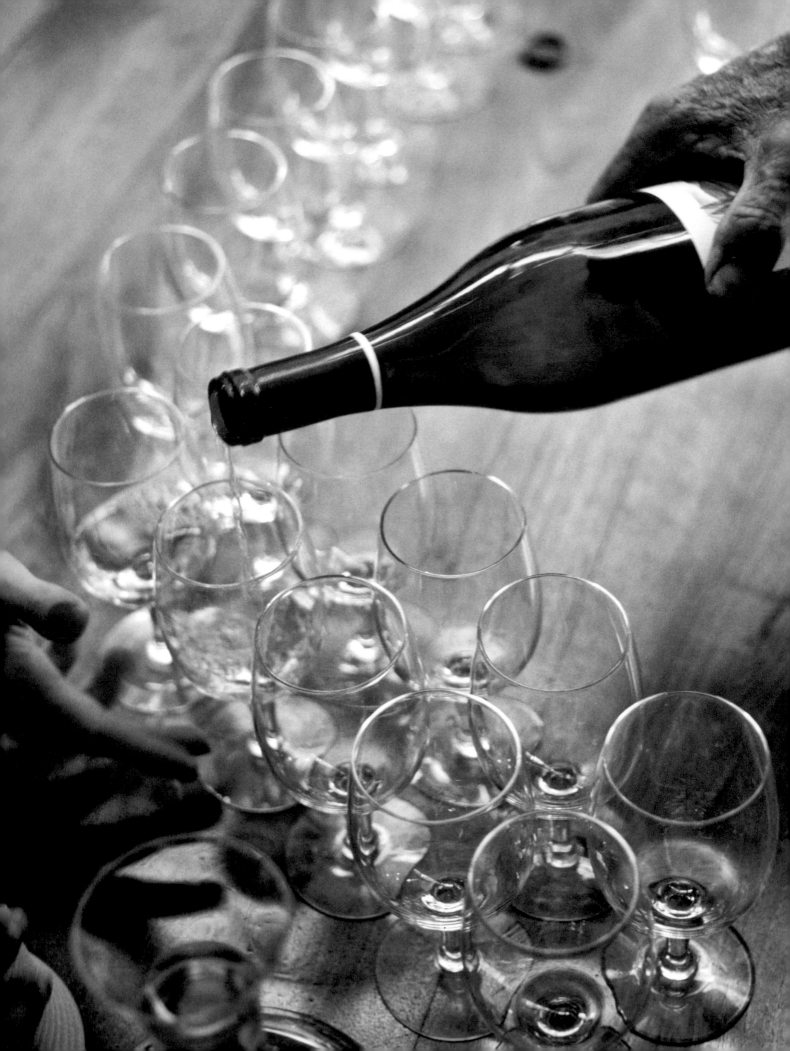

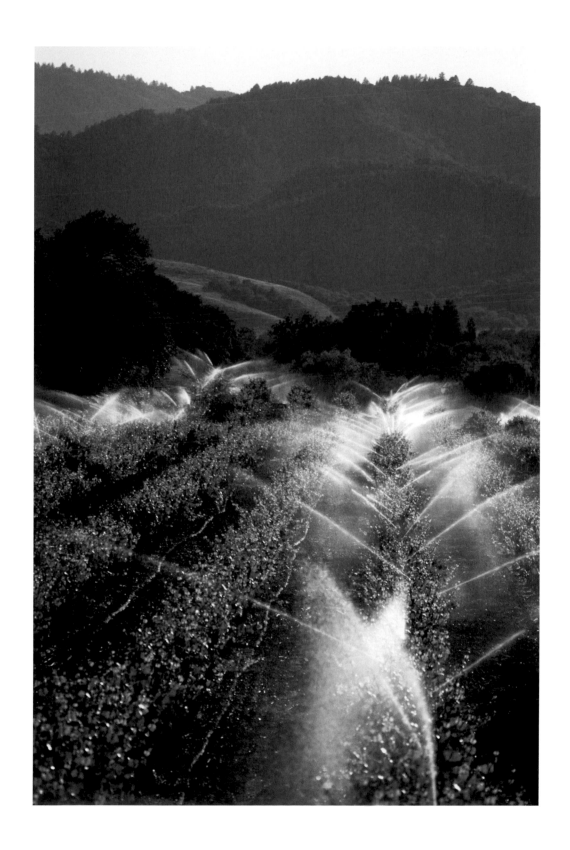

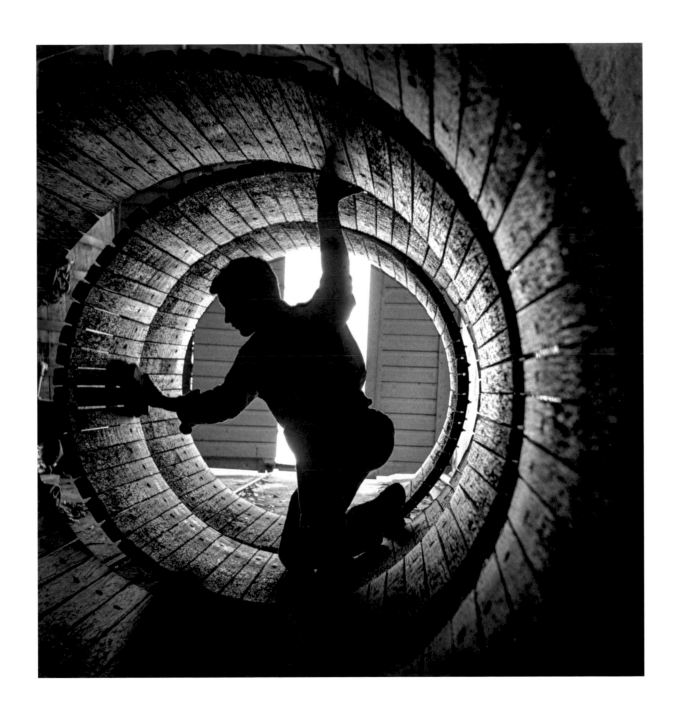

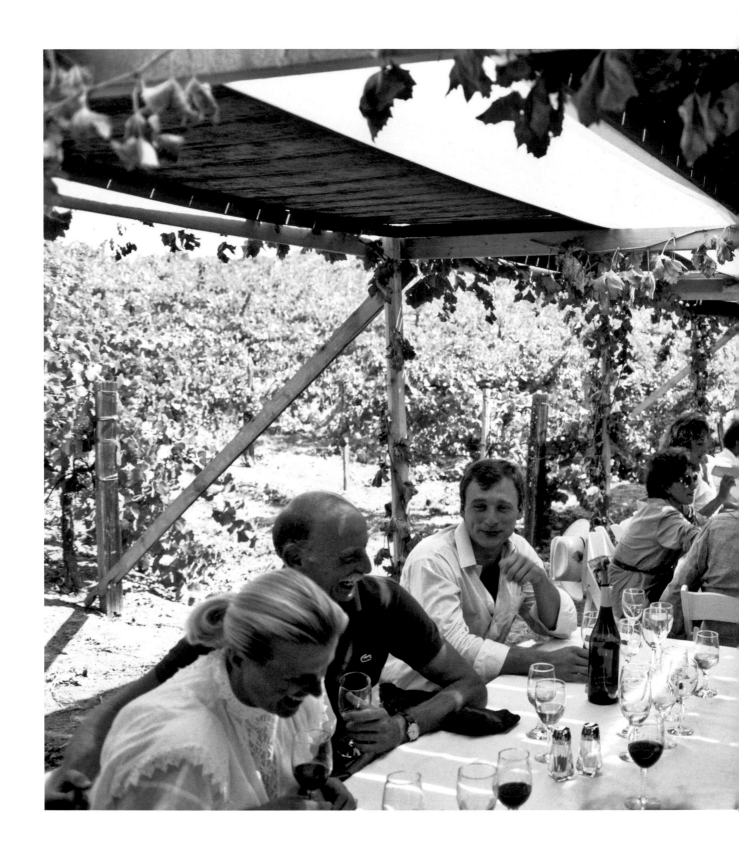

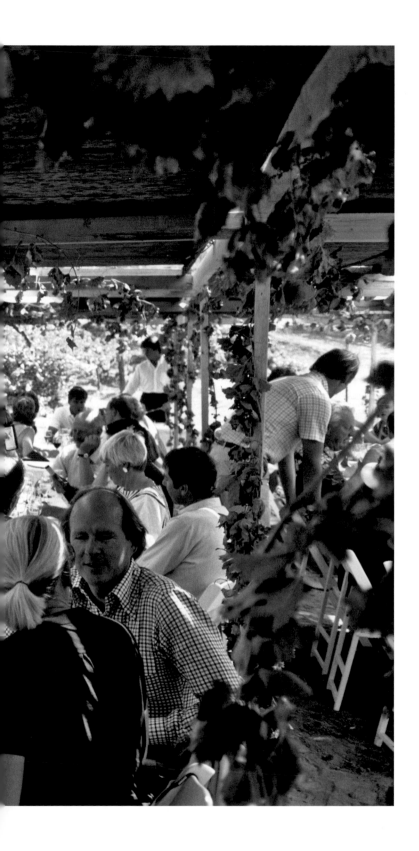

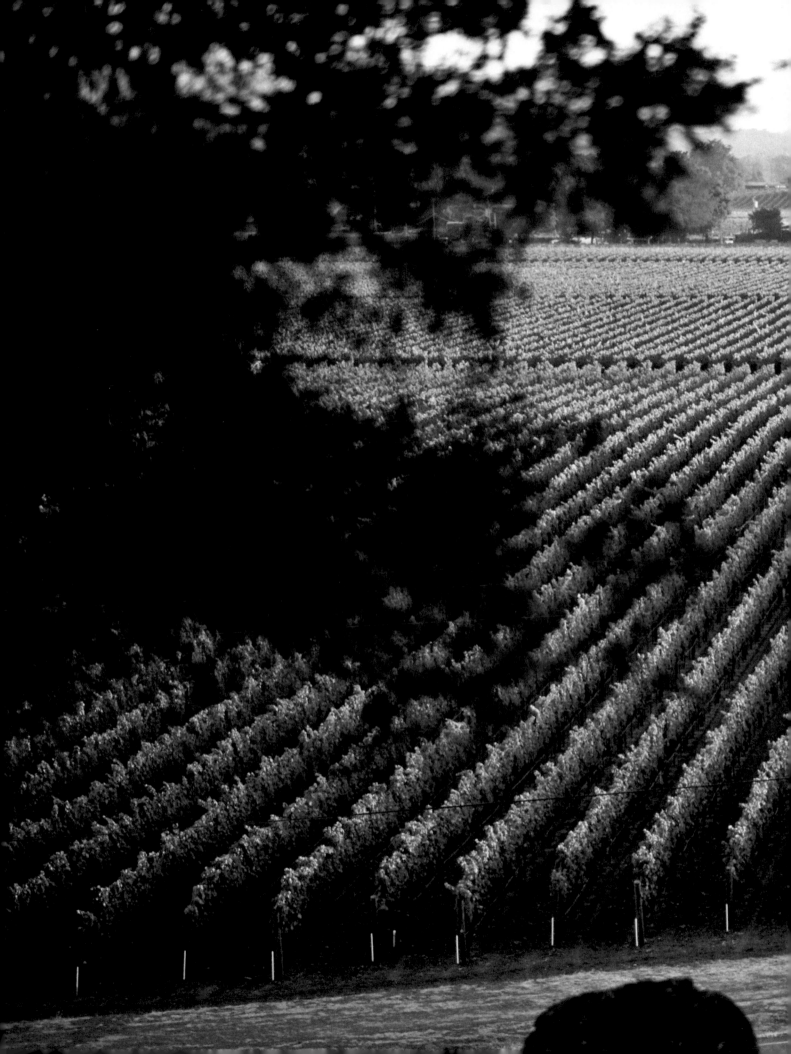

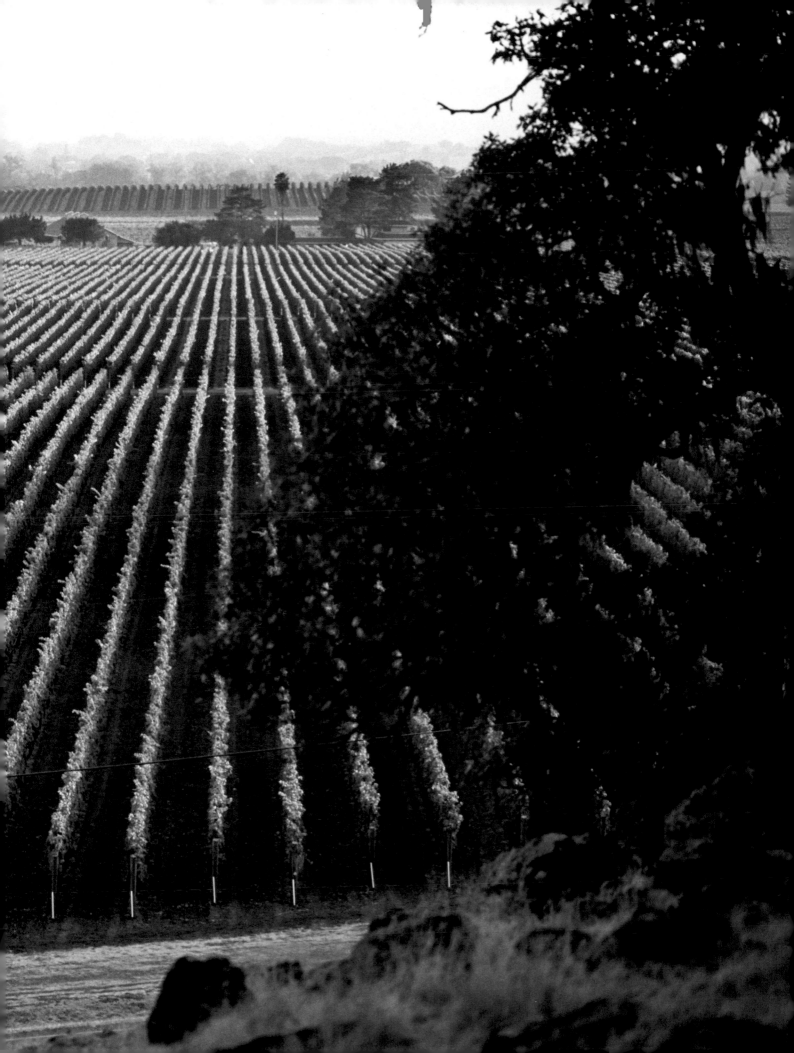

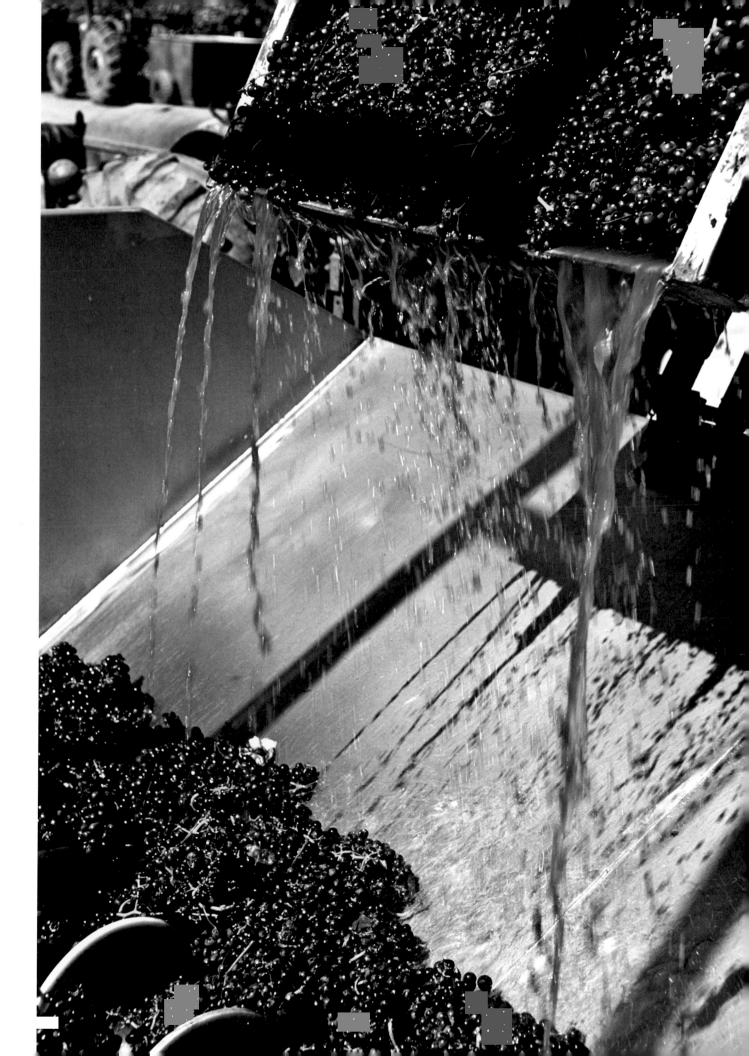

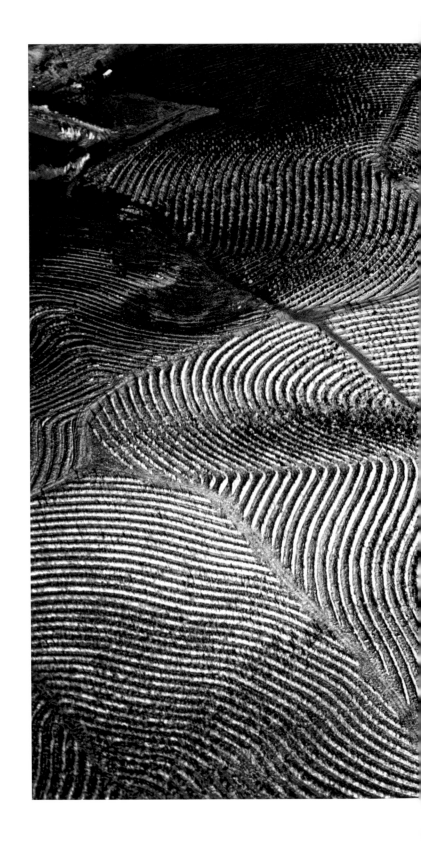

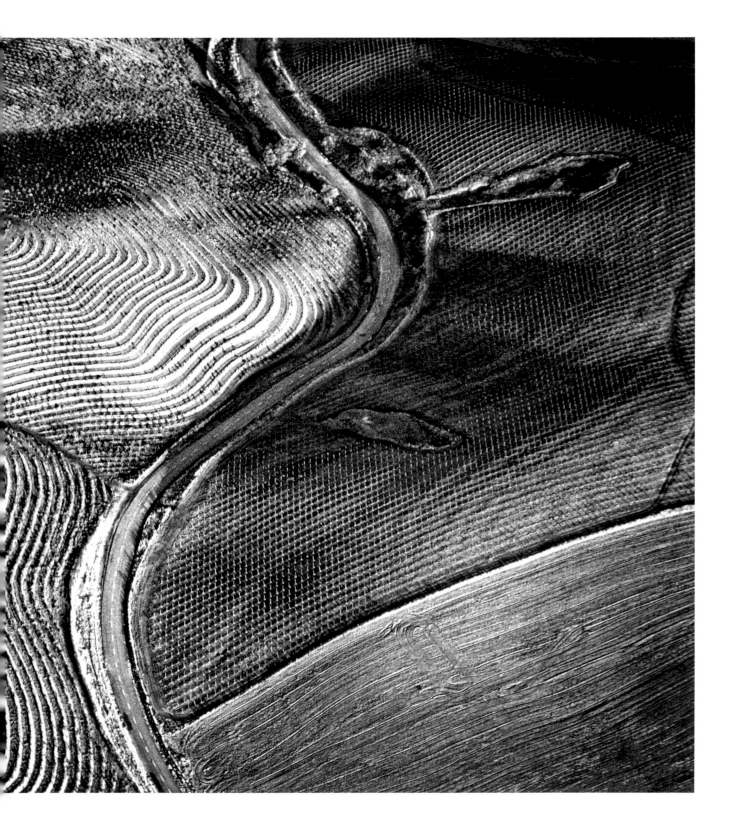

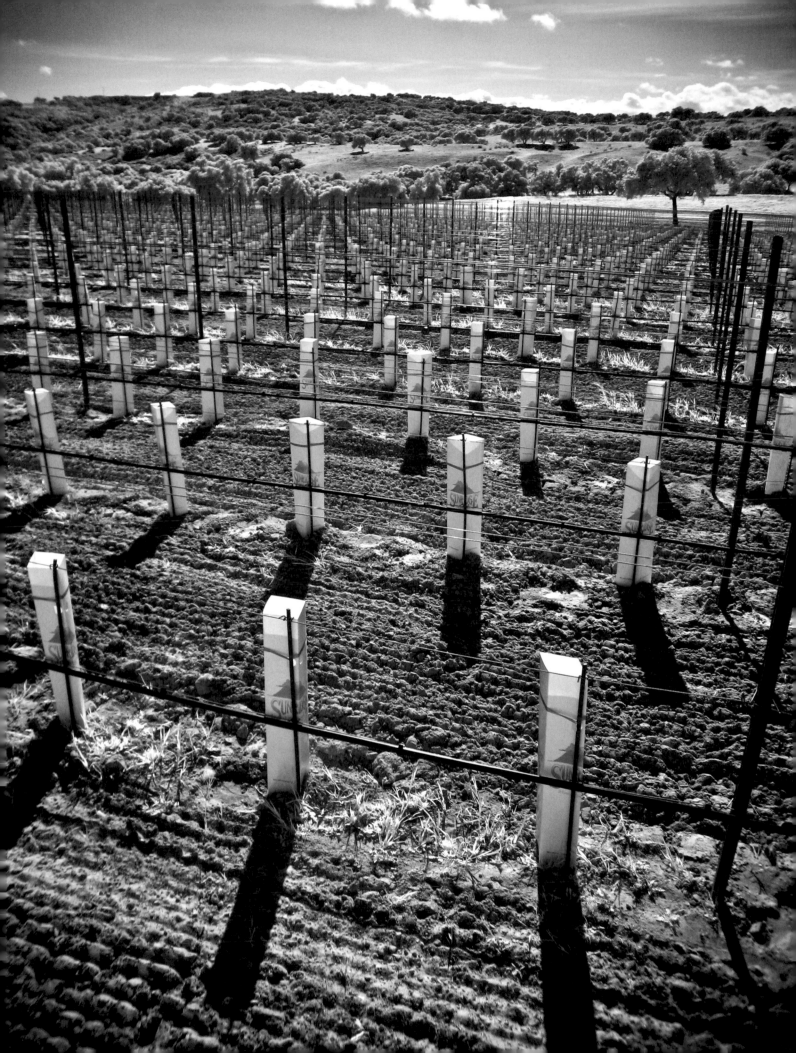

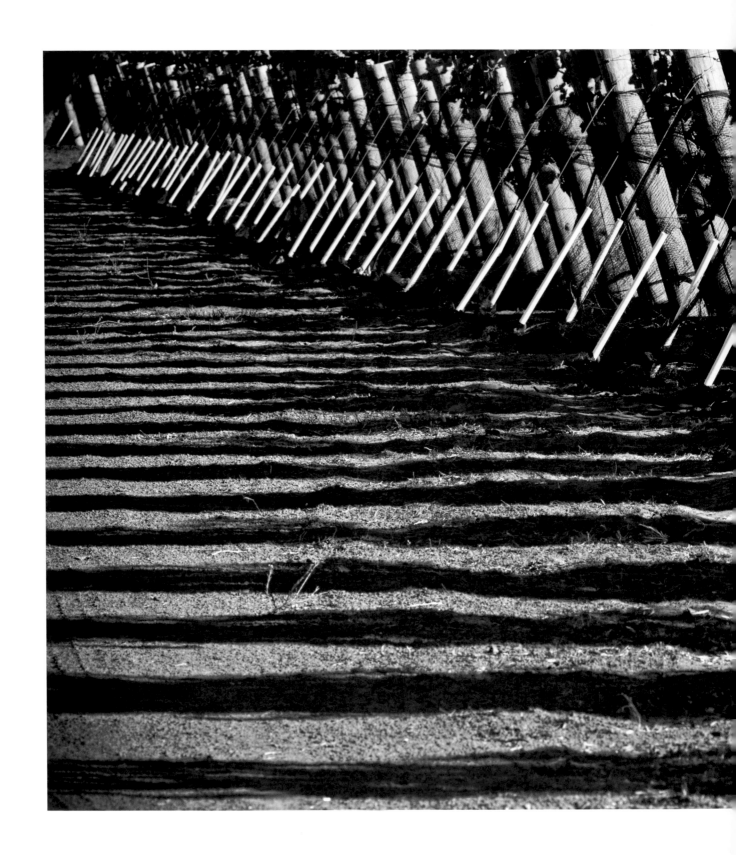

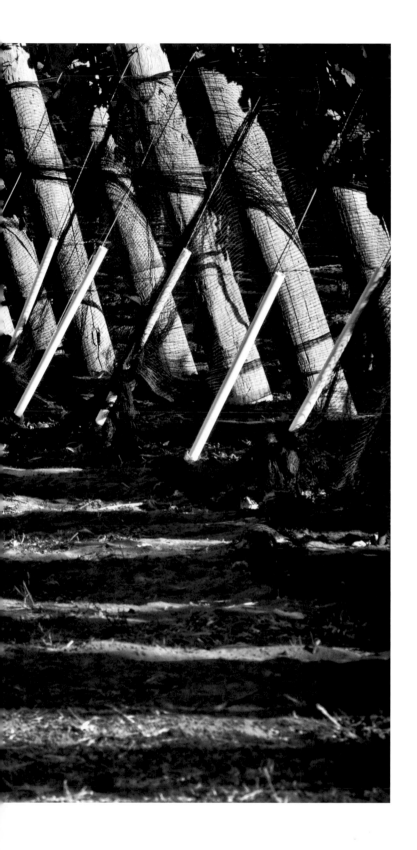

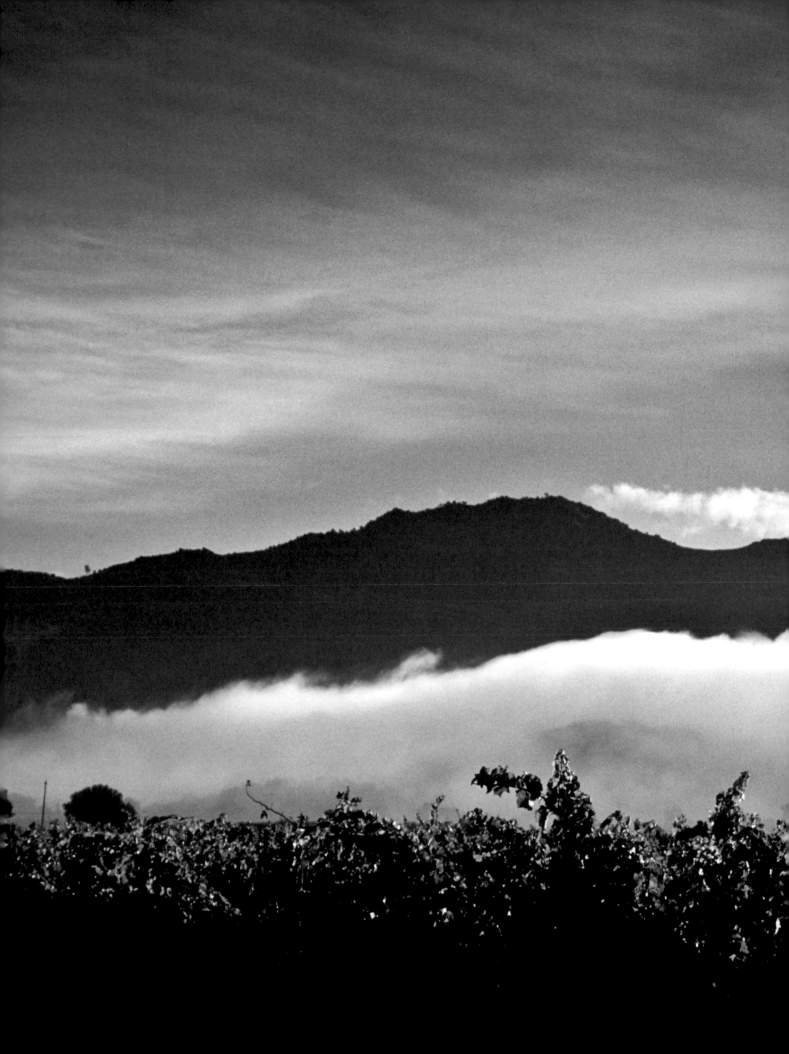

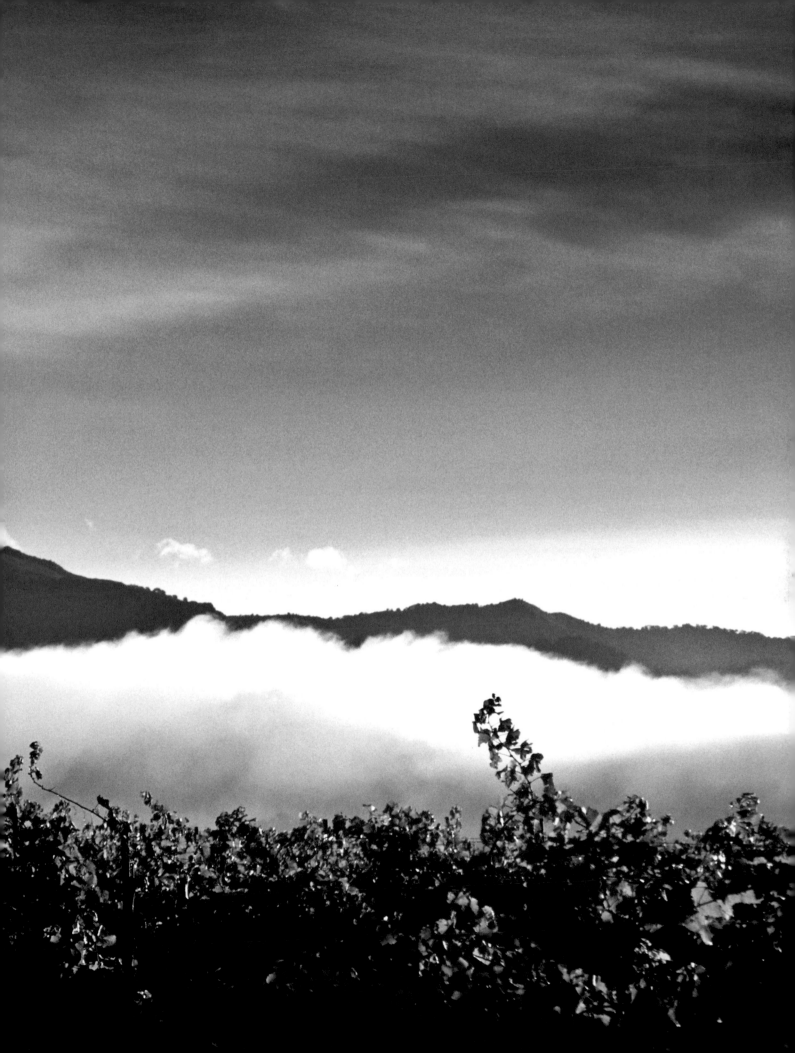

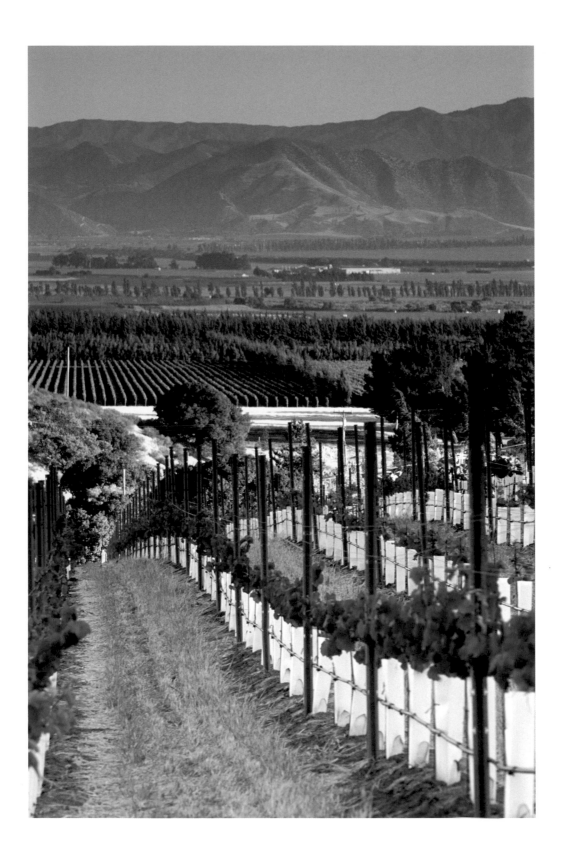

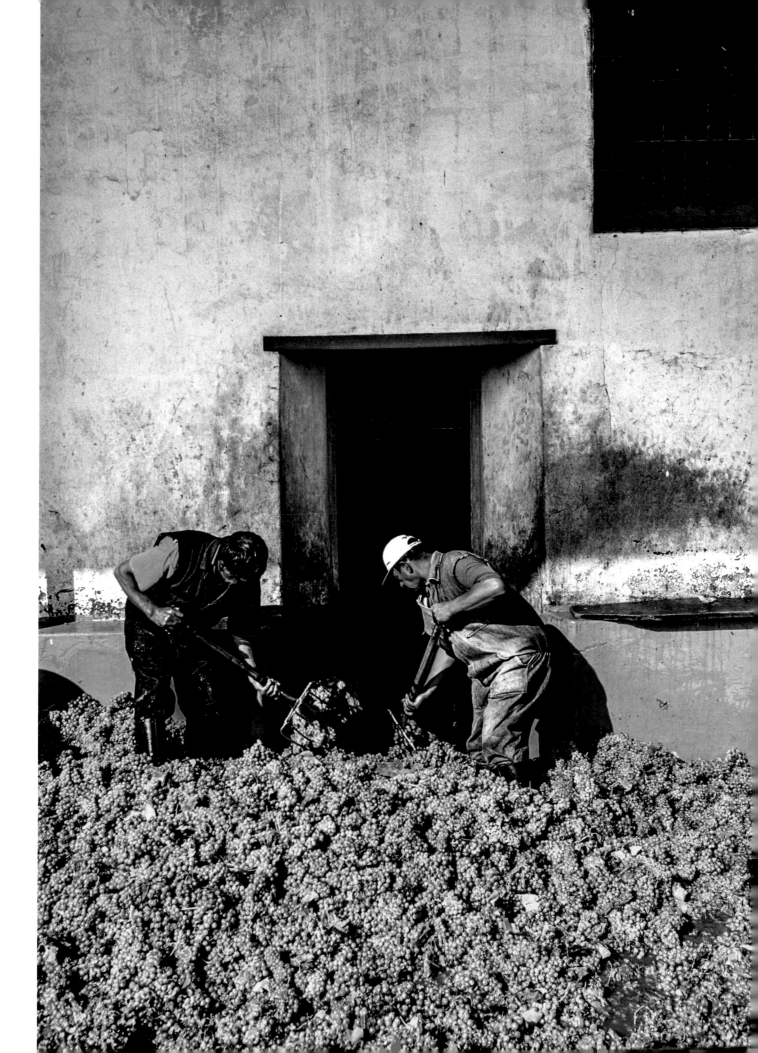

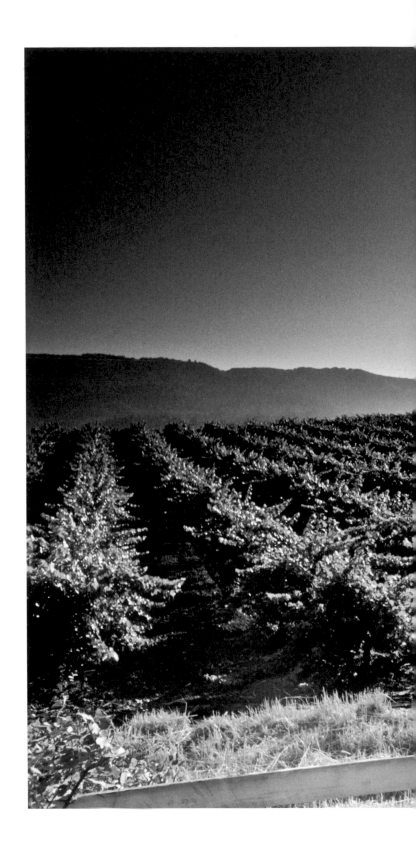

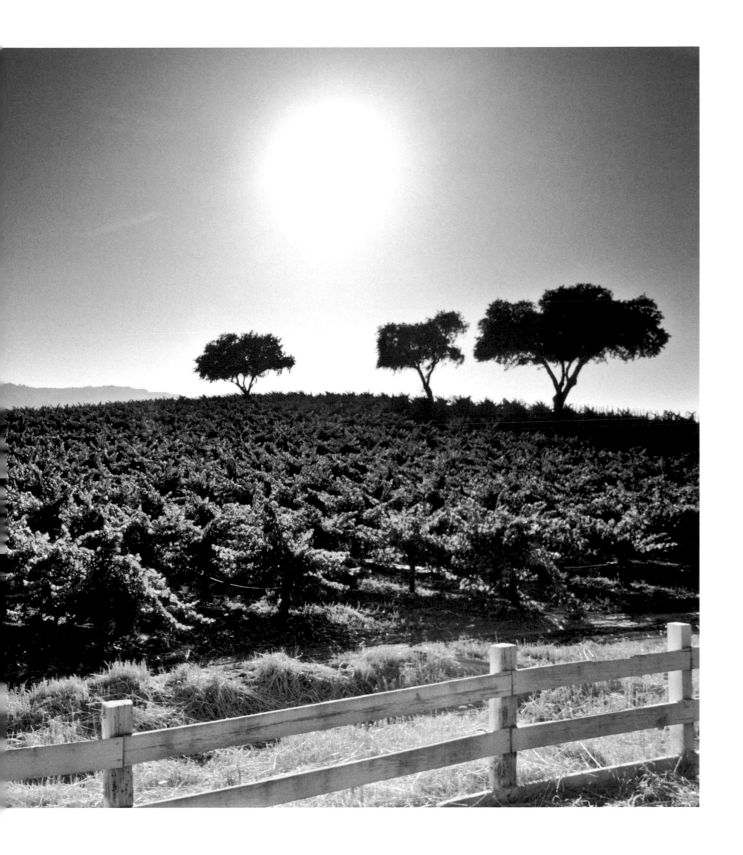

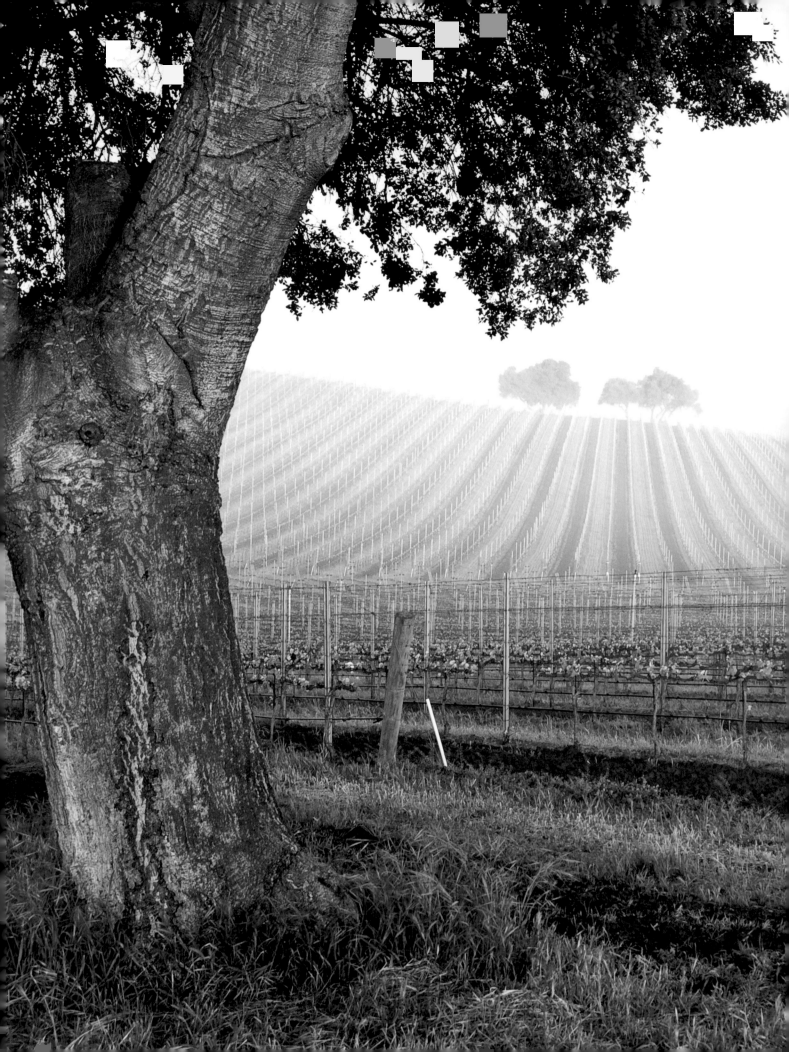

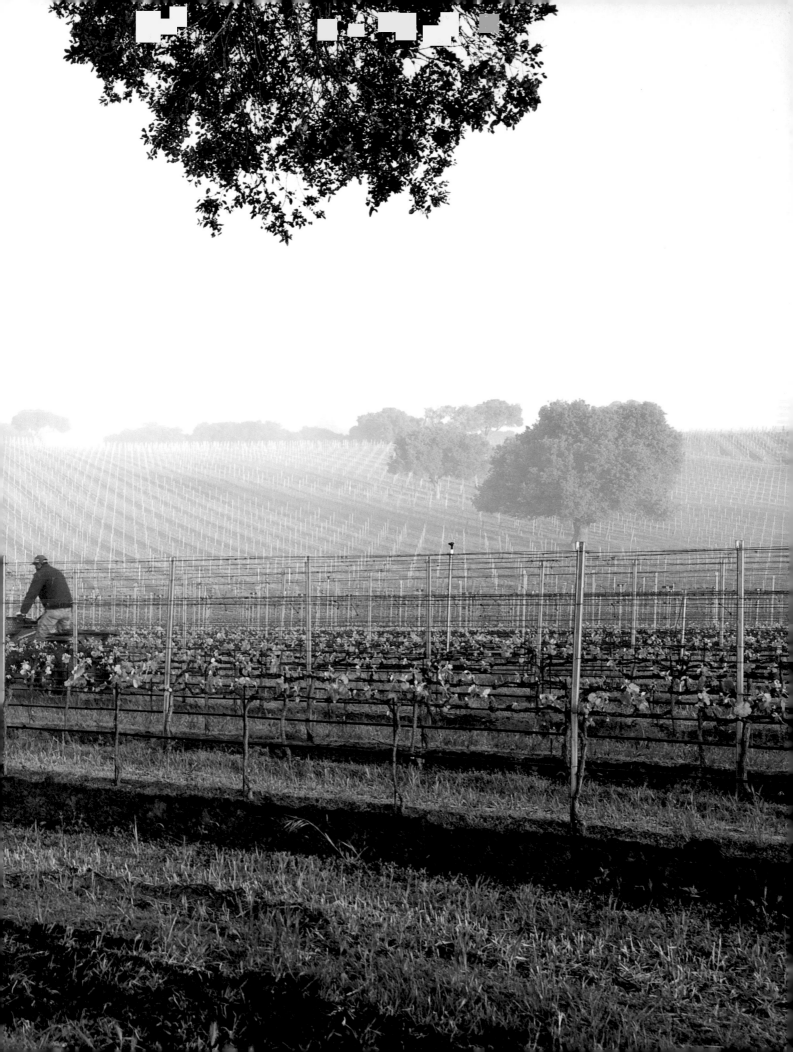

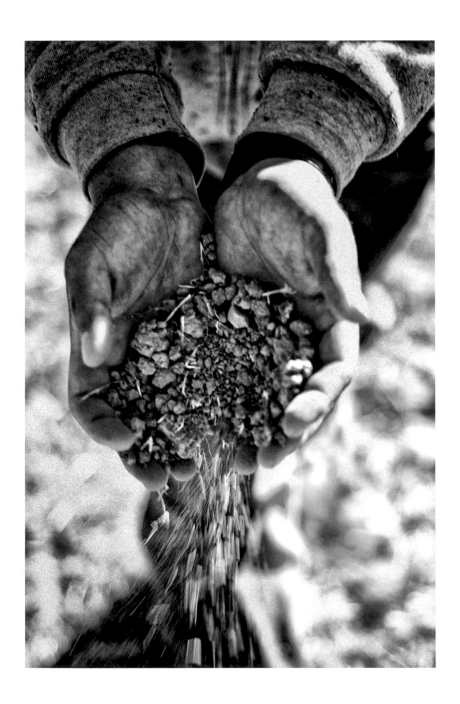

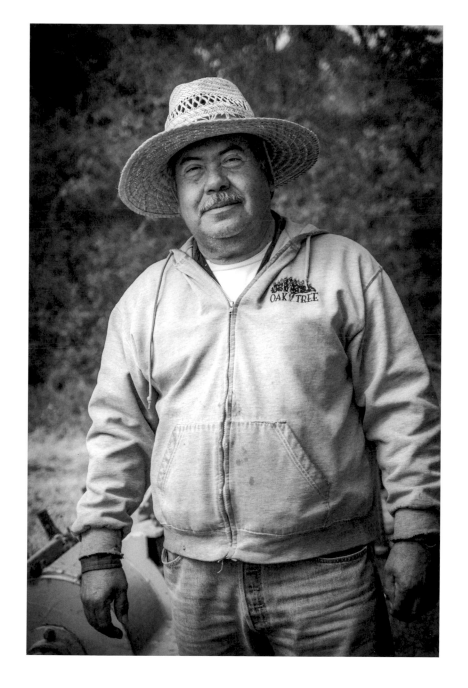

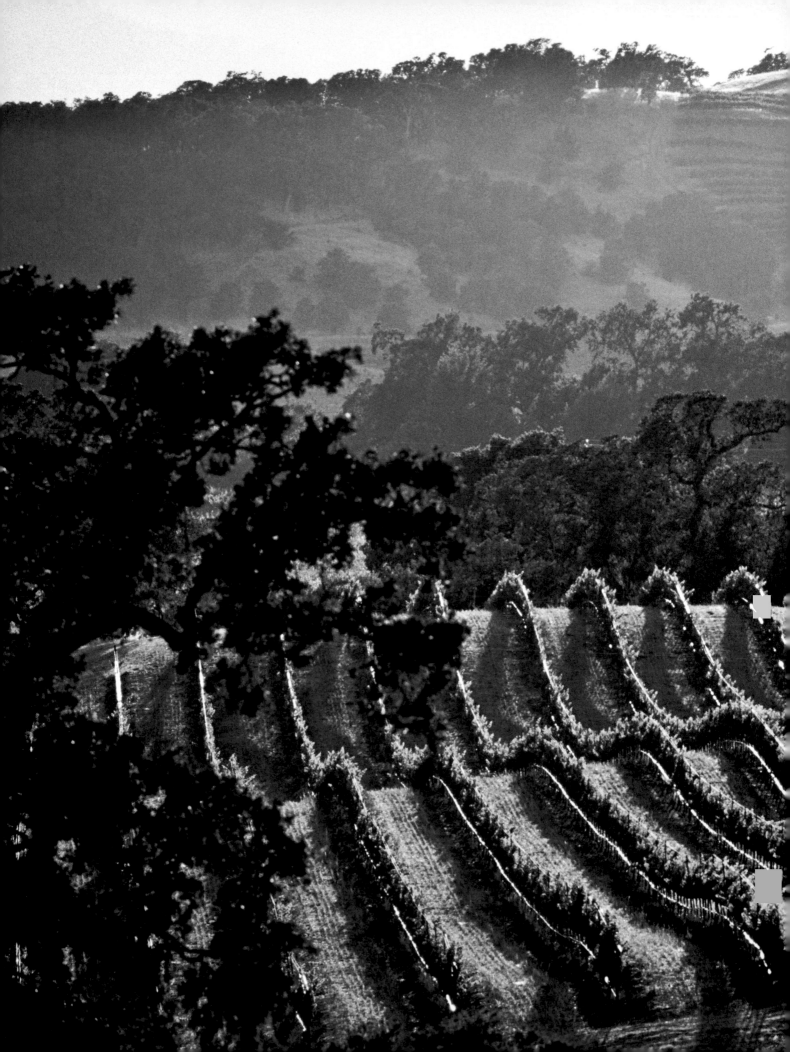

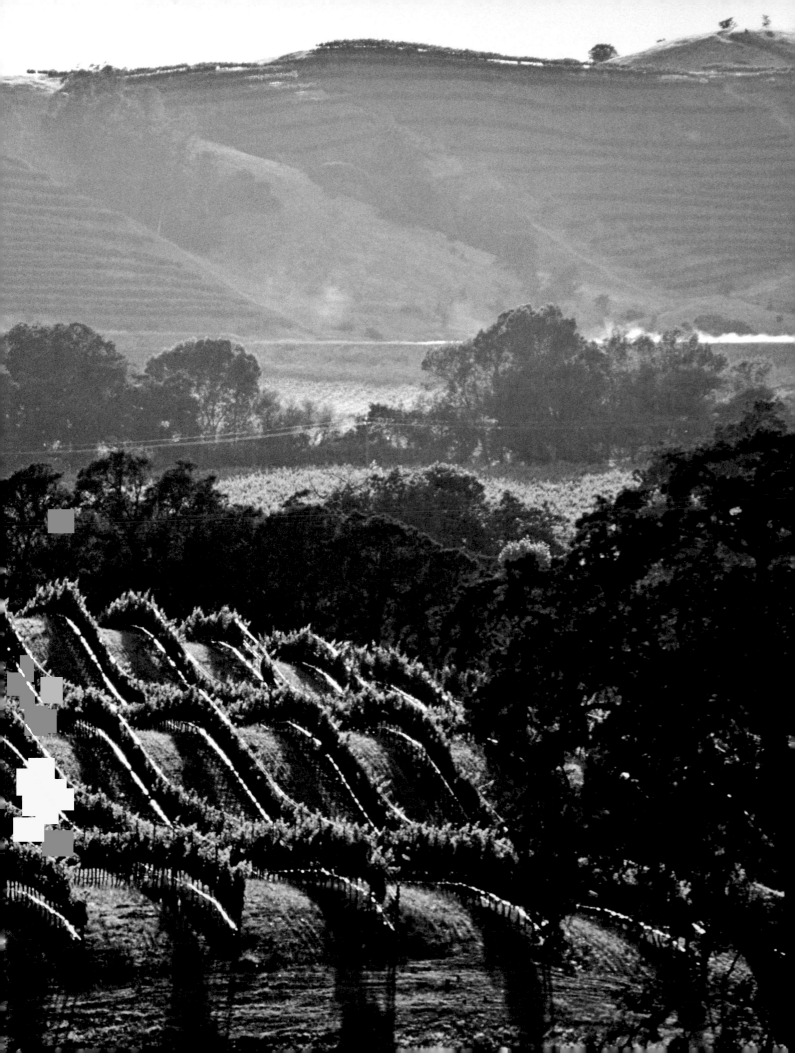

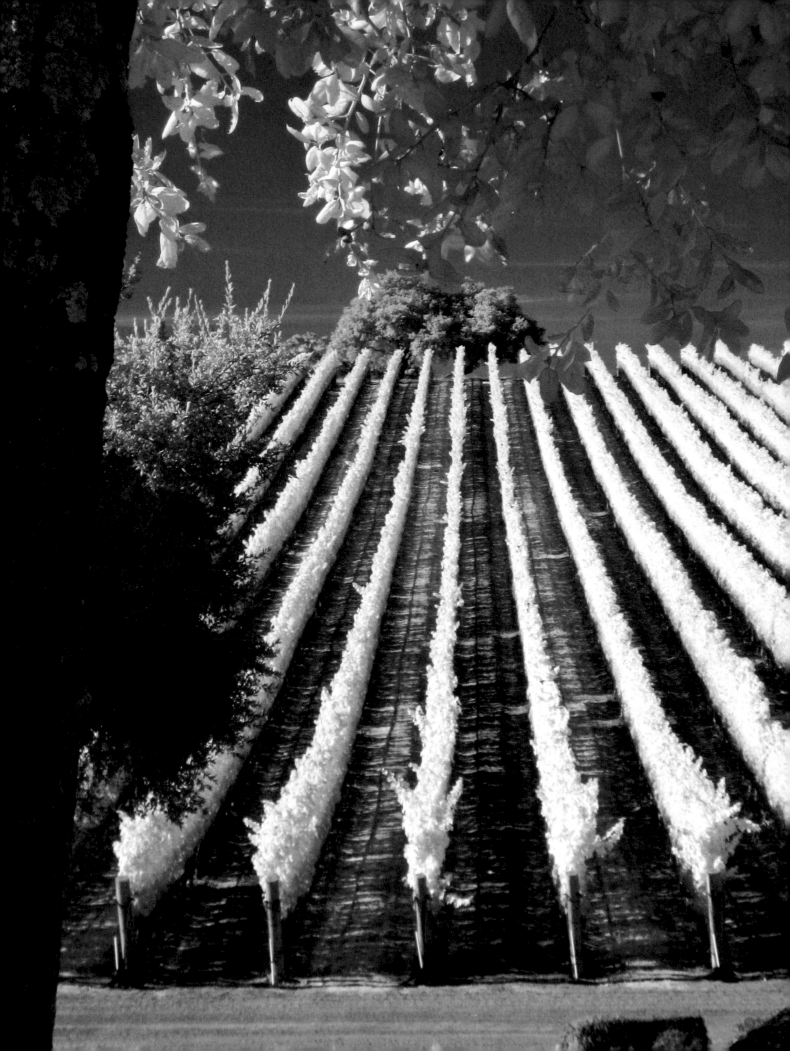

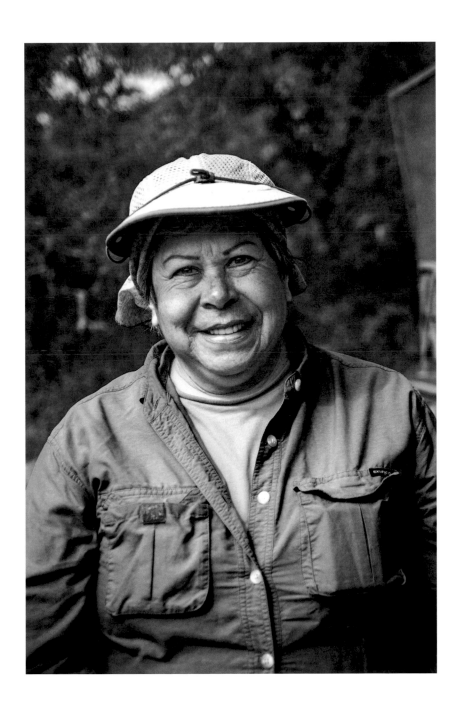

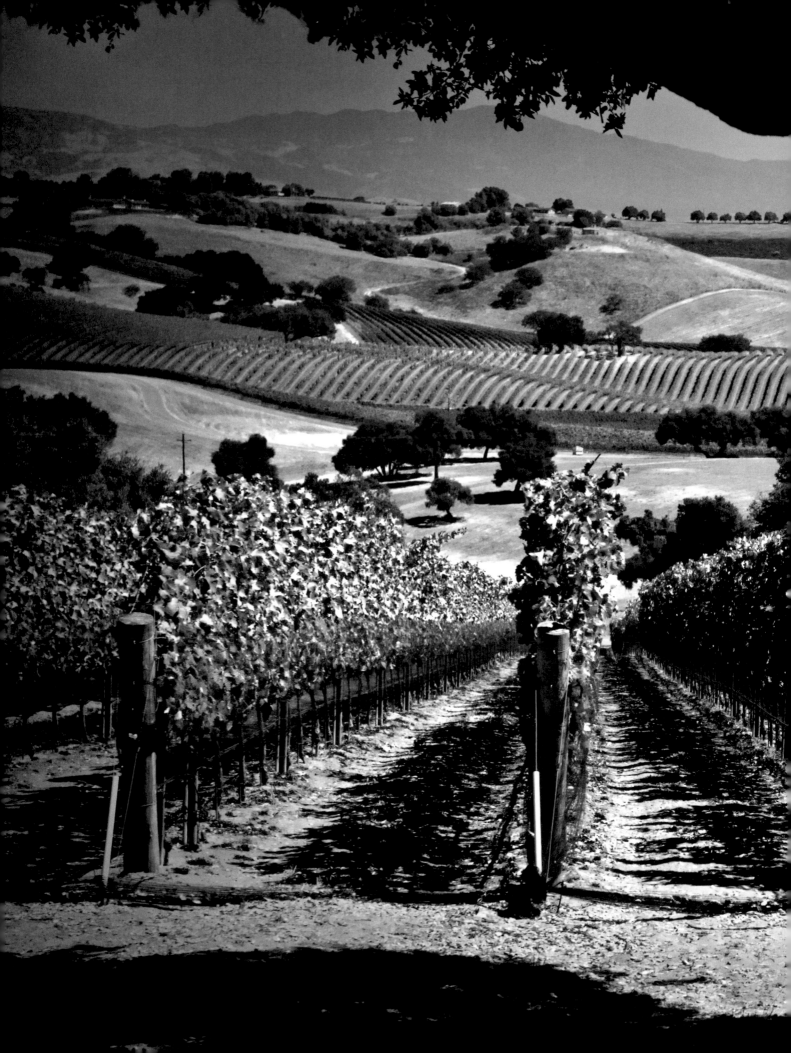

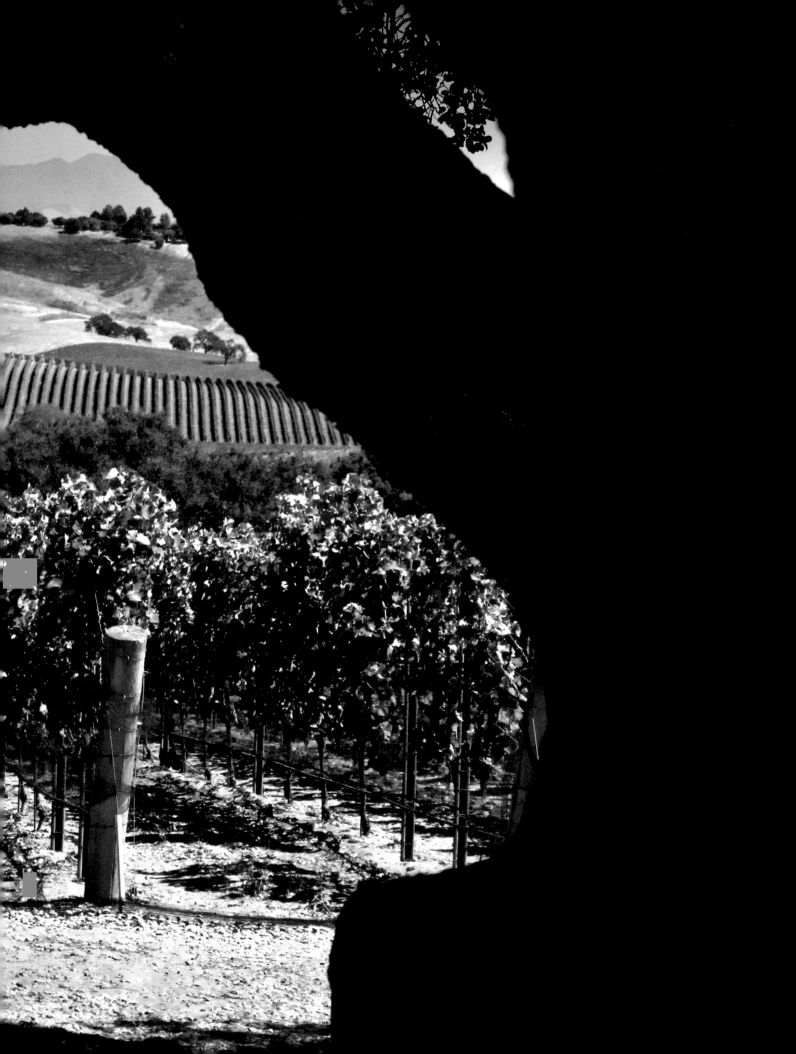

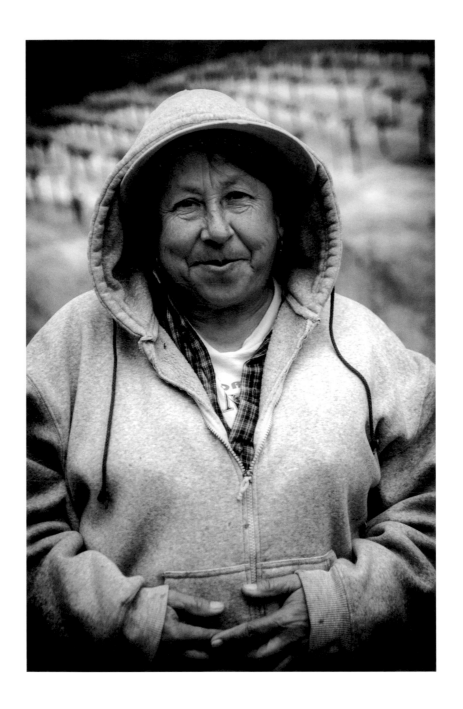

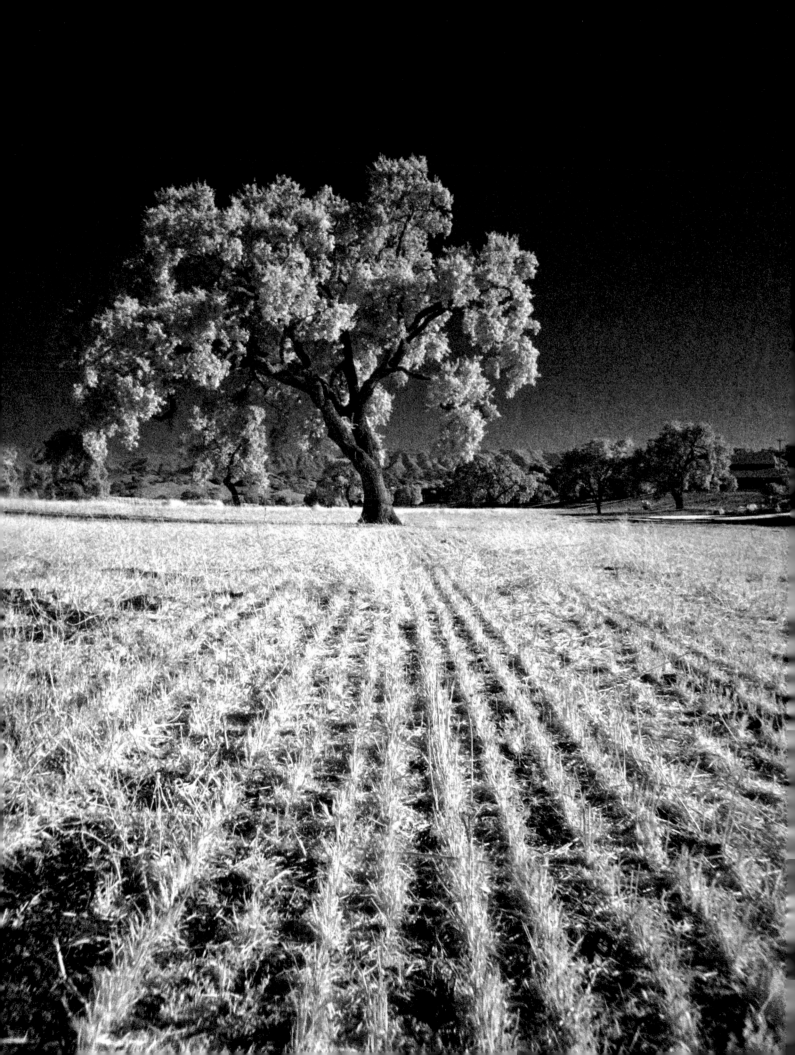

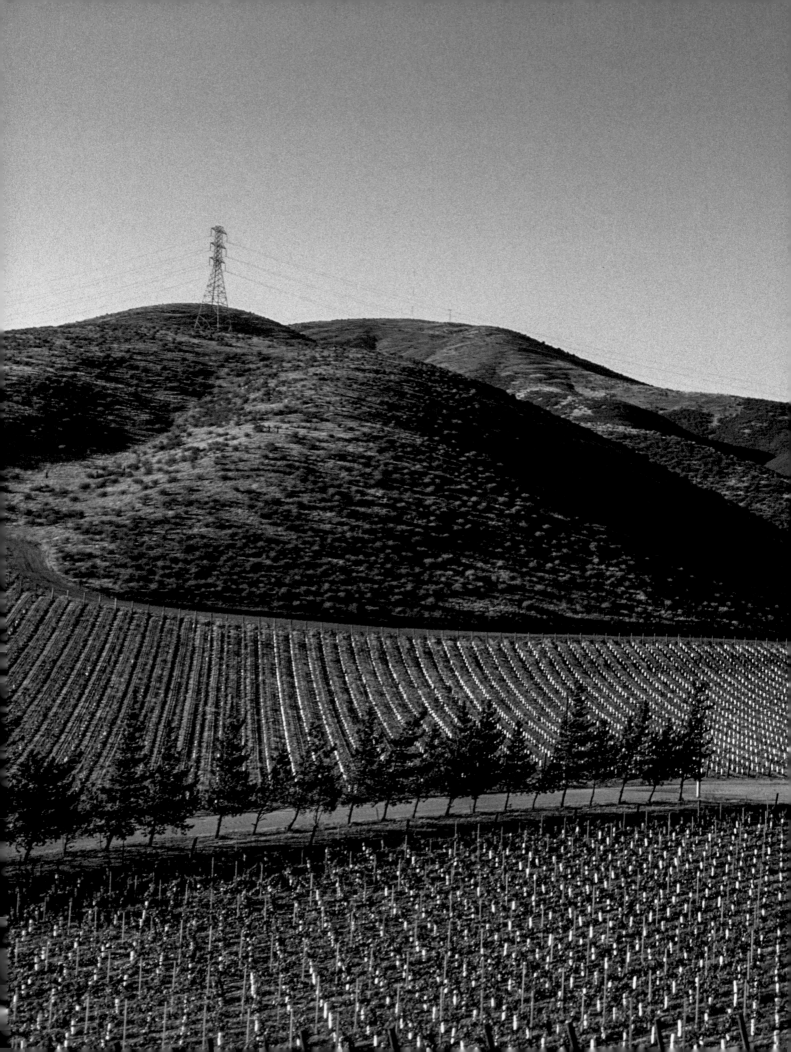

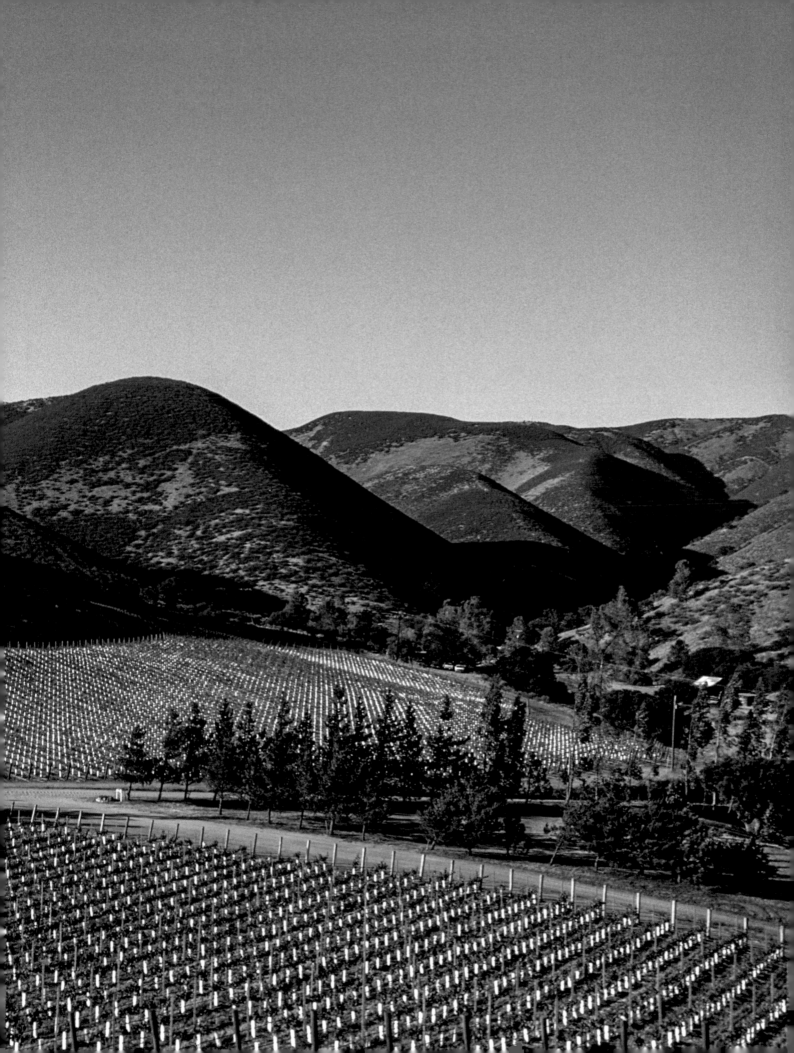

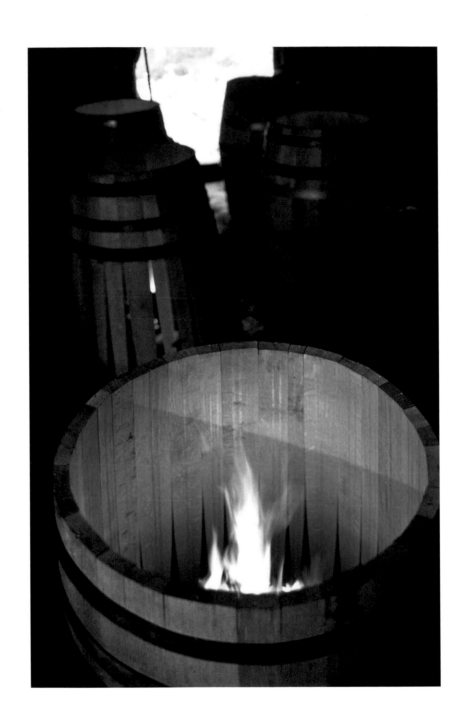

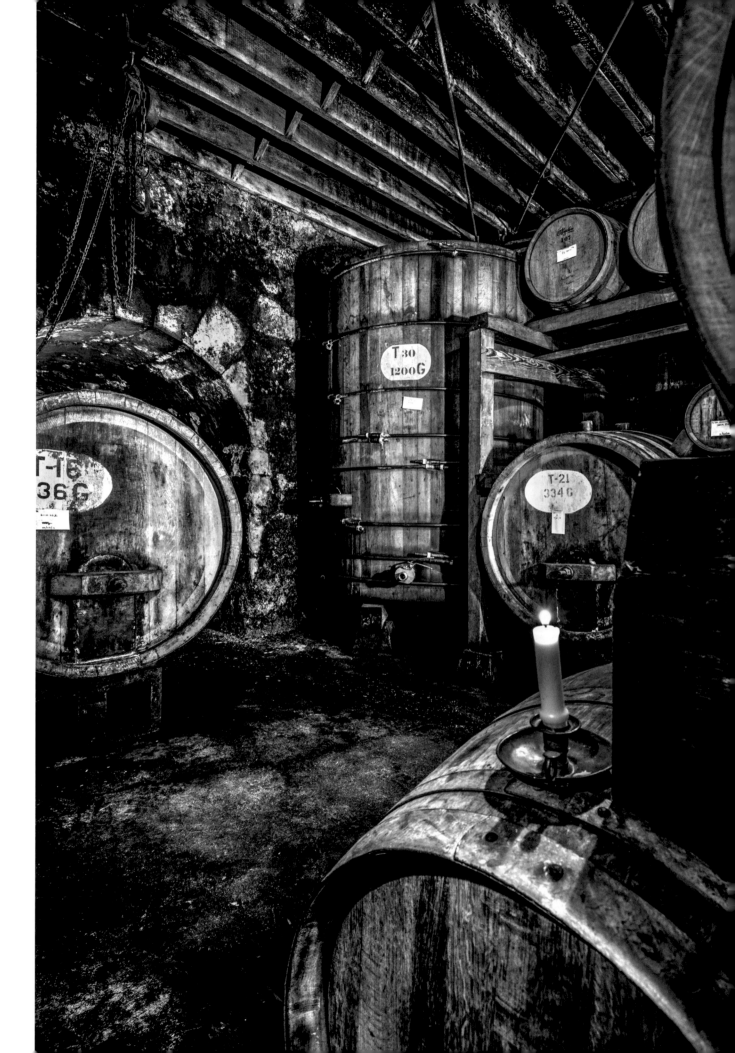

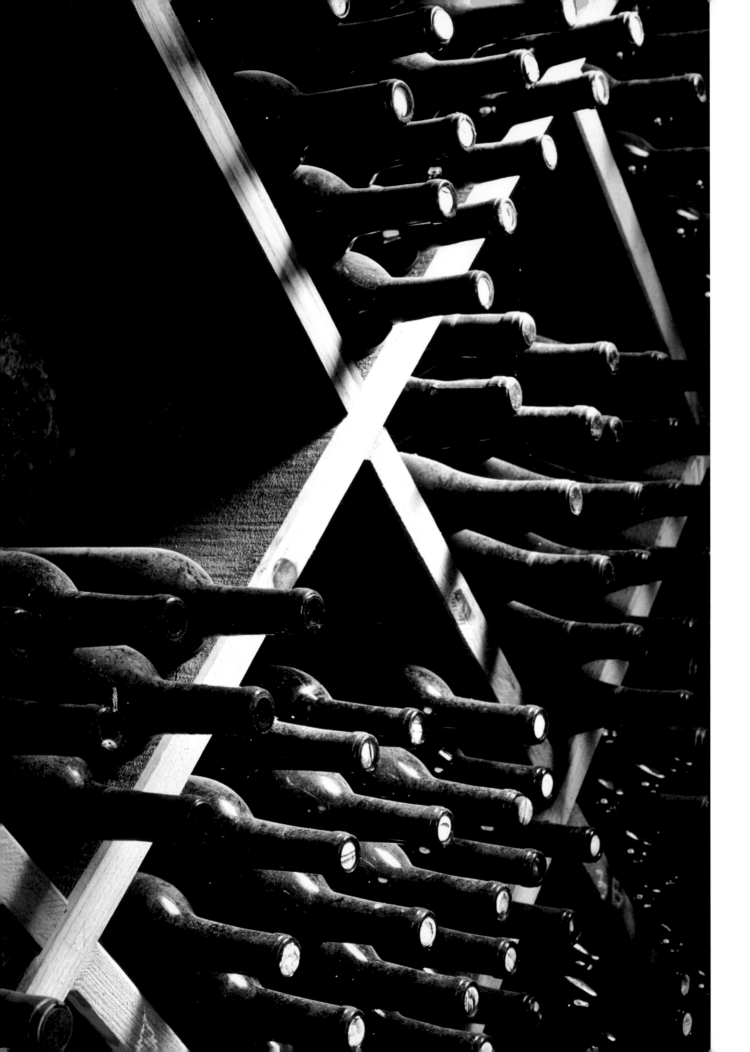

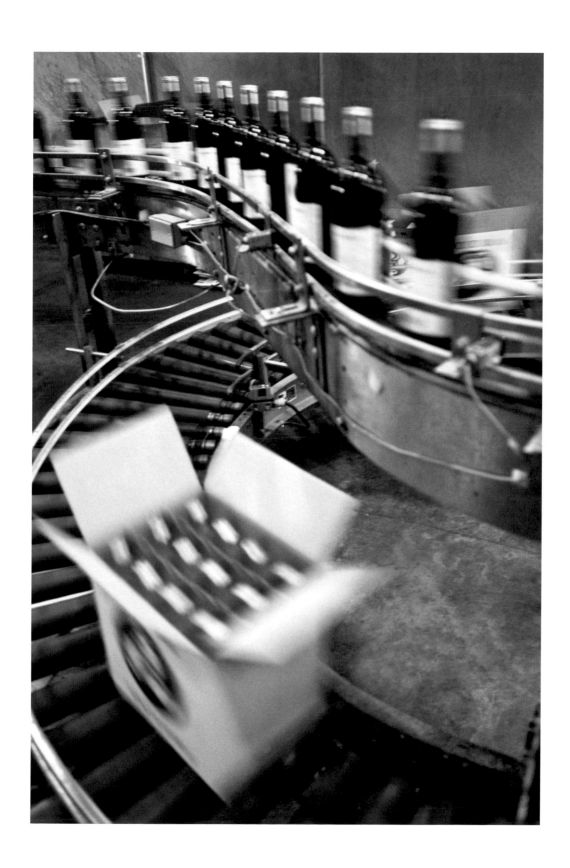

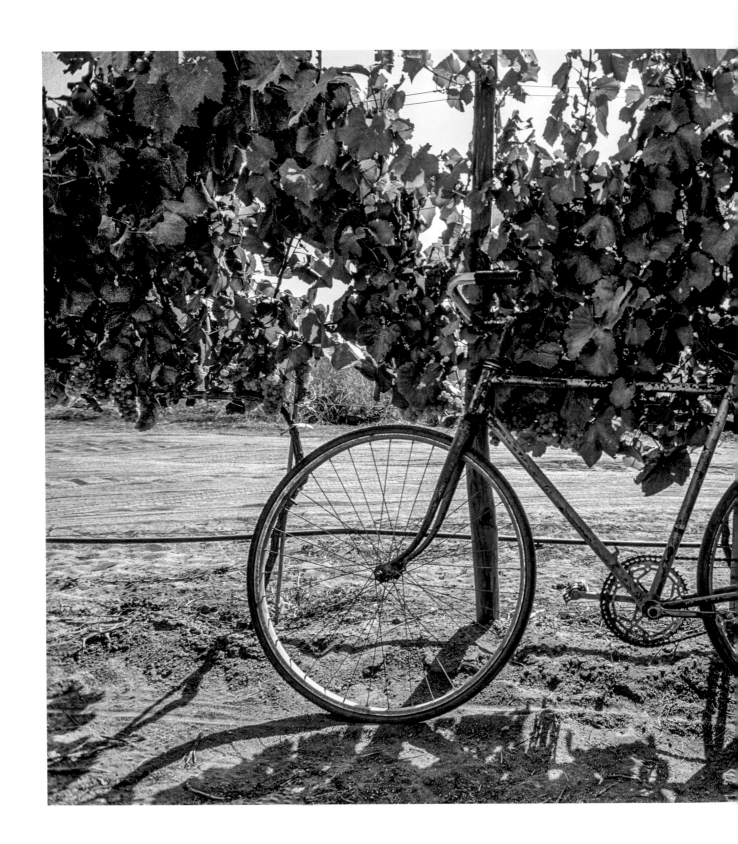

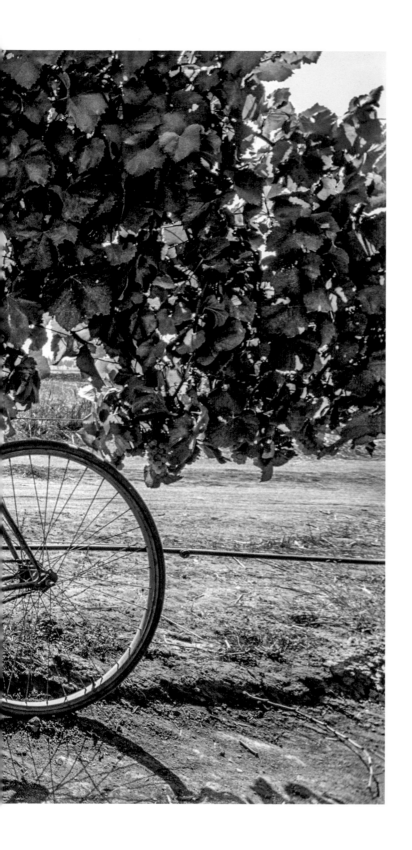

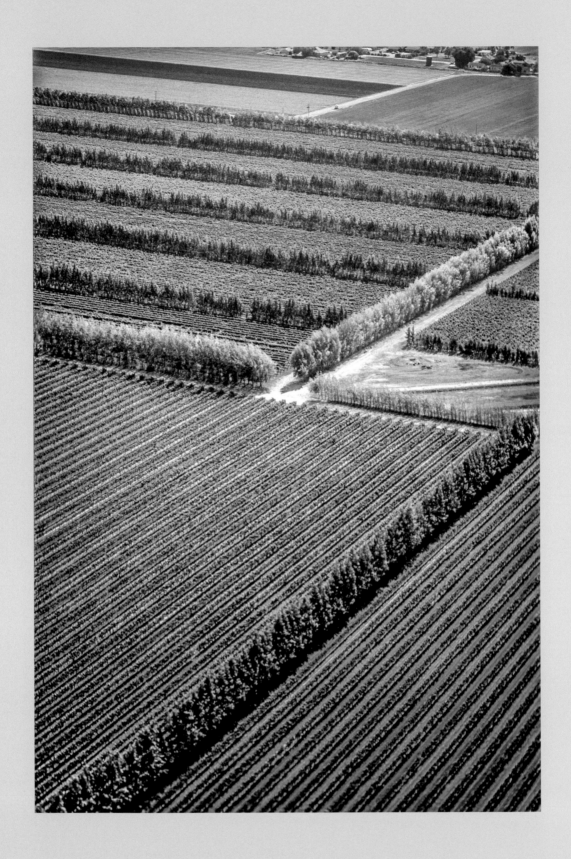

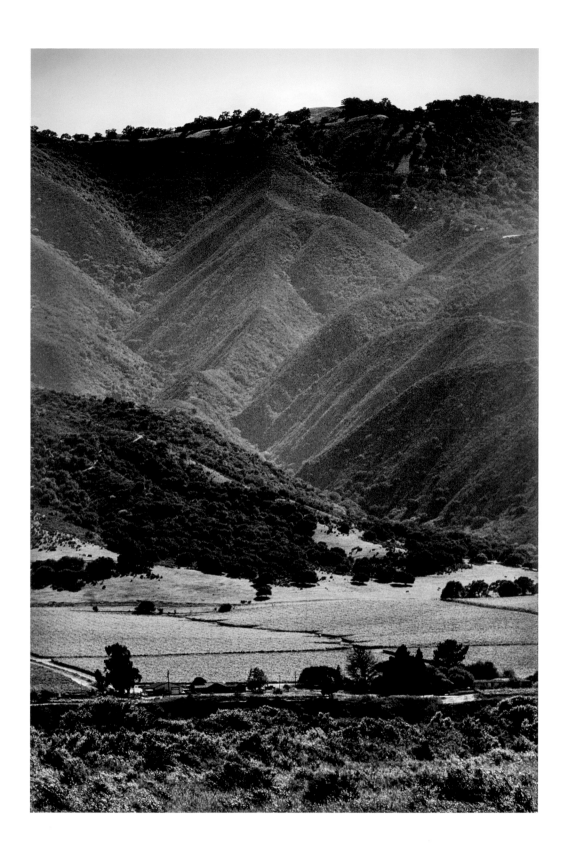

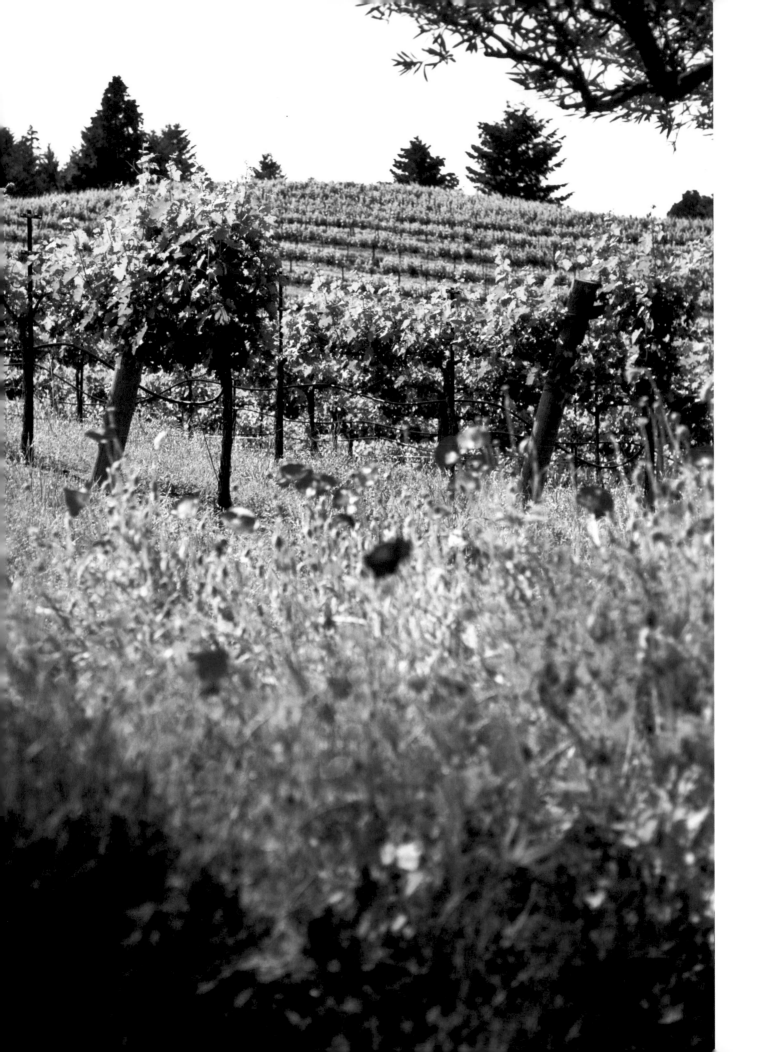

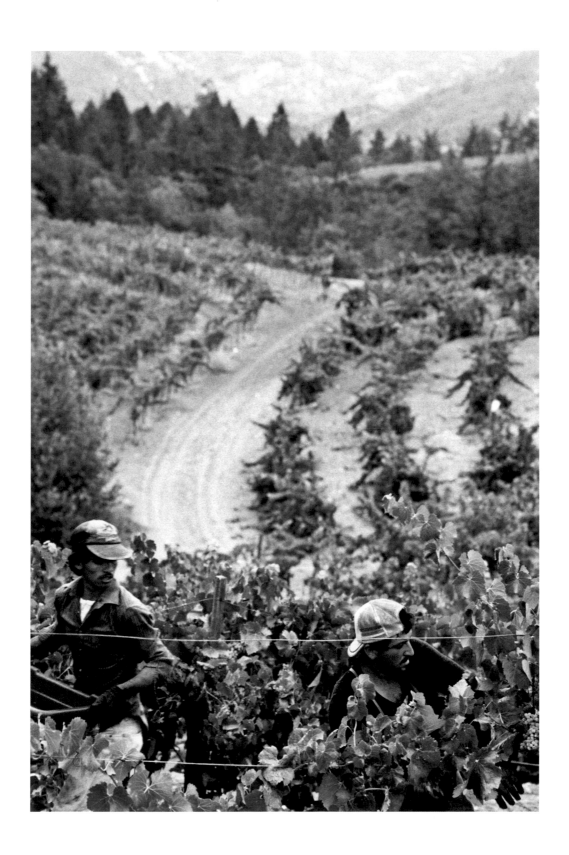

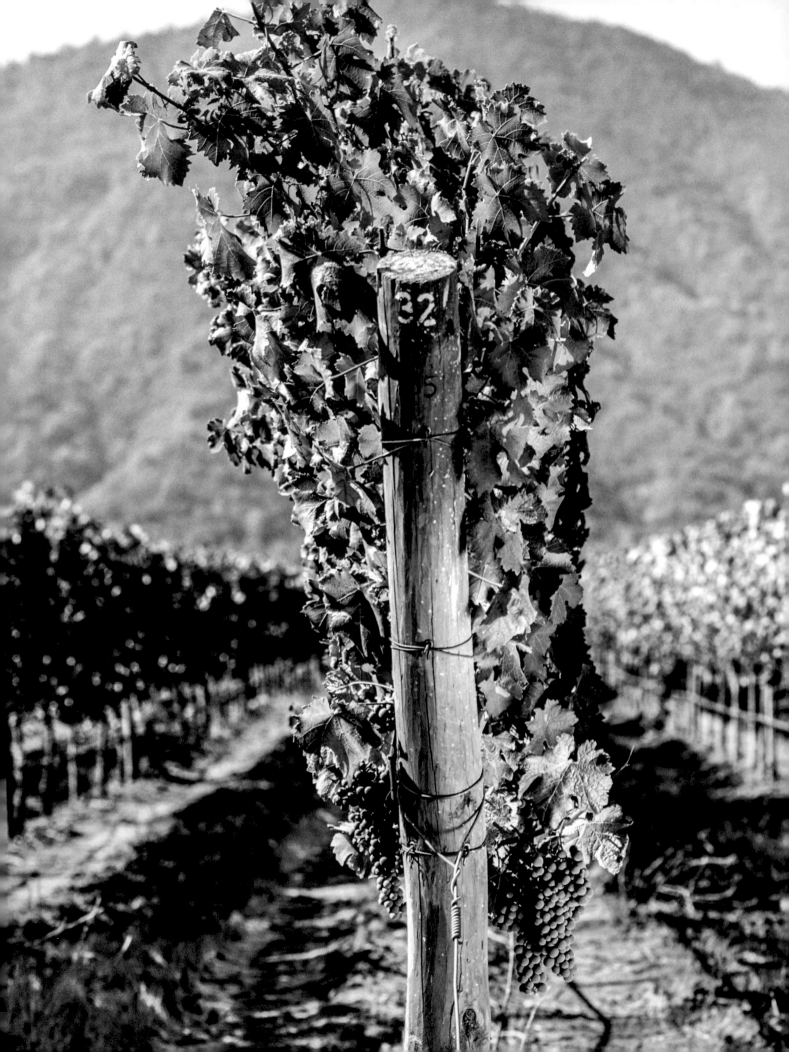

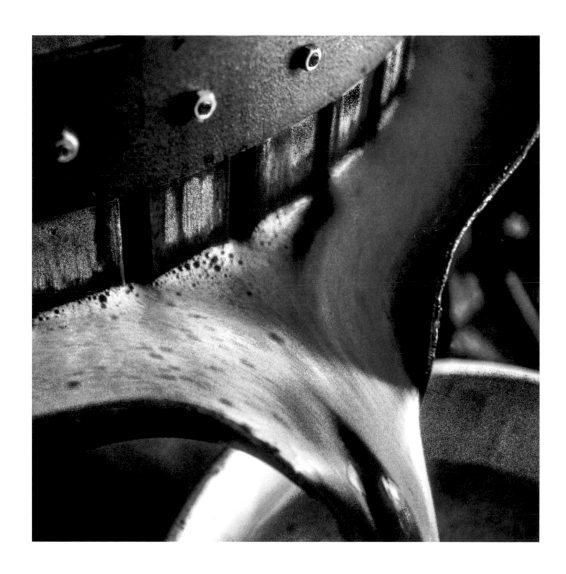

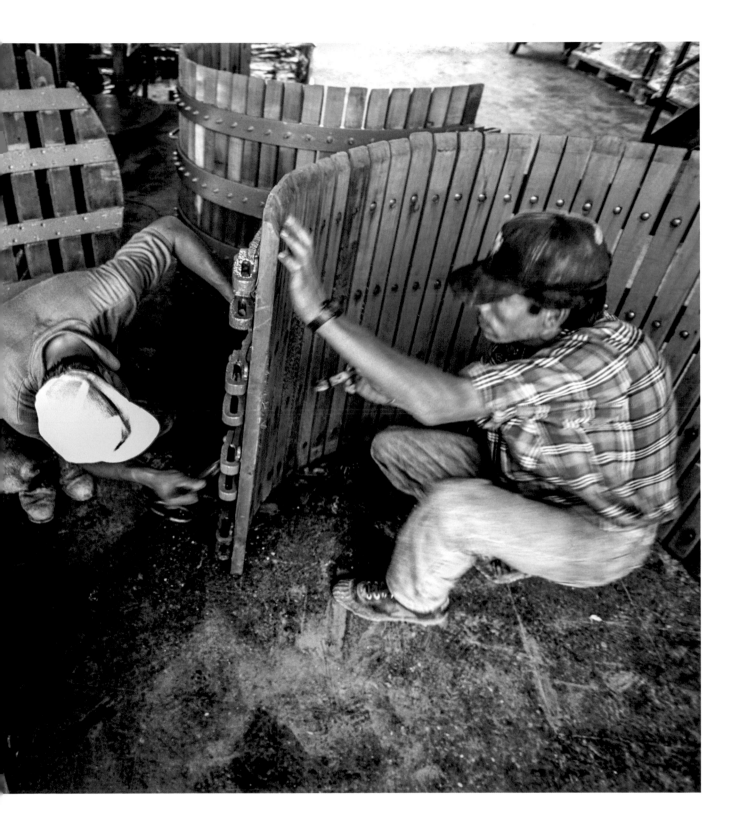

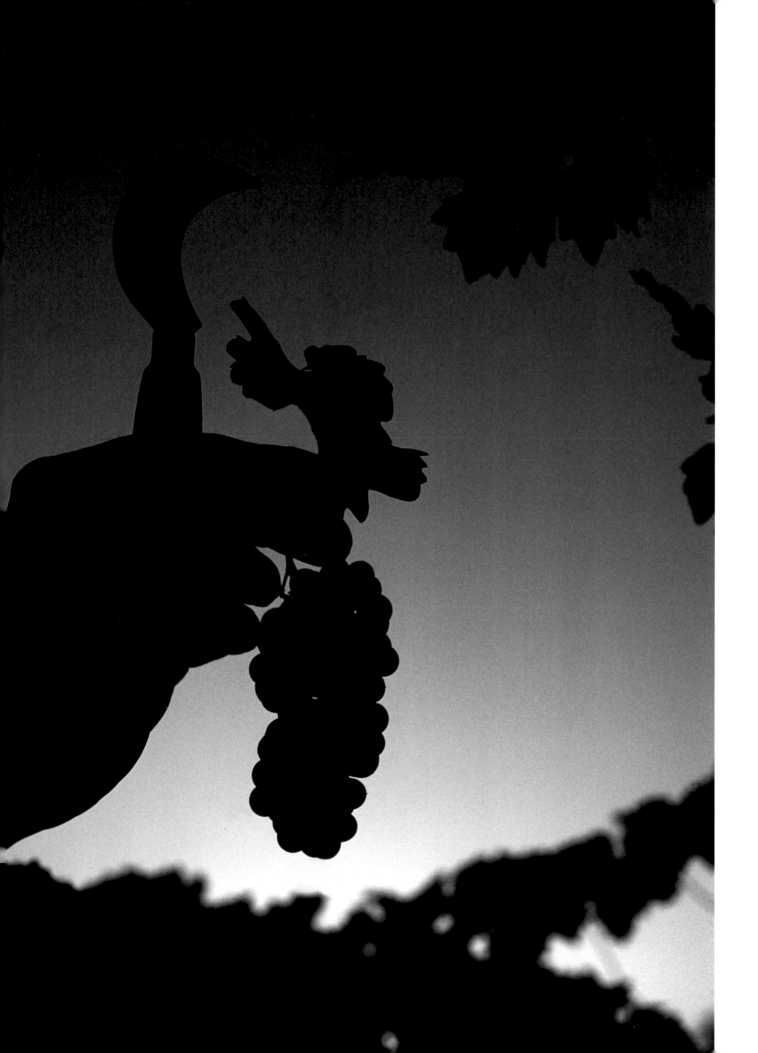

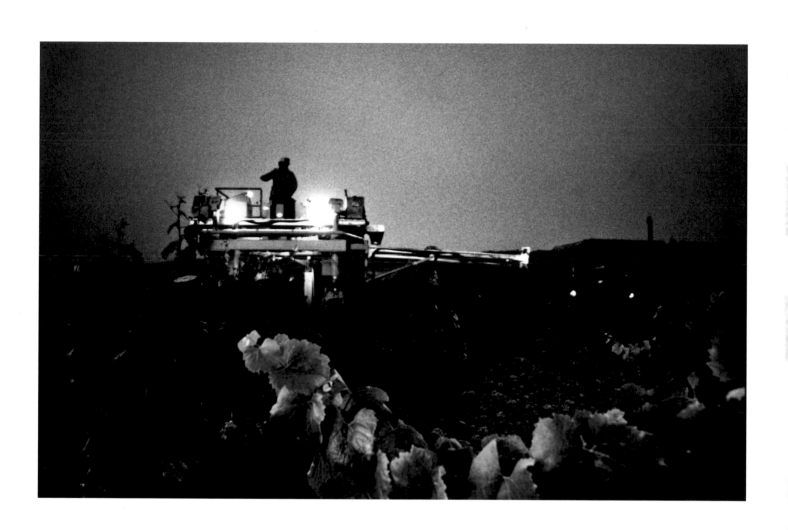

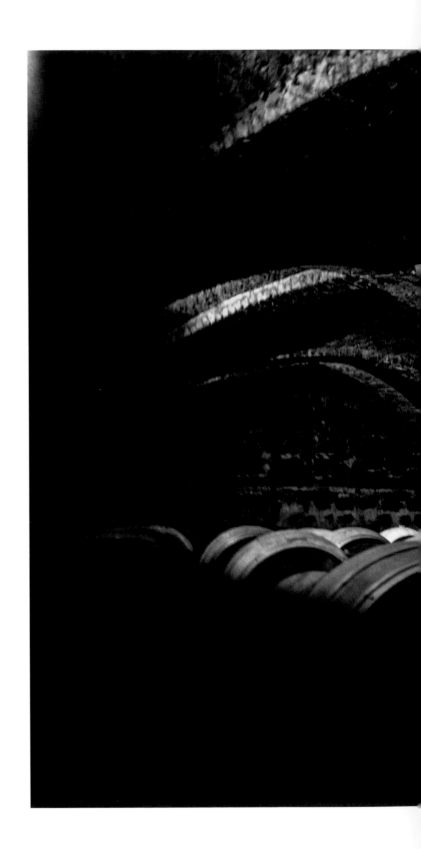

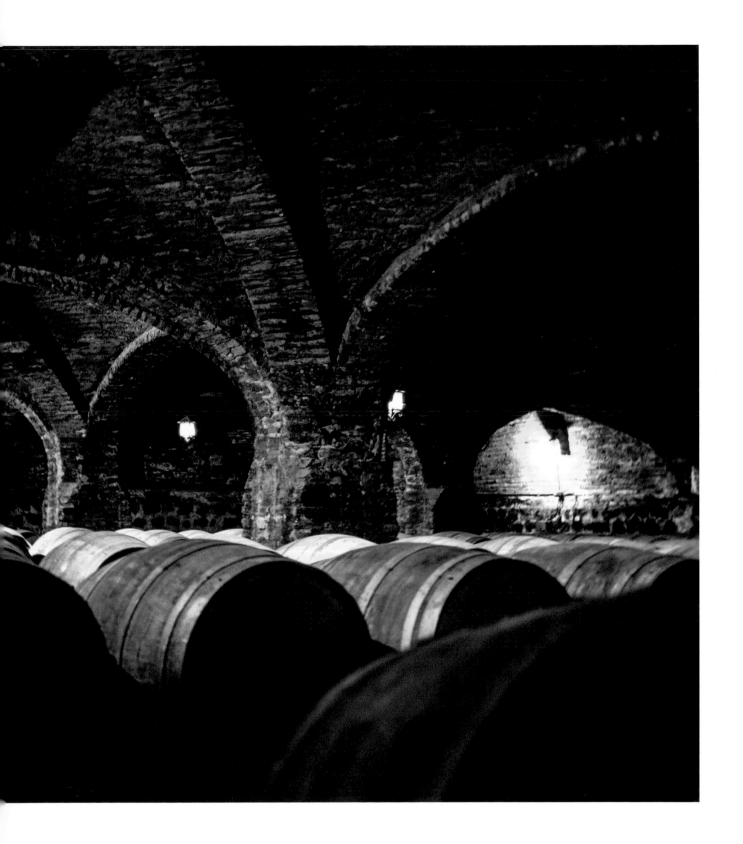

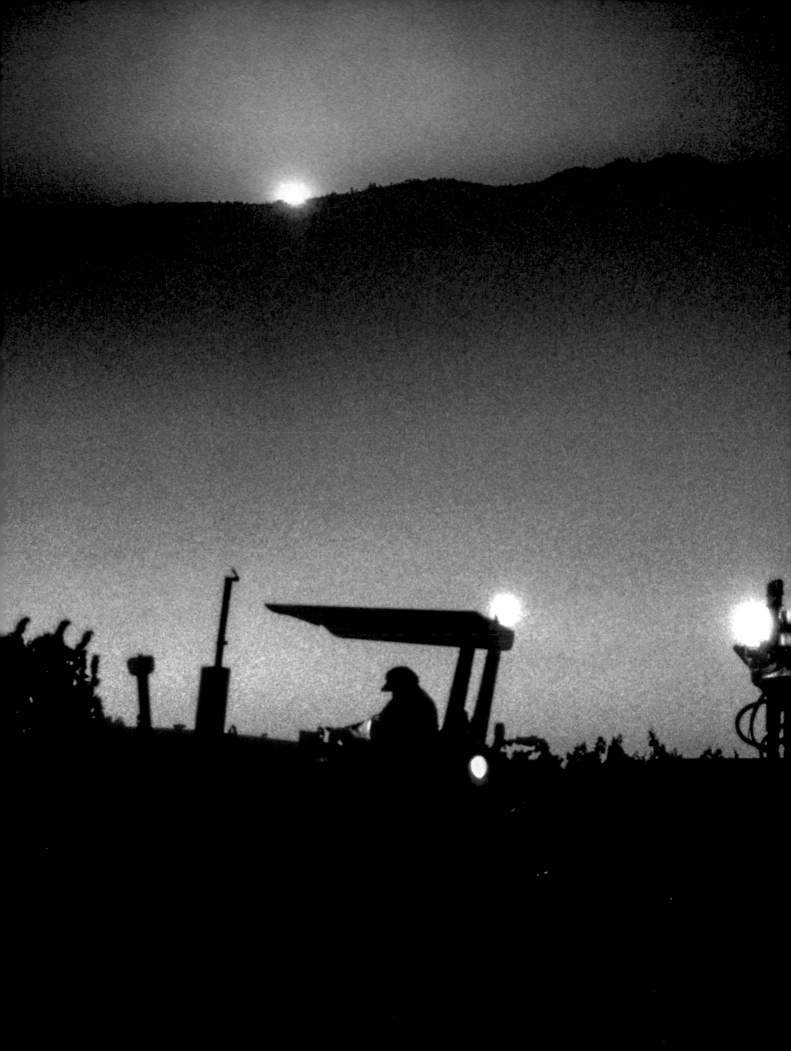

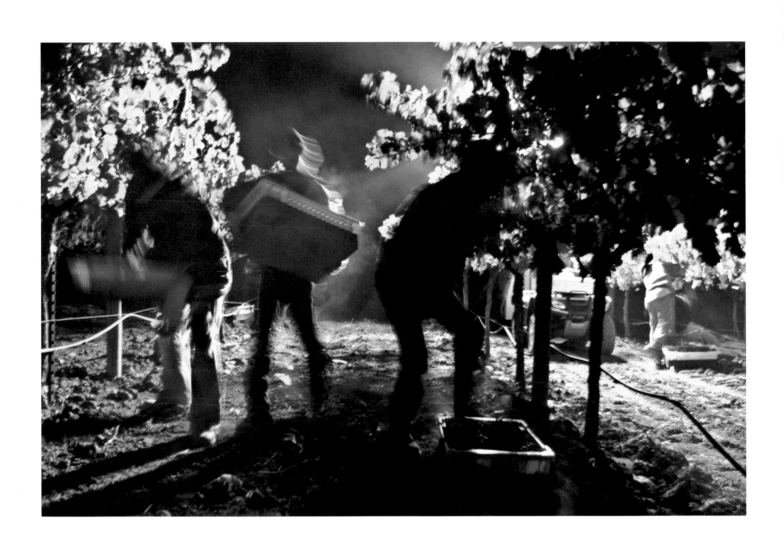

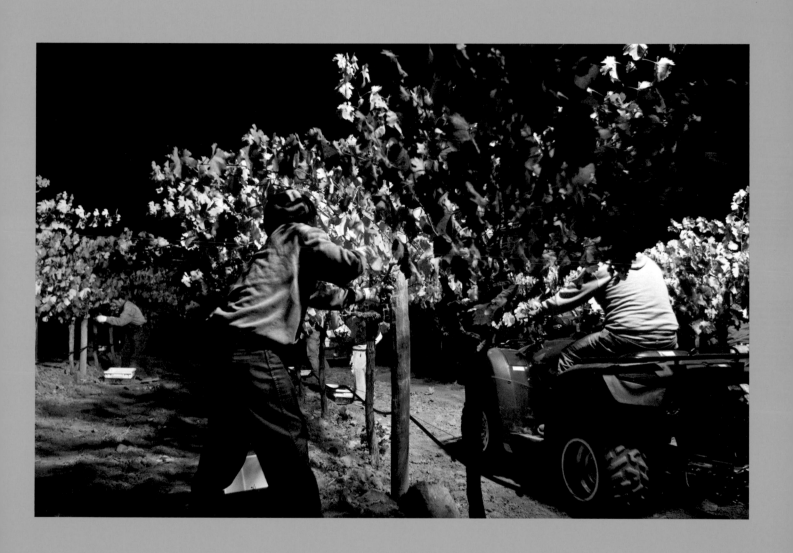

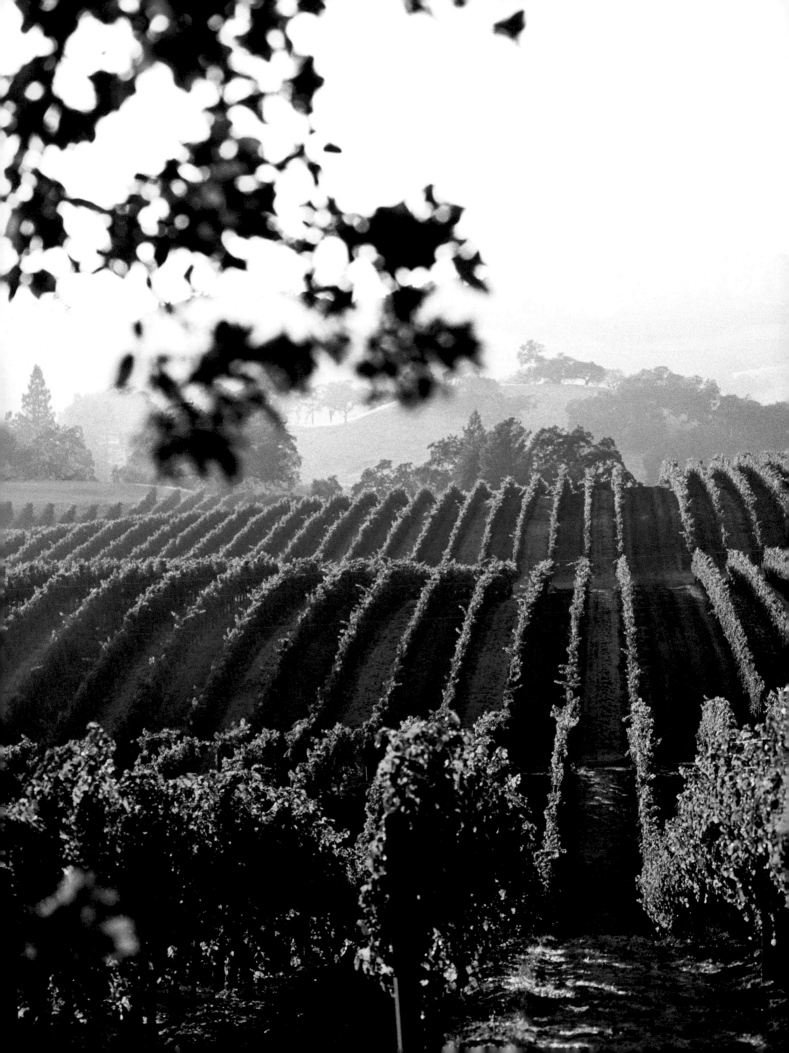

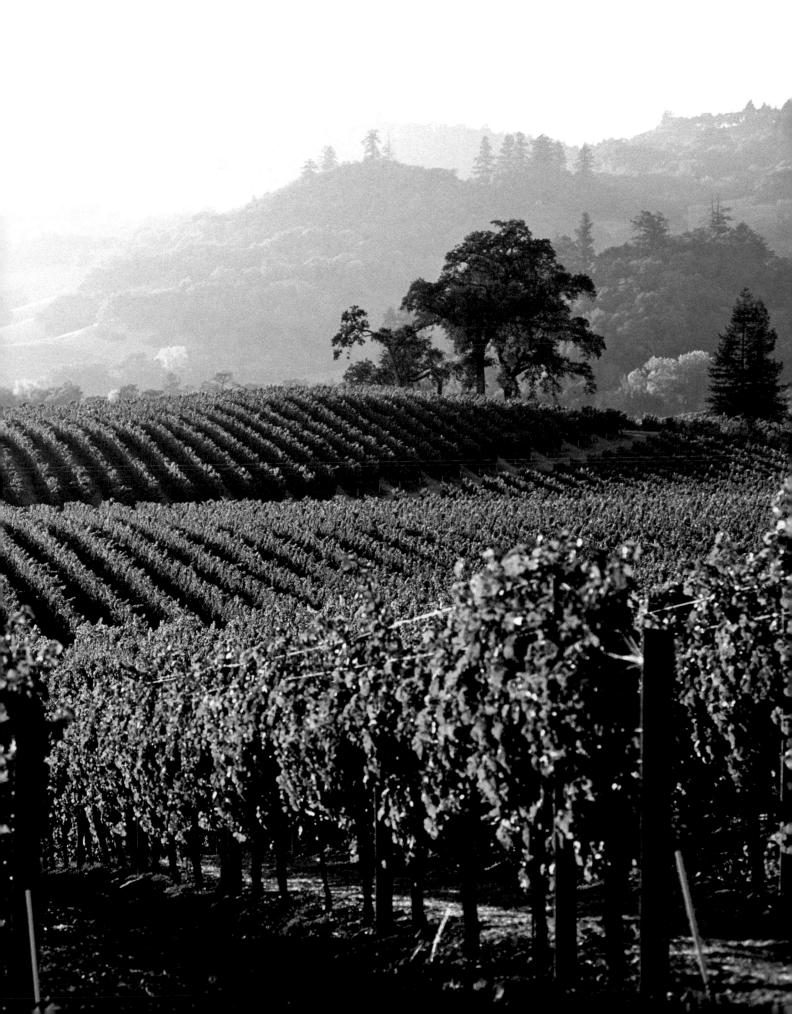

Picture-book hillside vineyards of the Robert Young Estate Winery in Sonoma County's Alexander Valley, California, 2015

Grape clusters drying inside a grower's home to concentrate flavors and sugar, Vernazza, Cinque Terre, Italy, 1966

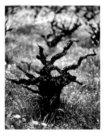

6 Like a stark sculpture, this old grapevine endures its winter dormancy, gathering strength for spring bud break, 1957. Following early tradition, this is called *head pruning*, or *gobelet* (for the glass it resembles).

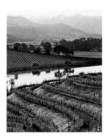

8 Quintessa Winery's owners lovingly sculpted a highly effective vineyard at this hidden jewel in the heart of California's Napa Valley, 1994

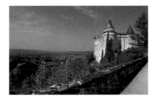

10-11 Château de Mercuès, known for its Malbec, located high above the Lot River in Cahors, France, 1990

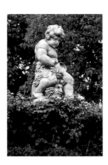

13 Bacchus statue in the garden of the Château Mouton Rothschild estate, in the village of Pauillac in the Médoc, Bordeaux, France, 1973

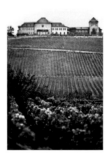

14 Schloss Johannisberg Vineyard, a historic Riesling vineyard and winery on the Rhine River in Germany, 1973

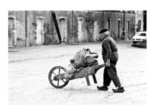

15 Winery worker at Château Sénéjac in Bordeaux's Haut-Médoc, France, 1973

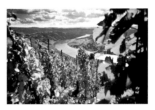

16-17 Terraced vineyards of the Côte-Rôtie (Roasted Coast) in the Rhône Valley of France, which make the vendage (harvest) a strenuous effort, 1973

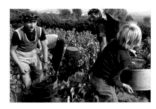

18-19 Piesport, on Germany's Moselle River, 1973

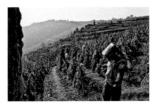

20-21 The Gautier family picking Gamay grapes, Fleurie, Rhône, France, 1973. In Beaujolais, the vendage is a family affair.

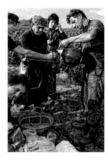

23 Gautier family taking a midmorning pause for *casse-croûte*: bread, cheese, and wine, 1973

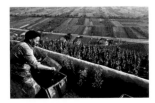

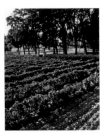

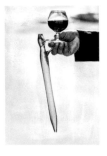

24-25 Vineyards of the Côte-Rôtie of northern Rhône Valley, France, 1973. The grape harvest is difficult on these extremely steep hillsides, but the Syrah prospers here.

31 The prized vineyards of Château La Nerthe in Châteauneuf-du-Pape, Rhône, France, 1990

37 Tasting wine direct from the barrel in the aging cellars, which requires a tubular glass wine thief

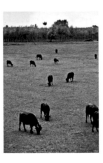

27 Château La Nerthe, one of the oldest estates in Châteauneuf-du-Pape, Rhône, France, 1990

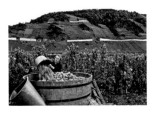

32-33 The wine grape harvest along the Moselle River, Germany, 1973

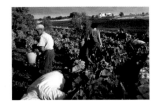

38 Harvesting grapes in Puglia, Italy, where the custom appears to be that all the locals work all crops, 1966

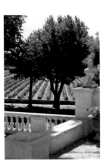

28 Buffalo in Campania, Italy, 1966. Originally introduced from India for labor, buffalo produce milk that is prized for the best mozzarella.

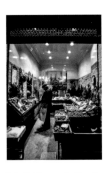

35 Daily marketing in Paris. The variety of specialty food shops dictates the path of Parisians.

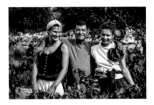

39 Harvest time, when friends and neighbors join in the vineyard, in the celebrated La Tourtine Mourvèdre vineyard of Domaine Tempier, Bandol, France, 1990

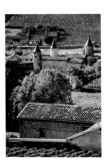

29 The picturesque Beaujolais vineyards running along the Saône River, where winemakers have crafted deliciously supple and fruity wines since the days of ancient Rome, 1973

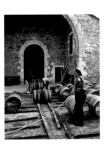

36 Readying oak cooperage for the Malbec harvest at Château de Haute-Serre, Cahors, 1990

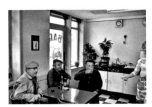

40 Wine workers, well known in this very local bar in Ampuis, Rhône, France, 1973

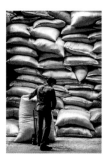

41 Sacks of champagne corks at the plant of Sagrera & Cie in Epernay, France, awaiting their traditional role in countless celebrations, 1990

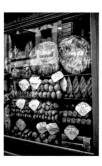

43 Parisian patisserie window displaying its range of temptations

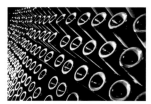

44-45 *Remuage*, or riddling, of sparkling wines, 1973. *Remuage* requires rotating the bottles and increasing their tilt until the sediment collects in the neck; disgorgement then ejects the sediment under pressure, leaving the wine perfectly clear.

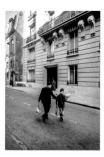

46 Parisian father and son return home from the marketplace, ready for dinner, 1973

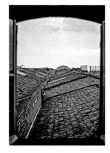

47 Red tile rooftops of old Bordeaux warehouses on the city's waterfront, 1973. These warehouses once housed barrels of claret (Cabernet) awaiting shipment to England.

48-49 Château du Clos de Vougeot, a wall-enclosed vineyard (clos) in the Burgundy wine region, 1973. This historic Cistercian winery was built in the twelfth and sixteenth centuries.

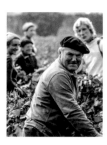

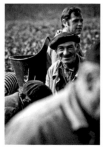

50 & 51 Château Carbonnieux, Pessac Leognan, one of the oldest estates in the entire Bordeaux wine region, 1973. Vendage is a venerated tradition.

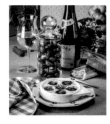

52 Escargots in garlicky butter sauce, paired with a steely Muscadet from the Loire and a baguette, signaling that all is right in the French world

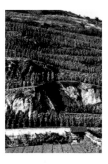

53 The steep, terraced vineyards of the Côte-Rôtie in France's northern Rhône, 1973. The Côte-Rôtie is the source of some of the world's most sought after Syrah wines.

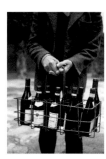

55 A French innkeeper bringing up new treasures from the cellar, Condrieu, Rhône, 1973

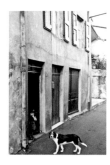

56 Small citizens of Condrieu, 1973. The Condrieu terroir, on the right bank of the Rhône, is famous for its white wines.

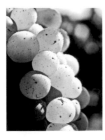

57 Wine grapes depend on a balance of sunshine and shade to develop their distinctive qualities. In most cases, white varieties ripen earlier than red.

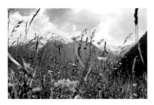

58-59 A mountain meadow in Carinthia, Austria, 1967. What expresses springtime more fully?

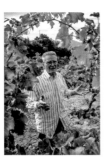

60 Lucien Peyraud in his La Tourtine vineyard. His Domaine Tempier set the mark for an increased percentage of Mourvèdre grapes in Bandol wines, elevating their stature.

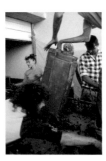

61 Hand sorting clusters fresh from the vineyards at Château de la Gardine, Châteauneuf-du-Pape, southern Rhône, France, 1990

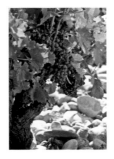

62 Southern Rhône, France, 1990. Rounded *galet* stones and untrained Grenache bush vines are quintessential sights in the Châteauneuf-du-Pape vineyard.

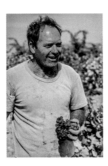

63 François Peyraud, Lucien Peyraud's son, who carried on the Domaine Tempier tradition and coveted reputation, 1990

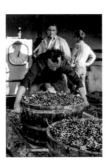

64 Weighing grapes at crush pad, Balaruc-le-Vieux, France, 1973

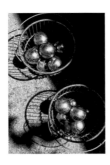

65 *Petanque* balls, weapons of the game that has long been an obsession in Provence, France, 1989

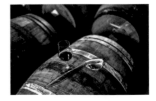

66-67 Glass wine thief, used to draw a sample from a barrel for tasting, 1986

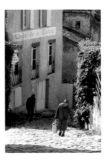

68 The steep streets of the historic fortified hilltop village of Saint-Émilion, Bordeaux, France, 1967. Vineyards, most often Merlot and Cabernet Franc, ring the town.

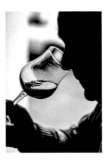

69 Anticipation—sampling the aroma, then tasting: the validation of the wine, 1990

70-71 The Provençal dining patio outside Lulu Peyraud's kitchen at Domaine Tempier, 1990

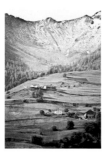

72 Idyllic mountain farmland in Carinthia, Austria, 1967

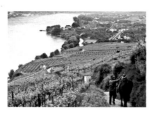

73 Bordering the Danube River, the Wachau Valley, among Austria's most popular white wine areas, 1967

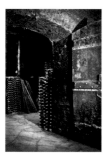

74 Négociant Calvet's old cellars in Beaune, Burgundy, France, 1973

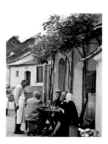

75 A pleasant drive through the vineyards surrounding Vienna, Austria, wouldn't be complete without pausing at a *heuriger* (wine bar) for a bite and tasting the new wine, 1966.

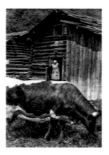

76 Dairy farming in rural Carinthia, Austria, 1967. Farming is demanding work in Carinthia's mountain areas.

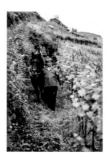

77 Ried Klaus vineyards, Wachau Valley, Austria, 1966. This vineyard is known for dry Riesling and Grüner Veltliner.

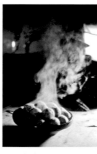

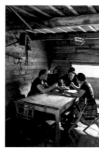

78 & 79 Sturdy mountain farm folks digging into a steaming bowl of dumplings at their midday meal, Carinthia, Austria, 1966

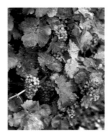

80 Ripe Moselle grapes, most likely Riesling, ready for the harvest at vineyard above Traben-Trarbach, Germany, 1973

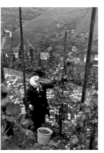

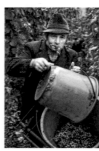

81 & 82 Along Germany's Moselle River, where everyone turns out when the grapes are ready for picking, 1973. Incredibly steep vineyards must be worked by hand.

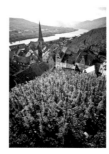

83 The town of Traben-Trarbach on the Moselle River, below precipitous vineyards of prized Riesling, 1973

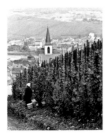

84 Picking Riesling grapes in the vineyards above Ürzig on the Moselle River in Germany, 1973

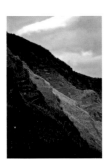

85 Frighteningly steep terraced vineyards above Bremm on the Moselle River, Germany, 1973

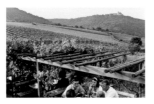

86-87 Locals enjoying an *heuriger* as grapes ripen in the vineyards that surround Vienna, Austria, 1967

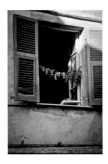

89 Grapes drying in a window in Vernazza, Cinque Terre, Italy, 1966. Sciacchetrà wines have intense, sweet flavors.

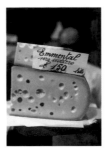

90 Fine Emmental cheese, complementing the magic of wine

91 Village homes in Vernazza, in Italy's Cinqe Terre, 1966

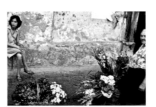

92-93 Flower sellers in the market, Naples, Italy, 1966

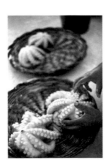

94 Octopus in the fishing port market, Dubrovnik, Croatia, 1966

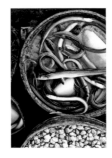

95 Eels in the Naples fish market, close to the boats, 1966

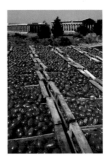

96 Ancient Greek temples at Paestum, Campania, Italy, framing a fresh harvest of tomatoes, the Italian dietary staple, 1966

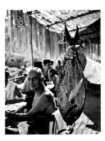

97 The Amalfi Coast, where Italians are close to the source for seaside dining, 1966

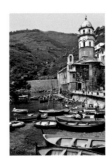

99 Village harbor of Vernazza in Italy's Cinque Terre, with steep, terraced vineyards in background, 1966

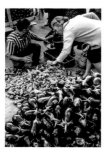

100 Local produce in the marketplace, Alberobello, Puglia, Italy, 1966

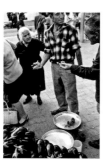

101 The Alberobello market, rich with ritual and drama, 1966

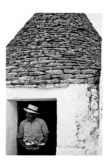

103 A conical-roofed house (*trullo*) typical of the construction in Italy's Puglia, 1966. Luigi Tateo raises pigeons here, in Bari.

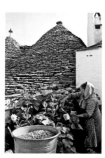

104 *Trulli* in Alberobello, Puglia, Italy, 1966. Locals raise beans in the gardens behind these whitewashed houses.

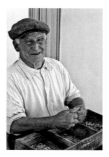

105 Seated outside the door of his *trullo*, a local resident shelling beans and sharing gossip with passing neighbors, Puglia, Italy, 1966

106 Row crops farmed between impressively old olive trees, Puglia, Italy, 1966

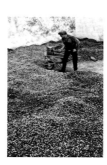

107 Ripe olives, ready to be pressed for oil, at the plant in Bitonto, Puglia, Italy, 1966

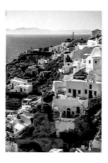

108 Oia, a village on the rim of an ancient volcano on the Greek island of Santorini, 1994

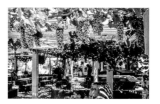

109 Volcan Winery's shaded tasting garden on Santorini, Greece, 1996

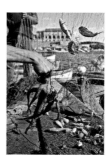

111 A fisherman unloading his daily catch in Porto Venere, near La Spezia, Italy, 1966

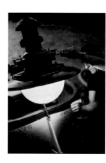

112 A *lampare*, a light lure used by fishermen plying the waters off the seaside village of Vernazza on Italy's Cinque Terre, 1966

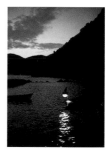

113 A *lampare* fisherman from Vernazza on his nightly quest along the steep shores of the Cinque Terre, Italy, 1966

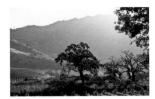

114-15 Shafer Vineyards, under the rocky cliffs and slopes of the eastern Napa Valley, 2003. The terrain is spectacular to view but challenging for wine growing.

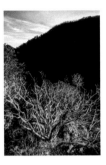

116 Dating from 1889, Mayacamas Winery and Vineyards, atop Mount Veeder, Napa County, commanding precipitous and rugged terrain for its Cabernet vineyards, 1960

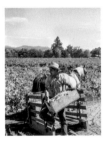

117 A horse pulling a sled of freshly picked grapes out of the vineyard at Fountaingrove, Sonoma County, California, 1946

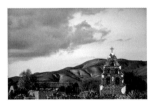

118-19 Mission San Miguel Arcangel, established in 1797 by the Franciscan order, in Paso Robles, California, 1992

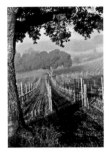

120 Morning fog on California's Central Coast, benefiting Jonata Vineyards' immaculate plantings, Los Olivos, 2008. Brilliantly conceived, Jonata's wines quickly achieved cult status.

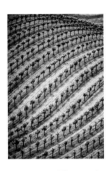

121 Taylor Vineyard, a dramatic triumph on the Silverado Trail in the Napa Valley Stags' Leap district, 2001

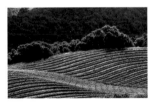

122-23 AND BACK COVER Quintessa Vineyard, a prized jewel in Rutherford, Napa Valley, lovingly sculpted by estate founders Valeria and Agustin Huneeus, 2006

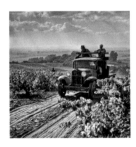

125 Picking old-head pruned vines at Fountaingrove Winery, Santa Rosa, Sonoma County, California, 1947. The area became popular for posh homes, but was devastated by wildfire in 2017.

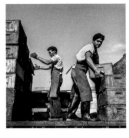

126 Inglenook, Rutherford, California, 1946. At that time, Napa Valley grapes were still being picked into wooden boxes, which have since been supplanted by plastic trays.

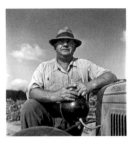

127 Vineyard boss at historic Fountaingrove Winery, Santa Rosa, California, 1946

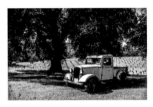

128 Dry Creek Valley, Sonoma County, California, 1992

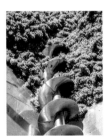

129 A faithful performer, Dry Creek Valley, Sonoma County, California, 1983. Freshly picked grapes are moved to the crusher by this stainless steel auger.

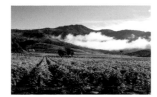

130-31 Fog in Napa Valley, 1973. The fog snakes its way up from the San Francisco Bay, balancing the Napa heat and providing a longer ripening.

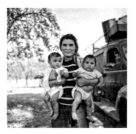

133 Migrant vineyard worker family at Almaden Winery, Santa Clara Valley, California, 1946

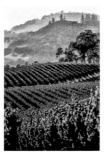

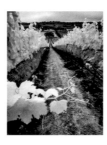

134 & 135 Lush, rolling hillside vineyards of Robert Young Estate Winery, Alexander Valley, Sonoma County, California, 2015. Steep, sloping vineyards are difficult to farm but often present advantages of sun exposure and drainage that result in premium fruit.

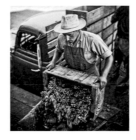

137 Grapes arriving at the crusher during harvest time at Inglenook Winery, Rutherford, Napa Valley, California, 1946.

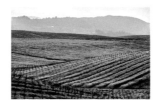

138-39 Dramatic vineyards of Gallo Frei Ranch in Dry Creek Valley, Sonoma County, California, 2003

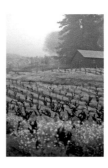

141 Jonata's vineyards above Los Olivos, Santa Barbara area, California, 2007

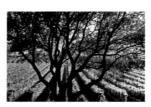

142-43 Screaming Eagle Vineyard, tiny jewel of the Napa Valley and producer of a cult favorite Cabernet, Oakville, California, 2008

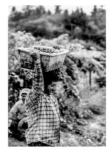

144 Picker in California's Napa Valley, 1988

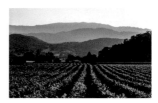

145 Old head-pruned vines in Dry Creek Valley, Sonoma County, California, 1979. These vines are prized for their fruit and ripen slowly in the coastal fog.

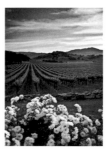

146-47 Sunset on the floor of the Napa Valley, signaling the hour for popping corks, 2000

148 Screaming Eagle Vineyard, Oakville, Napa Valley, California, 2000

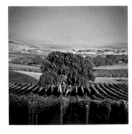

149 Jonata Vineyards, Los Olivos, on California's Central Coast, 2007

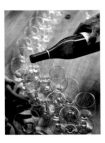

150 A delicious education: tasting wine at Robert Mondavi Winery, Napa Valley, California, 1988

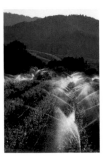

151 Overhead sprinklers at Yountville, mid–Napa Valley, California, 1975. These sprinklers require great quantities of water but provide frost protection at bud break in addition to irrigation.

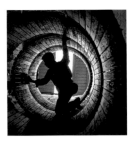

153 Wente Vineyards, the oldest continuously run family-owned winery in the United States, Livermore, California, 1949 Young Karl Wente prepares a basket press for the crush.

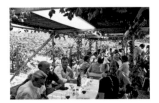

154–55 A harvest lunch in a hillside vineyard, celebrating a successful vintage, Spring Mountain, Napa Valley, California, 1988

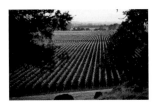

156–57 Sunset on prime vineyards of the Alexander Valley, Sonoma County, California, 2015

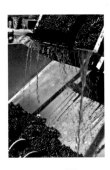

159 Preston Winery, Dry Creek Valley, Sonoma County, California, 1990. A load of freshly picked red grapes arrive at the winery, bursting with juice, to be moved by the auger to the crusher.

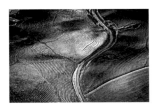

160–61 Napa–Sonoma, from the air, 1988. New vineyard planting follows the contours of the hills of the Carneros region, near San Francisco Bay.

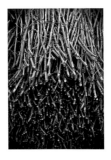

162 Jonata Vineyards, Los Olivos, California, 2006. Vine cuttings are grafted to resistant rootstock for planting as new grapevines.

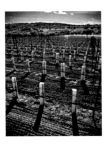

163 White sleeves protecting newly planted vines at Jonata Vineyards, Los Olivos, California, 2007

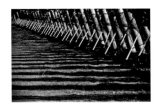

164–65 Jonata Vineyards, Los Olivos, California, 2007. Sturdy endposts anchor vineyard wire at each end of every row.

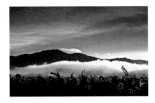

166–67 Grapes ripening in the lower end of the Napa Valley, benefiting from cooling morning fog, 1974

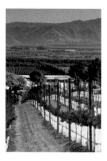

168 Paper sleeves protecting newly planted vines at Estancia Winery, Monterey County, California

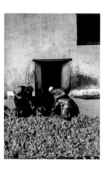

169 Freshly picked Sauvignon Blanc grapes arriving at Viña Santa Mónica, Rancagua, Chile, 1996

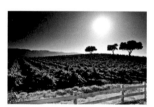

170-71 B. R. Cohn's Olive Hill Vineyard in Sonoma Valley, California, known for both olive oil and wine, 1985. Bruce Cohn previously managed the Doobie Brothers.

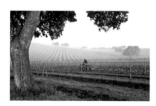

172-73 Early-morning dense fog from the nearby California coast balances midday heat at Jonata Vineyards, Los Olivos, California, 2008

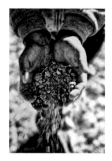

174 The rocks and soils in which vines are planted—a primary consideration, influencing every phase of the winemaking process, 2005

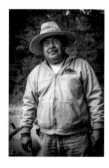

175 A longtime vineyard worker at Mayacamas, atop Napa Valley's Mount Veeder, California, 2014

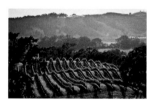

176-77 St. Supéry's Dollarhide Estate Ranch in Pope Valley on the far east side of Napa County, California, 2006. St. Supéry's is known for both its red and white wines.

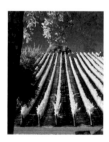

178 Well-groomed hillside vineyard of Jonata Vineyards in Los Olivos, California, 2008

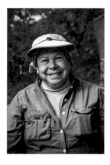

179 A longtime vineyard worker at Mayacamas, Mount Veeder, Napa Valley, California, 2014

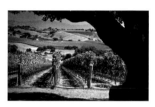

180-81 Old oak trees dotting the rolling hills of Jonata's vineyard, Los Olivos, California, 2006

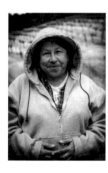

182 A longtime vineyard worker at Mayacamas, Mount Veeder, Napa Valley, California, 2014

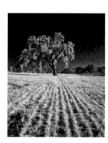

183 Native oak trees, which dominate California's landscape, often characterizing prime vineyard locations, Los Olivos, California, 2005

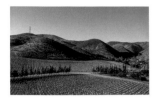

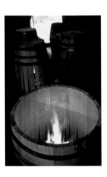

184-85 New planting dotting the windswept landscape of Estancia Winery in Monterey County, California, 1992

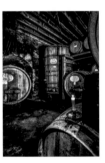

186 Small open fire, allowing oak staves to be bent in the barrel-making process, 1986

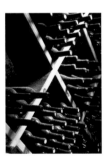

187 Original oak barrel room still in use at historic Mayacamas Winery, perched high above the Napa Valley on Mount Veeder, California, 2015

188 Crocker & Starr cellars, St. Helena, Napa Valley, California, 1978

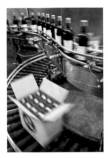

189 Bottling line at Ravenswood Winery, Sonoma County, California, 1992

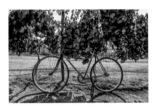

190-91 Alto de Casablanca vineyards, Casablanca, Chile, 1996. Vineyard workers commute by bicycle.

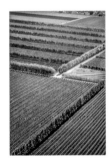

192 Aerial view of Estancia vineyards displaying rows of windbreak trees, vital for vine protection, 1992. California's Monterey County extends to the breezy Pacific Ocean.

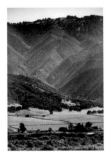

193 The dramatic mountain range that stands between Estancia's vineyards and California's Monterey Coast, 1993

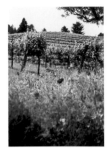

194 The vineyards of Dry Creek Valley in Sonoma County, California, renowned for their beauty as well as their distinctive wines, 1986

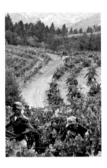

195 Pickers attacking the harvest at the mountainside Schramsberg Vineyards, known for its world-class sparkling wines, Calistoga, Napa Valley, 1989

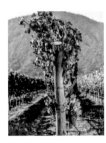

196 Veramonte vineyard, pride of Chile's Casablanca Valley, with over one thousand acres of enviable soil and cooling ocean air, 1996

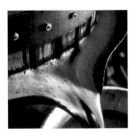

197 Grape must, the free-running juice of freshly crushed fruit, pouring from a traditional basket press, 1976

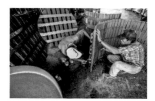

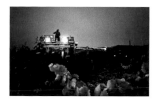

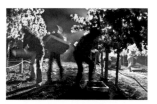

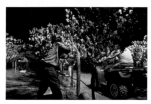

198-99 Basket press being assembled at Viña Aquitania, Santiago, Chile, 1996

201 Night mechanical harvesting of ripe grapes, which allows precise timing and takes advantage of cooler temperatures for delivering the fruit to the winery, Monterey County, California, 1986

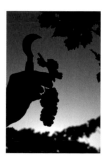

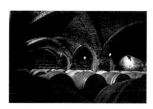

206 & 207 Handpicking premium Cabernet at night for maximum quality, Screaming Eagle Vineyard, Oakville, Napa Valley, California, 2004

200 A serpette, also known as a grape hook: a symbol of the grape harvest and the picker's constant companion, 1996

202-3 Winery aging cellars, Viña Santa Rita, Buin, Chile, 1996

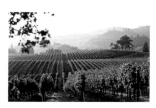

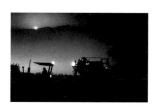

208-9 The grandeur of well-groomed California vineyards: Robert Young Estate Winery in Sonoma County's Alexander Valley, 1996

204-5 Night mechanical harvesting, Monterey County, California, 1996

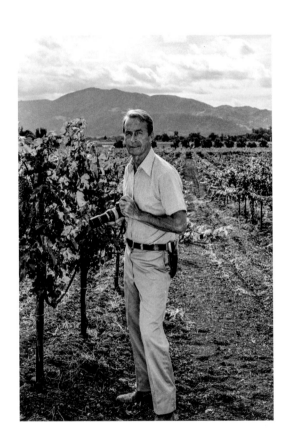

FRED LYON is a longtime resident
of San Francisco and was the owner of
Lyon Vineyard (left) in Napa Valley's
Oakville district, where he experimented
with winemaking. Lyon's work has
appeared in numerous publications and
has been exhibited at the the Museum
of Modern Art, the Legion of Honor
Museum, the Leica Gallery in San
Francisco; the Peter Fetterman Gallery
in Santa Monica; and the Art Institute
of Chicago. His previous books are
San Francisco: Portrait of a City and
San Francisco Noir.